digital
photography:
AN INTRODUCTION

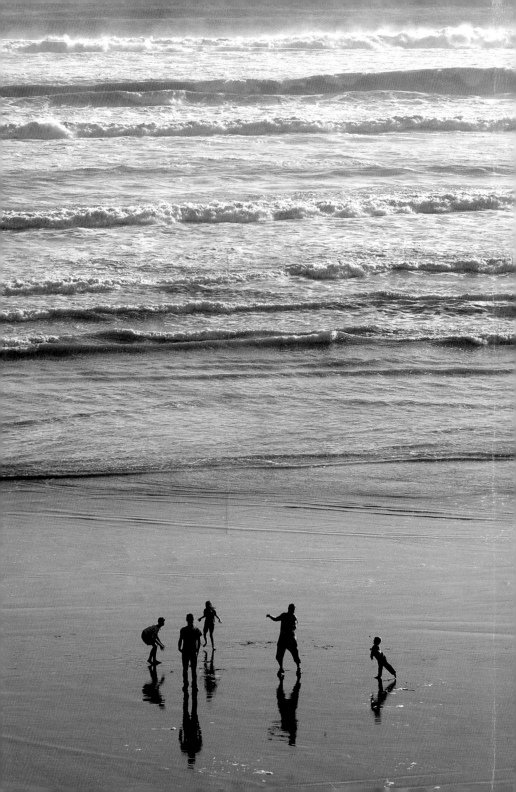

digital
photography:
AN INTRODUCTION

TOM **ANG**

LONDON, NEW YORK, MUNICH,
MELBOURNE, DELHI

Contents

To Wendy

Senior Editor Neil Lockley
Senior Art Editor Kevin Ryan
DTP Designers Sonia Charbonnier, Rajen Shah
Production Controller Heather Hughes

Managing Editors Adèle Hayward, Sharon Lucas
Managing Art Editor Karen Self
Category Publisher Stephanie Jackson
Art Director Carole Ash

Produced on behalf of Dorling Kindersley by
HILTON/SADLER
63 Greenham Road
London N10 1LN
UK

Editorial Director Jonathan Hilton
Design Director Peggy Sadler

First published in Great Britain in 2003
by Dorling Kindersley Limited
80 Strand, London WC2R 0RL

A Penguin Company

Copyright © 2003 Dorling Kindersley
Text Copyright © 2003 Tom Ang

2 4 6 8 10 9 7 5 3 1

A CIP catalogue record for this book is available from
The British Library

ISBN 1 4053 0235 6

Colour reproduction by GRB Editrice s.r.l., Italy
Cover reproduction by GRB Editrice s.r.l., Italy
Printed and bound by Star Standard, Singapore

See our complete catalogue at www.dk.com

The material in this book has previously appeared in
Dorling Kindersley's *Digital Photographer's Handbook*.

Introduction

One hundred and sixty years after the invention of photography, an enemy rose above the horizon. It threatened to sweep away film, make the dark-room redundant, and to exile the hard-won craft skills of picture-making. In a short time the threat grew as numerous new enemies appeared, in the shape of more and more digital cameras, scanners, image manipulation software, and the Web – all banding together to raze photography to the ground.

As photographers watched the approach with increasing apprehension, however, the threat turned out to be the best friend photography could have hoped for. Instead of fighting photography, digital technologies have in fact revitalized whole swathes of photographic practice, breathed fresh air into forgotten corners of image-making, and opened up a richly rewarding craft to more people than ever before.

In short, what was feared to be a clash to the death between classical photography and digital technology has turned out to be a union of tremendous fecundity – one giving us unexplored worlds of practical, creative, and enjoyable potentialities.

Digital Photography: An Introduction celebrates the maturing of digital photography as a force to be reckoned with. So here you will find all the love and enthusiasm I have for all of photography's traditional skills for creating expressive, effective, and rewarding images. At the same time, I share with you my thrill and wonder at the flexibility, power, and

economies possible with digital photography. Photographers are, today, working at the leading edge of image-making, contributing to the development of what is nothing less than a visual powerhouse of as yet undreamt of potential.

This book's aim is to help you to gain the most from this powerhouse. It brings together a vast amount of technical information and practical advice, and reveals numerous professional tips and tricks of the trade all in one compact volume. It is offered in order to help you to improve, enjoy, and understand the potent medium of communication that is the new photography.

Digital Photography: An Introduction aims to be your photographic companion. I hope it will help you on your own journey of visual, technical, and creative adventures, leading to personal discovery. Ultimately, I hope that it will help you to surpass its content. For you to do so will be your greatest compliment to this book – at which point, it would also be time heartily to congratulate yourself.

1

Total photography

Starting out

Covering the basic principles underlying digital photography, the range of equipment available for all budgets and degrees of expertise, and a good grounding in the technology – a wealth of information to help you make informed choices. And with its help you can easily keep up with the rapid changes taking place in digital photography. All the key concepts are clearly explained.

Choosing equipment

Many examples from the vast range of available digital equipment – including cameras, memory cards, image-manipulation software, computers, scanners, and printers – are all clearly displayed and discussed to help you choose the items that best suit your requirements.

The latest technology

Here you will find explanations of the most up-to-date technology – how it works and what it does.

Photographic pathways

Many people will already have made a significant investment in photographic equipment over the years and so will wish, for the foreseeable future, to remain wedded to conventional image-making – recording "analogue" pictures (*see opposite*) on traditional film. The good news is that this in no way bars them from the world of digital photography: all images (film negatives or positives, or colour or black and white prints) can be digitally scanned and, from that point on, any work on them regarded as digital photography.

Something magical happens when you combine the pathways through film-based and digital photography. A world of unimagined opportunity opens to you, with more than one way to achieve nearly any end – and from every fresh option arises yet new creative opportunities. In short, total photography (the combination of analogue with digital) gives you the best of both worlds. By increasing your options, it can inspire as it empowers. It is no exaggeration to say that the only limit is your imagination.

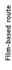

Digital route

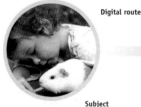

Subject

Film-based route

Digital camera
Anything you can photograph using a conventional film-based camera can also be recorded as a digital representation of the subject using a digital camera.

Memory cards
A digital camera uses memory cards to store the digital representation of the subject.

Print

Negative　　**Slide**

Film camera
A conventional camera records an analogue representation of the subject, with each image being recorded on an individual frame of film.

Film
Once exposed to light from the subject, minute changes take place in the composition of the image-carrying emulsion layers of the film. At this stage the image is invisible and is known as a latent image.

Processing
Processing the film in special chemicals amplifies the latent image so that a recognizable image of the subject appears. Depending on the film used, you could have a positive image (or slide) or a negative, which requires printing, in colour or black and white.

Analogue and digital

Analogue representation of the world is the one we are most familiar with as it is based on a perceptible relationship between the representation (the movement of the hands of a clock, say) and the thing itself (the passage of time). Map locations possess relationships similar to the real places, so the map is an analogue representation. Digital representation uses arbitrary signs whose meanings are predefined but bear no obvious relation to the thing. A digital watch could show the time in Chinese characters or Arabic numerals. Your post code uses letters and numbers arbitrarily to define a location. To know what the code refers to, you need a code book. Similarly, computer files (strings of symbols) may digitally represent the analogue image you see as a print or negative. But a point on the negative corresponds to – is an analogue of – a real thing in the original subject.

Storage

Once you are satisfied with the results of your work, you can store digital images on any of a range of removable media, including CDs, DVDs, and Zip and Jaz disks.

Processing in the computer

Images are downloaded directly into your computer as digital files. Now, using image-manipulation software, the digital adventure can begin.

Publish on the Internet

If you are connected to the World Wide Web you can send your digital images anywhere in the world as an attachment to an email. Equally, if you have a Web site you could exploit the Internet to reach a potentially enormous audience.

Scanning

Taking a print or a film original as your starting point, you can use a scanner to create a digital representation of your analogue image. Each scan is an individual digital file and you can work on it as if it had been taken with a digital camera.

Printing

In the time it takes to prepare chemicals to print in a darkroom, you could run off several prints from a desktop printer – all in normal room light. And even with readily affordable printers, print quality easily comes close to photographic papers.

Digital camera features

Many features of digital cameras are based on those of traditional cameras. The main handling difference is that rather than loading film you slot in a memory card. Nearly all digital camera features require electrical power, while many traditional camera features can be mechanically governed.

Digital zooming

This feature takes the biggest image produced by the lens and then enlarges the central portion – typically by two or three times. Digital cameras thus offer a zoom range that appears to be longer than that offered by the lens. The process is like you using your software to open the image produced by the camera's longest focal length setting and enlarging the middle of it. Digital zooming saves you the trouble and may possibly give better image quality, but it enlarges only the middle part. If you were to "zoom" into the image yourself, you can choose what part of the scene to enlarge.

Shutter control
The shutter button on a digital camera is in reality a switch that sets a whole series of complicated electronic operations in train.

Windows
You view the subject through the viewfinder window while other windows are used for autofocusing functions.

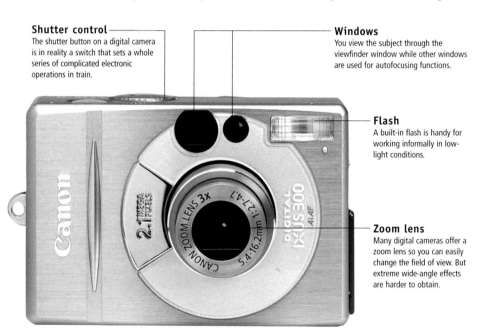

Flash
A built-in flash is handy for working informally in low-light conditions.

Zoom lens
Many digital cameras offer a zoom lens so you can easily change the field of view. But extreme wide-angle effects are harder to obtain.

Digital zoom
This feature takes the image produced by the lens's longest focal length setting and then enlarges the central portion of it. The digital camera thus offers a zoom range that appears to be longer than that offered by the lens alone.

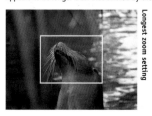

Longest zoom setting

Digital zoom enlargement

Transferring images
The camera's capacity to record images is limited by the capacity of the memory card in use. You can slot in a new card as the first fills up or transfer files to other storage devices or a computer. Some cameras connect directly to a printer, allowing you to print without any intervening computer.

Focusing in the dark

In one method, a beam of infrared (IR) light is projected from the camera. The beam scans the scene and reflects back from any object it meets. A sensor on the camera measures the angle at which the beam returns, translates this into a subject distance, and sets the lens accordingly. However, this method is prone to interference from, say, an intervening pane of glass, which reflects the beam prematurely. The other method uses a pattern of light from the camera or flash unit, which directly assists the focus detectors to assess the image itself.

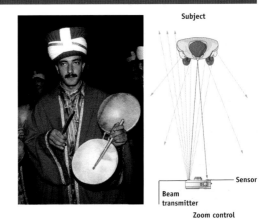

Subject

Sensor

Beam transmitter

Zoom control

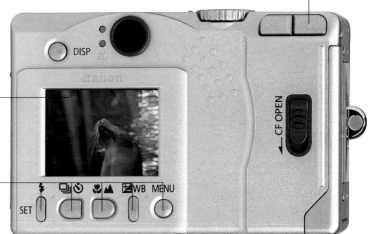

Controls
Switches and buttons set different modes of operation, such as the image-quality settings.

LCD screen
The LCD enables the camera to display images within seconds, as well as providing information on the camera settings used.

Setting buttons
Combinations of buttons and LCD information enable a large range of settings to be made, adding to the camera's versatility.

Viewfinder systems

Four viewfinder systems (to enable you to frame and focus an image before recording it) can be found in digital cameras. The simplest uses an LCD (liquid crystal display) screen to present a low-resolution image of the subject. Most cameras offer in addition a direct-vision viewfinder. This is a small lens (separate from the image-taking lens) through which you view the subject. Having this allows you to turn off the LCD and so save battery power, but since you are not viewing the subject through the image-taking lens, subject framing is prone to inaccuracy.

The best system is the single lens reflex (SLR) arrangement, identical to that in a conventional camera. It gives you an accurate view of the subject and makes focusing very easy. An alternative is what appears to be an SLR system, but the traditional focusing screen is replaced with an LCD screen viewed through the eyepiece. This screen is sufficient for framing but resolution is not high enough for precise focusing.

Digital cameras

The digital camera that is best for you depends on what you want to do with the images. If you only want to make small-sized prints or send images via emails, then a basic model is best.

Basic digital cameras

For many purposes, a basic digital camera – one producing image definition of 640 x 480 pixels or 1,024 x 768 pixels – is not only adequate, it is preferable to those of higher resolution. Image quality is more than adequate for use with an email, or for pictures printed small in newsletters or brochures. Most models are viewfinder-types and designs vary from small modules, which fit onto a hand-held organizer, to those that look and operate just like autofocus, film-based compacts.

Spend more and you can have a 2-megapixel camera offering a zoom lens and better quality all round. Bear in mind, however, that many basic digital models are Windows-only.

Basic model
Check that even a basic camera accepts removable memory cards – otherwise you will have to return to base in order to off-load images once the internal memory is full.

Basic models may not be able to capture images in quick succession.

A 50x enlargement from a 2 MB image (produced by a 0.7-megapixel camera) shows poor detail and colour, but it would still give images perfectly acceptable for postcard-sized prints.

Agfa CL 20

A simple lens helps to keep costs as low as possible.

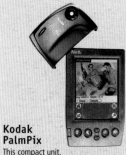

Kodak PalmPix
This compact unit, which links onto the HotSync terminals of a Palm device, offers VGA image quality (640 x 480 pixels resolution) at an economical cost to Palm owners.

Goodmans GDC 3116
This camera is compact and neat with a basic range of features, yet can be had for a very low price. It delivers a 3-megapixel image but lacks fine quality. Nevertheless, it is worth considering as your first digital camera.

Kodak DC3400
A neat, capable camera that is very easy to use and good value, offering 1,280 x 960 pixels resolution. This model also features a 3x zoom and very good build quality for its price. Users, however, may find it bulkier than others in its class.

2-megapixel cameras

These 2-megapixel cameras produce good-quality ink-jet prints up to about 25 x 20 cm (10 x 8 in), making them suitable for high-quality newsletters, brochures, and publication to postcard size – and all without the high equipment and data-storage overheads that are associated with images of higher resolution.

A wide choice of cameras is available, from ultra-compact rangefinder types to substantial SLR-like designs with wide-ranging zoom lenses. All these cameras offer built-in flash, LCD screens, a zoom lens, autofocus, and autoexposure. Other features may include the ability to make short video clips, record sound, and control over exposure settings such as shutter time or aperture.

When deciding on a suitable camera, check that the camera's connection is suitable for your computer. For speed of use, USB or FireWire (IEEE 1394) is preferable to other types.

2-megapixel model

Camera offering SLR-viewing give accurate framing but are much bulkier than viewfinder models with otherwise similar specifications.

Rotating dials are easier to use than buttons.

Infrared sensors may permit focusing in total darkness.

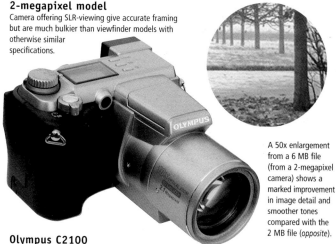

Olympus C2100

A 50x enlargement from a 6 MB file (from a 2-megapixel camera) shows a marked improvement in image detail and smoother tones compared with the 2 MB file (*opposite*).

Kodak DC5000
A chunky, relatively rugged camera with oversized controls that handle well. As a result, it is more likely to be suitable for those with slight physical disabilities than other digital cameras. It also performs well.

Fuji FinePix 2600 Zoom
For its price, a neat camera offering good interpolated resolutions of over 3 megapixels and a range of photographic controls such as spot metering. Excellent results are possible, although its menu options take some getting used to.

Canon Digital Ixus V
This is a versatile camera offering high performance and a good resolution of 1,600 x 1,200 pixels, all in a superbly compact and stylish case. It is also fun and easy to use.

Digital cameras continued

3-plus-megapixel cameras

With a 3.3-megapixel digital camera you have really crossed over into the realms of professional-quality image-making. Cameras in this category are capable of producing good-quality ink-jet prints up to A4 size, or even greater. If work requires the type of reproduction quality demanded by a magazine, you can enlarge to A5 size; with non-critical subjects, or certain "artistic" treatments, such as graininess, blur, or other distortion-type filters, then you can safely enlarge prints to A4 and greater, since these treatments disguise any slight imperfections in image quality.

If your camera is intended for professional use, then ruggedness and reliability should be key factors in your decision-making process. In these respects, cameras in this class are generally built to a higher quality and with better electronics and a wider range of features than cameras of lesser image resolution. But bear in mind that these

When choosing a camera, test all its features – this main switch is inconvenient.

A pop-up flash is not obscured by lens accessories.

3-plus-megapixel model
With a two-section body that allows the lens to be swivelled and excellent optical quality that is outstanding close-up, this camera has become a popular choice.

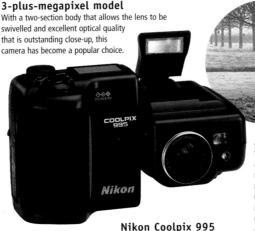

Nikon Coolpix 995

A 50x enlargement from a 9 MB file (from a 3-megapixel camera) may not show much more detail than a 6 MB file, but detail is sharper and clearer (compare with enlargements on previous and following pages).

Casio QV3000

Looking like an ordinary camera, this model offers a 3x zoom delivering good image quality to a 3-megapixel sensor. The camera is relatively inexpensive and it is easy to use, if somewhat large and bulky.

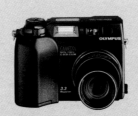

Olympus 3030Z

A well-specified camera offering many functions and capable of producing high-quality results of 3.3 megapixels with a 3x zoom lens. It is quite a small camera, however, and some controls may be fiddly to use, but it is a popular choice.

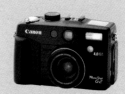

Canon G2

With its 4-megapixel sensor, 3x zoom, and a rugged body, this capable camera is a good choice for more serious work. It is also easy to use with a good range of exposure controls at its disposal. It also takes high-performance flash units.

cameras not only cost more to purchase in the first place, but they are also costlier to maintain. This is due to the fact that their larger files require more storage space (images with more pixels take up more memory space) and larger files take more time to work with than smaller ones. So, opt for one of these higher-resolution cameras only if you really need the extra quality.

Note that some cameras give images containing more pixels than the specification of the camera seems able to produce. If so, these figure have been arrived at by adding pixels through a process of "interpolation" and may not represent any true improvement in the detail captured by the camera.

When deciding on a suitable camera, check that the connection is suitable for your computer. As was mentioned earlier, USB is faster than serial, while FireWire (also IEEE 1394 or iLink) is better than either. In addition, check the type of battery: Li-ion or NiMH types are better than NiCd.

There is a growing number of single lens reflex (SLR) designs in this class of digital cameras, but not all of them allow for interchangeable lenses. If your photographic work is likely to demand that you use a wide range of lenses, make sure any camera you are thinking of buying is suitable (*see pp. 18–9*).

Real resolution

In photographic terms, resolution is a measure of how well an optical system is able to discern, or separate out, fine subject detail to a "visually useful" extent – in other words, so that there is usable contrast to distinguish one detail from another. Camera manufacturers may make claims that their 2.5-megapixel sensor can produce files equivalent to a 4-megapixel sensor through pixel interpolation. The fact is that while an image cannot reveal more information than was captured in the first place, it is certainly possible to process the basic information of an image file in different ways in order to give the impression that there is more information than is really present. But the final arbiter of any such claim is your subjective check of the image itself. Not only should you confirm that you can see more detail and see it more clearly, don't forget to make sure that subject colours are true, that contrast is realistic, and that the file-size output is appropriate to the task in hand. Why handle a 12 MB file, for example, when all the detail you need is contained in 8 MB? Note, however, that a form of interpolation, that of colour, usually takes place in the capture of the image by hand-held digital cameras (some cameras work in a different way).

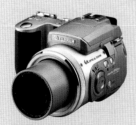

Fuji FinePix 4900 Zoom
Capable of delivering an interpolated file of some 4 megapixels from a 2.4-megapixel sensor, this camera produces excellent results from a wide range of controls. It has a 6x zoom lens, handles well, and is very reasonably priced.

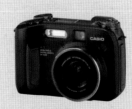

Casio QV4000
This is a sturdy, capable camera with a good range of features, such as spot metering and a wide selection of scene modes. Delivering nearly 4 megapixels, it is capable of fair-to-good-quality images from its 3x zoom lens.

Ricoh RDC-1500
This model looks unusual but is practical and easy to use. The 3-megapixel images from its 3x zoom can be of very good quality, while its close-up ability allows it to focus as close as 1 cm (⅖ in). Emails can be sent from the camera.

Digital cameras continued

SLR digital cameras

The single lens reflex (SLR) design, in which the lens that projects the image for recording is the same as that used to view and focus the subject, is the most versatile available. With digital cameras, however, there are now two different types of SLR. In the focusing-screen type (the most common) you look through an eyepiece to view the image on a focusing screen. The advantage here is that no power is consumed. In the second type you look through an eyepiece but what you see is a magnified LCD. As this is not an optical view, but depends on a sensor sending signals to the LCD screen, it consumes power.

If it is important that you view the actual image, you will need the more professional digital cameras such as the Canon D60, Nikon D1 series, Fuji S2, and the sturdy Kodak professional SLRs.

Another distinction between SLR digitals is whether or not the lens is interchangeable. The

Buttons access many functions, which differ from the usual SLR handling.

SLR viewing is ideal with a powerful 6x zoom.

SLR model
Extremely well-received camera with good handling qualities. Its versatile 6x zoom delivers an interpolated 6-megapixel image of high quality at a very competitive price.

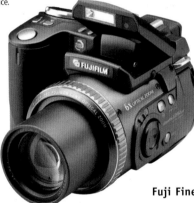

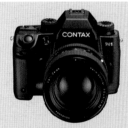

This 50x enlargement of a 6-megapixel file (18 MB) shows only minor improvement over the 9 MB file, and for many purposes hardly any change would be visible.

Fuji FinePix 6900 Zoom

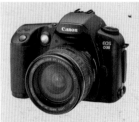

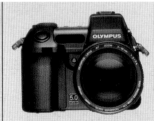

Canon EOS D30
This highly successful and popular camera model has an image resolution of 3 megapixels and very rapid response times. It accepts the full range of EOS camera lenses and other accessories.

Olympus E-20
Rapid response is the principal feature of this camera. Operating with minimum delay, it handles much like a film-based camera. It delivers high-quality, 5.4-megapixel images with its 4x zoom lens, but is fairly expensive.

Contax N Digital
Unlike other interchangeable-lens SLR digital cameras, the Contax does not increase the effective focal length of conventional lenses, as it uses a full-size sensor. In addition, the camera is sleek and refined.

less-expensive SLRs do not feature interchange-ability, but their zoom lenses may accept accessory lenses. These are screwed into the front to extend both wide-angle and telephoto coverage.

For the type of performance required by sports photographers, photojournalists, and the like, three features of digital SLRs to consider are burst-rate, capacity, and latent period. The first is a measure of how many shots the electronics will allow you to take in rapid succession: a burst-rate

of 3 fps (frames per second) is regarded as a min-imum. The capacity indicates how many pictures can be taken before the camera needs to stop and process the information. This is follows by a latent period in which images are written to the memory card, which can take a minute or more. Needless to say, film-based cameras have an advantage here, as some can shoot 36 frames in less than five seconds. The film-based latent period is, of course, the time needed to change films.

Sensor size and field of view

A camera lens projects a circular image. The sensor or film captures a relatively small rectangular area at the centre of this projected field of view. If the rectangle extends to the edge of this circle of light, the sensor is able to capture the full field of view. If the rectangle falls short of this, then the field of view is reduced. Many SLR digital cameras of the type that accept conventional 35 mm format lenses use small sensors – thus, the field of view available to the sensor is reduced. As a result the 35efl (35 mm equivalent focal length) is multiplied: in other words, the field of view is equivalent to that of a lens with a longer focal length. For example, on the Nikon D1, focal length is increased by about 50 per cent compared with the 35 mm format coverage; while the Contax, with its large sensor, does not increase effective focal length at all.

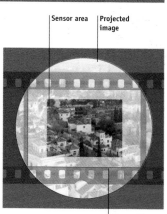

Sensor area | Projected image

35 mm film area

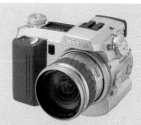

Minolta DiMage 7
Though not as good-looking as the Olympus, it does have slightly superior specifications and, arguably, better handling to produce 5.2-megapixel images through a 7x zoom. The camera also comes in at a lower price.

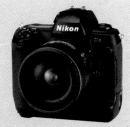

Nikon D1X
A benchmark for mid-range, professional-quality digital cameras, the Nikon D1 series offers robust camera bodies with excellent picture quality, but at a relatively high price. Camera handling could be further refined.

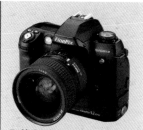

Fuji S2 Pro
An interchangeable-lens SLR based on the Nikon F80, therefore accepting Nikon lenses. This high-performance camera captures 6-megapixel images and, although compact and comparatively lightweight, it is expensive for its class.

Digital "film" memory cards

For a time, it seemed that there would be just three types of digital-image memory cards. Unfortunately, there are now several systems all vying for pole position. For the photographer, the main consideration is compatibility between personal equipment: if you own only one camera, there is no problem: you can download images directly to your computer. But as soon as you have another camera or you want to use another device, you must ensure compatibility. In this respect, the most versatile memory card is the CompactFlash. But cards from other manufacturers promise higher transfer rates, better capacity, economy, or size.

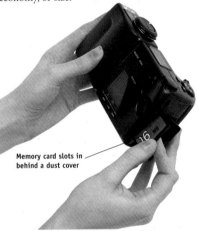

Memory card slots in behind a dust cover

Using the memory card
Memory cards are easily replaced in a camera, but do not try to change cards when the camera is reading from or writing to the card – usually a light warns you when the card is in use.

All cards have to be slotted into the camera so that recorded images can be saved onto them. The first time you use one, it may have to be formatted (structured to receive data) by the camera. Unlike film, you can remove the card at any stage before it is full and slot it into a reader to transfer files to a computer. You can also erase images at any time to make room for more. However, don't try to remove the card while the camera or reader is accessing it: wait for the lights indicating card activity to go out before removing the card.

CompactFlash
The most widely used and available memory card, with a choice of card readers and a variety of capacities to suit different budgets. Capacities range

from 8–512 MB – with the best-value cards being those offering 64–80 MB capacity. Some types offer faster operational speeds: this is worthwhile as the larger-capacity cards take longer to write data than smaller ones.

SmartMedia
Extremely lightweight, compact, and wafer-thin – therefore fragile. The maximum capacity of the card is limited by camera's circuitry, so you cannot take advantage of advances in card technology without changing the camera's features. Maximum capacity is as high as 128 MB.

MicroDrive
Ultra-miniature hard-disk drive that fits into CompactFlash type II slots. Used by professional-quality digital cameras as it is relatively robust, fast, and offers very high capacities – from 170 MB–1 GB. The higher-capacity drives are very expensive.

MemoryStick
Introduced by Sony and used widely on digital cameras as well as Sony video cameras, thus allowing interchange, but independent card readers are scarce and compatibility with other makes of digital camera is poor. Not as widely available as CompactFlash, so may be relatively more expensive. Capacities range from 8–128 MB.

Floppy disk

This memory system is used by only a very few cameras, such as the Sony Mavica range. It is characterized by very slow read and write speeds and very small capacities. It is of limited and decreasing use and not recommended. Do not confuse this with floppy disk adaptors that enable SmartMedia or MemoryStick cards to be read in a computer's floppy-disk drive.

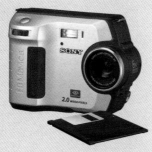

ID Photo

This type of card uses magneto-optical technology on a 5 cm (2 in) diameter disk to hold 730 MB of data. The card has been created by a consortium of companies consisting of Sanyo, Olympus, Hitachi, and Maxwell.

CD-R

This small 7.5 cm (3 in) version of a CD-R disk is used by, for example, the Sony MVC-CD 1000 camera. The disk cannot be reused but it is inexpensive and offers a good capacity of 156 MB. The disks can be played on nearly every CD-ROM player, though they may not be very widely available for purchase.

Card care

- Keep memory cards well away from magnetic fields, such as magnets, television monitors, audio speakers, and so on.
- Keep cards cool: don't leave them in a car on a hot day or lying around in bright sunshine.
- Keep cards dry: don't take them out into warm, humid conditions immediately after coming out of an air-conditioned room, for example.
- Keep memory cards dust free: the contacts are extremely fine and can easily be damaged by small particles of dirt or grit. In sandy or dusty conditions, don't remove a card from the camera unless you are safely sealed inside a tent or car.
- Keep memory cards in their protective cases whenever they are not in use.

Memory card readers

There are two ways of transferring images taken on your digital camera. First, you can connect the camera to your computer and instruct the camera's software to download images. Second, you can take the memory card out of the camera and read it to the computer. To do this, you need a memory card reader, a device with circuitry to take the data and send it to the computer, usually via a USB cable (though some use a FireWire interface). The reader needs to be designed for the different cards that are available. Models that consist of a core reader and adaptors for the different types of card are preferable, though dedicated readers may be more reliable.

Using a reader

When slotted in, the reader opens the card as a volume or disk. You can then copy images straight into the computer.

Choosing a scanner

Today's scanners are so powerful and capable that even professional-quality instruments are within reach of anybody who can afford a digital camera or computer.

Flat-bed scanners

Flat-bed scanners are somewhat like photocopiers – you place an original face down on the glass and a sensor runs the length of the original to make the scan. If your print is large enough and good enough, even inexpensive scanners are capable of producing results that can, with a little work, be turned into publication-quality images. These scanners can also be used as a type of close-up camera for taking images of flat subjects at full-size or high magnification.

Flat-bed scanners can be adapted for transparent originals using a transparency adaptor, which is usually another light source that resides in the lid above the scanner bed that moves in step with the

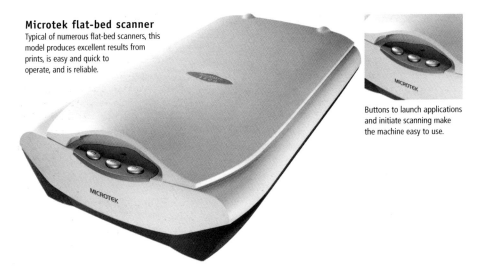

Microtek flat-bed scanner
Typical of numerous flat-bed scanners, this model produces excellent results from prints, is easy and quick to operate, and is reliable.

Buttons to launch applications and initiate scanning make the machine easy to use.

Scanmaker X6
An inexpensive 600 x 1,200 ppi scanner from Microtek working with a SCSI interface suitable for older computers. There is also a USB version, one with advanced driver software, and another with a transparency adaptor.

Scanmaker X12
Typical of many basic scanners in offering good reflective original performance, and with resolution of 1,200 x 1,200 ppi. A transparency adaptor and both SCSI and USB interfaces are available – and all at a reasonable price.

Scanmaker 3600
A very inexpensive scanner for the beginner, with a USB interface (easy to use but limits the speed of operation) with 600 x 1,200 ppi resolution suitable for scanning prints. A transparency adaptor is also available.

scanner head under the original. Check that the adaptor is supplied with the scanner, as a separate one can add considerably to the total cost.

If you intend to scan flat originals of about A4 size, an entry-level scanner offering resolutions in the region of 600 ppi (points per inch) – often quoted as 600 dpi (dots per inch) – will be fine.

For scanning artwork up to A3, you will need an A3-size scanner, which is far more costly than an A4 type. Scanning a large original in sections in order to blend the parts together is not recommended with entry-level machines, as unevenness around the edges is likely to make a poor match.

Well-known manufacturers, such as Umax, Microtek, and Heidelberg, offer machines that cater for a range of needs, from the home-office worker upward. In general, it is true that the more you pay the better performance you can expect – in terms both of its mechanical operation and the software interface.

Before you buy

- Examine the interface – the software with which you control the scanner – as some examples can be confusing and badly laid out.
- Check that the scanner's connection is suitable for your particular computer: the best is FireWire (which is also known as IEEE 1394); USB is a low-cost option; while SCSI may be used by some professional-grade equipment.
- Make sure that you can return the scanner to the store if it does not work with your computer and software. Operating conflicts are not uncommon.
- If you need to scan films or transparencies, ask whether a transparency adaptor is extra. If so, check on how much it costs.

Transparency adaptors

Should you need to scan medium- or large-format films you need, in the first place, a scanner with a transparency adaptor. This is simply a light source that shines light through the transparency or film onto the scanner's sensor. The area for scanning transparencies is almost always smaller than that for artworks or prints, which are scanned by reflected light. Many scanners use a light panel something like a light-box; others a light that traverses the length of the glass platen. Yet others use a sliding tray arrangement.

Transparencies require a higher scan resolution than prints. So-called "repro-quality" scanners offer resolutions of at least 1,200 ppi in one direction and their maximum density ratings should equal or exceed 3.5.

CanoScan FB1210U
A compact scanner offering good interfaces as well as rapid, fuss-free operation with 1,200 x 2,400 ppi resolution and good-quality colour. Its transparency adaptor designed for medium-format film works well.

Heidelberg Linoscan 1200
An economical entry-level desktop scanner with an optical resolution of 2,400 x 1,200 ppi. An integrated transparency unit makes it suitable for film as well as reflection originals.

Heidelberg F2650
A superb scanner able to produce pro-quality scans by reflected light up to A3 in size, as well as good-quality scans of transparent materials using a respected and sophisticated software driver. It is, however, an expensive package.

Choosing a scanner continued

Specialist film scanners

For the digital photographer, a specialist film scanner represents the best balance of features and quality. Modern film scanners can provide excellent-quality results at a very reasonable cost, producing reproduction-ready scans for a fraction of the cost of an SLR camera and less even than a middle-of-the-range digital camera.

The principal manufacturers, such as Nikon, Minolta, Kodak, Canon, Polaroid, and Microtek,

all offer film scanners producing results, which, with a little work, are suitable for professional use. For 35 mm film originals, it is hard to beat the Nikon Coolscan range: the 4,000 ppi performance gives results that are more than adequate for the production requirements of virtually all publications. Minolta, Polaroid, and Nikon also make good-quality machines for larger film formats.

Most scanners accepted 35 mm both as cut film strips and mounted transparencies, using film

Canon FS4000 US
This modern desktop film scanner offers remarkably good optical performance – sufficient for many professional tasks, as well as convenient features and easy connection to the computer.

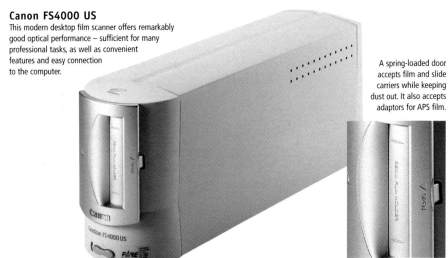

A spring-loaded door accepts film and slide carriers while keeping dust out. It also accepts adaptors for APS film.

Microtek FS 35
A basic but inexpensive film scanner controlled by a simple software interface. It accepts both film strips and mounted transparencies. Results are acceptable for use on the Internet and for small-sized enlargements.

Minolta DiMage Scan Elite
A compact and efficient scanner for 35 mm film, with an easily navigated driver interface. It scans at resolutions of up to 2,820 ppi and has a convenient dust-removal feature.

Microtek 4000t
A scanner with an excellent software interface and scans up to 4,000 ppi for the 35 mm format. It comes with good-quality accessories, such as a colour-calibration target and software, but it is no longer class-leading in quality.

carriers or slide holders that are inserted into a slot on the front of the machine. For the medium-format, all scanners accept cut film strips but some also accept mounted transparencies. Some scanners are available with an adaptor suitable for APS (Advanced Photo System) film cartridges.

Selecting a scanner

Scanner features that you should consider before buying include:

Resolution Choose a machine that offers an optical resolution of at least 2,700 ppi (points per inch). This will create files around 20 MB in size, which should be enough for fair-quality A3 ink-jet prints or for magazine reproduction up to about A4 size.

Maximum density Look for a machine offering a maximum density of at least 3.6 – this will allow you to scan colour transparencies to high quality.

Quality of film carriers Some carriers are flimsy and you may find others awkward to use.

Film formats An APS adaptor is usually an extra cost. For a panoramic format 35 mm, you are likely to need a medium-format scanner. These offer as many as eight different film carriers but many will be optional items at extra cost.

Driver interface On most scanners you have no choice but to use the manufacturer's, and some

are far easier to use than others. Try them out first in the store if you can. Otherwise, read reviews in specialist magazines.

Over-sampling Some scanners can sample an original more than once, combining information so that differences are averaged. This has the effect of keeping genuine, repeatable information – and because unwanted data or noise is random, over-sampling strips out image-degrading artefacts.

Computer connection The best option is FireWire (which is also known as IEEE 1394). USB is a low-cost option, while SCSI may be used by professional-grade equipment.

Other useful features

If you have occasion to make many scans at a time, it is useful to be able to present a stack of transparencies to the scanner and leave it to work on them automatically – this is known as batch scanning. The Nikon scanners for 35 mm slides are very well designed in this respect.

Another useful feature is automatic dust removal, available on scanners from Polaroid, Nikon, and Minolta among others. When implemented well, this can save much post-scanning work eliminating the hairs and dust always found on film. Note, however, that scratches or other defects in the film may not be removed.

Minolta Scan Multi II
A medium-format scanner that offers good performance with scans of up to 2,820 ppi resolution with 35 mm film. It has dust removal and other convenient features for formats up to 6 x 9 cm.

Nikon LS-8000
A large, solid machine that scans up to medium-format originals at a resolution of 4,000 ppi with dust removal. It has a range of accessories to accept formats from 6 x 9 cm to 35 mm and smaller.

Powerlook 3000
Made by Umax, this is a thoroughly professional-quality scanner. It scans up to A4 size by reflected light and handles transparencies (slides) up to 10 cm (4 in) wide with resolutions up to 3,000 ppi.

Choosing the best software

It is likely that with the purchase of your digital camera, scanner, or computer, you will have all the software you need to make a start in digital photography. In addition to the utility software that enables your computer, digital camera, and scanner to talk to each other, you will need an image-manipulation application, and the most widely used is Adobe Photoshop. However, many photographers do a great deal of satisfying work using much less costly, easier-to-learn software.

Entry-level image editors are all easy to use. For PC-only, consider MGI PhotoSuite, which offers many features at a very low cost, while JASC Paint Shop Pro has a good suite of features at a slightly higher price. Other low-cost options to consider include Ulead PhotoImpact, Microsoft Picture It, and MGI LivePix. Adobe PhotoDeluxe is easy to use but you may outgrow it quickly. A better choice is Adobe Photoshop Elements, which has a powerful feature set and is easy to use.

Adobe Photoshop

Ease-of-use is not the first feature that Photoshop is noted for, but that is what experienced users most appreciate. The reason is that it is easy to customize Photoshop so that working with its numerous features can be highly streamlined and efficient. Besides this, there is Photoshop's power

Adobe Photoshop

While Photoshop is not easy to use, its ability to manipulate numerous layers and masks is unrivalled by any software. Despite certain limitations concerning Brush and tonal controls, Photoshop continues at the top of any list of recommendations.

and versatility. This power has been greatly extended by the numerous software plug-ins that allow you to extend its every feature – from specialized saving of JPEG files and the removal of dust-specks to an infinity of filter effects. However, in addition to its relatively high purchase price, Photoshop also requires large amounts of RAM for it to function efficiently and fully. If you handle files not larger than 5 MB, then 64 MB of RAM will be adequate; however, most digital photographers work with file sizes of 10–20 MB, in which case 256 MB or more RAM should be installed. Don't forget that more RAM will be needed if you wish to run a desktop publishing or Web-page design program at the same time.

Other image editors

More professional and costly software provides powerful features with slightly different slants.

JASC Paint Shop Pro
This Windows-only program is a very popular alternative to Photoshop. It is cheaper and less system-intensive.

Ulead PhotoImpact
A Windows-only program offering graphics and Web-design tools, as well as a good features for image editing.

Adobe Photoshop Elements
A stripped-down version of Photoshop but offering extra features, such as panorama-creation. Good for beginners.

Corel Painter (Mac and PC), for example, produces a multitude of paint-like effects together with image-editing tools, some far more powerful than those available in Photoshop. Corel Photo-Paint is a serious competitor for Photoshop and at a cheaper price. Equilibrium DeBabelizer is designed for image processing in batches and its tools for making global changes to many images are extremely powerful.

Plug-ins and extras

Plug-in software applications are programs in their own right, but they are written to make use of another application's core program, or "engine". Photoshop itself comes with many of its own. PhotoTools from Extensis is exceptional in adding a good range of tools, including convenient buttons to supplement the standard menu. Another popular choice from Extensis is Intellihance, which is used to make quick, overall image improvements. The most popular plug-ins are those that produce special effects, such as sun bursts, metallic and bevelled text, blurs, and so on. Kai's Power Tools, Alien Skin, and Xenofex each offer a wide range of effects – and between them, more than anyone would ever need. But beware, special effects are exactly that – effects for special occasions. Repeated use rapidly becomes overuse.

Before you buy

When purchasing software, particularly professional applications with more advanced features, you should check the following:

The operating system required If you do not have the latest computer, check that the version of your operating system, such as Mac OS 9.2 or Windows 95, will run the software.

Minimum RAM Check how much RAM the software needs to run efficiently. One advantage of amateur software is its modest demands for RAM, while Photoshop will take all the RAM you can give it. If you wish to run many applications at once – word-processor, page-design, and image-manipulation software – you will need a great deal of RAM to keep your machine running quickly and smoothly.

Minimum hard-disk space Check how much hard-disk space the software needs. In addition to the space for the software itself, it will need space to store temporary working files – the larger your files, the greater the space required.

Dongle protection A very few applications use a special plug – the dongle – that connects between your keyboard and computer to prevent software piracy. Avoid these if possible, as the dongle itself can be incompatible with your computer's connections.

Corel Painter
A very powerful and satisfying program for producing a vast range of effects simulating artist materials for print and Web.

PhotoRetouch Pro
Powerful, sophisticated, and elegant to use – probably the best program for photographers working digitally.

Corel Photo-Paint
A fully professional program, rivalling Photoshop for features, with powerful tone controls and brushes.

Choosing the best printer

Modern ink-jet printers produce excellent print quality at low prices, they are generally reliable, and most are easy to use. The only downside is the cost of the inks and good-quality paper. However, while the ink-jet is the dominant technology, it is not the only one. When near photographic quality is required, there are dye-sublimation printers, and for printing graphics-heavy pages, the colour laser is more suitable. Features you should consider in an ink-jet printer include:

Paper handling Some printers detect paper size and make settings to suit, particularly those able to print off a card reader. Others take a large range of papers, from ordinary weight to cardboard. Some models also accept paper on a roll, allowing small posters to be printed (*see pp. 178–9*).

Resolution In general, higher-resolution printers deliver better-quality results, but the issue is not simply about resolution. The difference between

Ink-jet printer
Typical of modern ink-jet printers, this model takes a variety of papers on a nearly straight paper path and is simple to use, but good prints need several minutes to output.

Being able to change ink tanks separately is an economic arrangement.

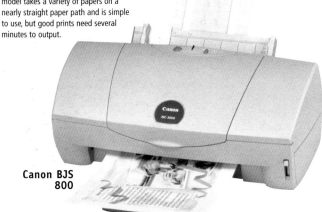

Canon BJS 800

A paper-thickness-adjustment control is a useful feature.

Canon BJC 85
This is a compact and lightweight printer that is entirely portable when fitted with an optional battery pack. Quality is good, considering its size, but operation is slow.

Hewlett Packard 940C
Capable of producing very good image quality, this printer is easy to use and has an unusually large paper capacity for its size and class.

Lexmark Z52
Despite their low cost, Lexmark printers can produce very acceptable image quality. Good printing speeds are also possible when using non-smudge inks.

2,000 dpi (dots per inch) and 2,880 dpi is of no practical significance: the precise way in which the printer software uses the dots available is far more important (*see right*). Looking at results when comparing printer quality is better than reading technical specifications.

Four or six inks In general, printers using six colours for printing are more likely to produce photographic quality than those using only four.

Separate ink cartridges Most desktop printers keep all colour inks in an integrated cartridge (the black is usually separate). This means that if you print out a lot of images with, say, blue skies, you will have to change the cartridge when the cyan ink has run out even though there is still plenty of magenta and yellow. Canon desktop printers are notable for having separate tanks for each colour.

Printers with card readers Some printers able to read card devices, such as CompactFlash and SmartMedia, can print directly off a card, without the need for a computer. This is convenient for basic proof-printing – to check the quality of images from a shoot – or if you repeatedly need to make prints to order, as you can store prepared files on a card and print them off as needed.

Half-tone cells

Printers can lay more than 2,000 dots of ink per inch (dpi) but since no printer can change the strength of the ink and not all can vary dot size, not all dots are available for defining detail. Thus, printers use groupings of dots – half-tone cells – to simulate a greyscale. At least 200 grey levels are needed to represent continuous tone. Therefore, a printer must control a large number of ink dots just to represent grey levels, reducing the detail that can be printed. In practice, detail resolution above 100 dpi meets most requirements. Now, if a printer can lay 1,400 dpi, it has some 14 dots to use for creating the effect of continuous tone. If you multiply together the four or more inks used, a good range of tones and colours are possible.

Filling in cells
Each cell accepts up to 16 dots – counting a cell with no dot, 17 greyscale levels are thus possible. Cells should be randomly filled. Here, they have a regular pattern, so when cells are combined a larger pattern emerges. The device resolution is used to place more ● dots in each cell.

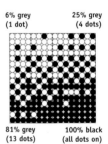

6% grey (1 dot) 25% grey (4 dots)

81% grey (13 dots) 100% black (all dots on)

Epson Stylus Photo 895
This printer has a built-in PCMIA card reader, and can produce very high-quality, stable prints up to A4 in size.

Hewlett Packard 1220 CPS
Capable of producing professional-quality prints to A3 size and larger, this printer has good colour control and PostScript capability.

Epson 2000P
Printing up to A3 size using pigment-based inks enables this printer to offer class-leading print longevity as well as high image quality. Operation, however, can be tricky.

Choosing the best computer

The serious digital photographer will spend at least as much time at the computer as actually out taking pictures. The computer has, in effect, simply replaced the darkroom.

What to look for in a computer

All Apple Mac computer models G3 and higher are capable of digital photography but they may need extra RAM. All Windows machines with Pentium series chips and higher are also suitable but are also likely to need a boost in RAM. You should consider 256 MB to be the minimum.

However, less-obvious features, such as the quality of the mouse and keyboard, can make a difference to your enjoyment and comfort. If the keyboard action is not to your liking or if you find the mouse uncomfortable, then do not hesitate to change it: these replacement accessories are inexpensive and if you ask for the change at the time of purchase, they may be even cheaper.

Desktop computer
Modern computers at their best combine style with tremendous computing power. Despite its very compact form, this iMac is capable of professional-quality image manipulation, as well as video and music editing.

Apple iMac

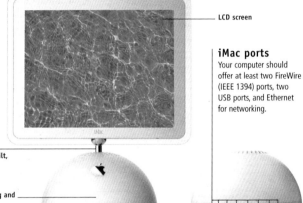

LCD screen

iMac ports
Your computer should offer at least two FireWire (IEEE 1394) ports, two USB ports, and Ethernet for networking.

Adjustment for screen swivel, tilt, and height

Computer casing and door for CDs

Apple ibook
Although compact and lightweight, this laptop is capable of full-scale image processing as well as Internet access. It makes an ideal companion for the digital photographer on location, since some models can burn CDs.

Packard Bell laptop
Laptops running Windows software are very numerous and similar to each other. Modern examples, such as this model, are well capable of image manipulation, but they may need extra drives to burn CDs and so on.

Apple PowerBook
Slim but offering a large screen, this machine is more powerful than most desktop computers and is capable of all but the most processor-intensive tasks. Highly recommended machine for digital photography.

Software packages

When budgeting, don't forget the cost of software – a full suite of software for image manipulation as well as desktop and Web publishing can easily cost more than the computer itself. However, it is sensible to start with modest applications until your skills develop – professional software can be very frustrating and hard work to master, while simpler packages are far cheaper and still produce good results (*see pp. 26–7*).

Adjustable viewing
For best viewing comfort, you should be able to adjust both the height as well as tilt of the screen to suit different work practices: close for Web design or word-processing; further away for image manipulation.

Laptop or desktop?

Many modern laptops have more than enough power for digital photography. Some, like the Apple laptops, are not only more powerful than most desktop types, the screen is of sufficient quality and large enough for serious work. Against the premium cost of miniaturizing is the convenience of a computer that takes up no more desk space than an open magazine.

Computer interfaces

When making your purchase, ensure that the computer interfaces available match those of the equipment you wish to use with it:

- Universal Serial Bus (USB) is easy to install and use with data-transmission speeds adequate for printers, removable drives, and digital cameras.
- FireWire (IEEE 1394), also known as iLink, is a high-speed standard suitable for professional work. An excellent choice for removable drives, extra hard-disks, and professional digital cameras.
- Small Computer Systems Interface (SCSI) is tricky to use with heavy cables but large numbers of devices will interface and it is capable of very high performance.
- Serial incorporates various types suitable for low data rates, such as between mouse and computer. Not recommended for digital camera use.

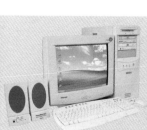

Mesh 1.8 GHz
Desktop computers running Windows offer good value for money, and often come with accessories, such as speakers, thrown in. They can be used for image manipulation but poor colour control may be a problem.

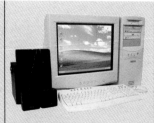

Mesh 2.0 GHz
Windows computers with ultra-fast chips may appear to be more than a match for Apple computers, but for image manipulation Apple Macs operate more efficiently and can complete Photoshop tasks as quickly.

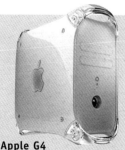

Apple G4
All the capacity, computing power, and convenience you need for the highest levels of digital photography. Scanners, extra hard-disk drives ,and printers are easily installed and colour control is top-level.

Computer accessories

As your expertise in digital photography increases, there are many computer accessories that will make life easier and increase your enjoyment.

Graphics tablets

These input devices are an evolutionary step up from the mouse. Comprising a flat tablet, like a solid mouse mat, and a pen-like stylus, graphics tablets give you excellent control over hand-drawn lines. They also allow you to increase line width or colour depth by varying the pressure of the stroke – something that is impossible to do with a mouse. The tablet part can be small, about the size of a mouse mat, or as large as your desk.

Removable media

Digital photography produces huge amounts of data and removable media provide the essential storage space you need. In general, the bigger the capacity the cheaper it is per megabyte of data. The smallest you should work with is the 100 MB or 250 MB Zip disk: these are inexpensive and the 100 MB size is very widely used by both Mac and Windows owners. But for digital images, even the 250 MB disk is limited in capacity. Far better are Jaz disks, of which there are two types: the 1 GB version is widespread but this is being superseded by the 2 GB disk. The larger, 2 GB disks are much less expensive per unit of data and, in addition, the 2 GB drives are faster than the 1 GB drives, but they are not the most reliable of media.

DVD-RAM technology offers remarkable capacities for the lowest cost – a disk holding 9 GB of data (9.4 GB nominally) will cost less than three DVD video films. The disadvantage is that reading and writing speeds are relatively slow. The best choice of all are the DVD-RAM drives that also write CDs.

Compact disks (CDs)

The best option for exchanging files with other people is the CD. It holds up to 700 MB, and once written it cannot be changed. Rewritable CDs (CD-RW) are available: these can be written, erased, and rewritten many times, but inconvenience and compatibility worries mean that the CD-RW is not a recommended option. CD-writers (now often integrated with computers) are relatively inexpensive accessories, costing less than about the price of three or four DVD video films.

CD writers with the fastest write speed do not cost that much more than slower writers – a 32x write speed is not unusual – and they will save you a great deal of time in the long run. So-called "burn-proof" writers are more reliable at writing disks than those without this feature.

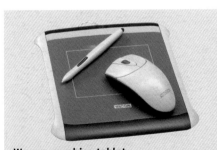

Wacom graphics tablet
Graphic tablets come in a range of sizes – starting with models smaller than a mouse mat – to suit different ways of working. Large sizes can take up the entire desk area. The pen and mouse tools also cover a range, from simple devices to those sporting several buttons to access various functions.

Zip 100
Zip disks hold just less than 100 MB of data, which is really the minimum size of removable storage for digital photography. Drives are very widely used in computers while the disks are sturdy and reliable, making them ideal for general use. Higher-capacity, 250 MB Zips are also available.

UPS, surge protectors, adaptors, and cables

Computer systems are very susceptible to even very small fluctuations in the amount of electrical current powering them. Because of this, you may want to consider protecting your equipment from power surges and failures – something that is even more worthwhile if you live in areas with uncertain power supplies. Saving frequently as you go ensures that, if the worst happens, and your machine does crash, then at least not too much of your work will be lost. However, apart from the frustration and wasted time involved in restarting your computer, an uninterruptible power supply (UPS), although possibly expensive to buy, is essential. This is a battery that powers the computer and monitor for a short period in case of a power loss, giving you time to quit the application and shut the computer down safely.

A surge protector prevents sudden rises in power from damaging your delicate equipment and is well worth its relatively low cost. Other accessories you will accumulate are leads to connect devices to your computer and to each other, and adaptors that allow older equipment, such as those based on SCSI, to be used with newer systems, such as FireWire.

USB ports
USB (Universal Serial Bus) is a widespread protocol allowing devices to be plugged straight into a working computer and be recognized and connected.

Parallel printer port and connector

SCSI ports
The SCSI interface remains important for its use in scanners and studio digital cameras.

Adaptors
You can adapt SCSI to FireWire or to USB, serial to parallel, and so on. If equipment is incompatible, there is likely to be an adaptor to solve the problem, though conflicts with other devices may result.

USB peripheral port and connector

USB computer port and connector

Parallel ports
Connectors using parallel technology are complicated and can be less reliable, so their use is falling.

SCSI computer port and connector

Zip CD writer
CDs are universally readable in modern computers anywhere in the world, so they are ideal for sharing data. But make sure that the format is ISO 9660 to ensure compatibility between Mac and PC machines. Compact forms can be powered directly from the FireWire lead.

LaCie DVD writer
DVD is the most cost-effective technology for removable storage. It is compact and can store 9 GB with ease. However, it is slow to read and even slower to write, being many times slower than modern CD writers.

Setting up a workroom

A workroom for digital photography has the huge advantage over the traditional darkroom used by film-based photographers in that it does not need to be light-tight – any spare room, or just a corner, is suitable. Nor are chemicals, trays, timers, safe-lights, or running water required.

The ideal environment

The key requirement of a digital workroom is comfort: you are likely to be spending long hours sitting in the same position, so don't allow the computer to become a source of ill health. Take note of the following points:

● Ventilation should be adequate to dissipate the heat produced by the computer and monitor during hot weather.
● You should be able to subdue the lighting with heavy curtains or blinds to help screen contrast.
● There should be sufficient electrical outlets for your equipment needs.
● The desks you work on should be stable and capable of taking the heavy, static weight of a large monitor without wobbling.

● The desk/chair should be at the correct height so that, when seated, your forearms are horizontal or inclined slightly down when at the keyboard.
● There should be ample space underneath the desk for your legs.
● The chair should support your back and legs.
● Arrange desklamps so they do not shine onto the monitor screen. Some lamps are especially designed for computer use, illuminating the desk without spilling light onto the screen.
● Keep an area free for drink and food. Make sure anything spillable is kept well away from electrical equipment or disks.
● Arrange the monitor so the top of the screen is about level with your eyes, or slightly higher.
● Your monitor's screen should not face any light source, such as a window or a lamp.
● You can make a hood at least 20 cm (8 in) deep from black cardboard to block unwanted light reaching the screen and degrading the image.
● Arrange for a picture-editing area, containing a lightbox and your files, away from the computer and monitor.

The digital photographer's desk

The ideal desk area has all the equipment within easy reach. The arrangement of equipment will vary, depending on precisely what you are doing and your own preferences, but everything should fall conveniently to hand. It is convenient to locate the monitor in the middle, preferably in the inside corner of an L-shaped or curved desk.

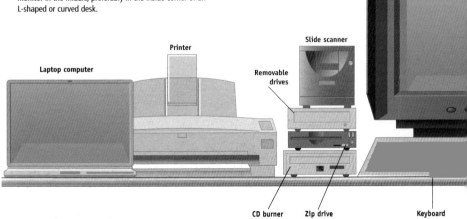

Laptop computer

Printer

Slide scanner

Removable drives

CD burner Zip drive Keyboard

• Ensure you have safe storage for data files – any magnetic-based media, such as Zip, Compact-Flash, and so on, should be stored at least 30 cm (12 in) away from the strong magnetic fields produced by monitors, speakers, and electric motors. In addition, keep magnetic media away from direct sunlight and other heat sources.

Electrical arrangements

Most computer peripherals draw low current at low voltages compared with domestic appliances. This is fortunate, as the peripherals for even a modest workroom could easily sprout a dozen power leads:

• If you are in any doubt about electrical safety, seek advice from a qualified person.

• Never wire more than one appliance into the same plug.

• Never replace a fuse with one of a higher rating.

• Don't plug a device into a computer or peripheral that is switched on unless you know it is safe to do so. Even then, never unplug a device that is halfway through an operation.

Avoiding injury

It is unlikely that you will work the long hours at high levels of stress that lead to repetitive strain injury, but you should still take precautions:

• At least every hour, get up and walk around and take a few minutes away from the screen.

• After two hours in front of the screen, take a longer break – stretch your limbs and look out of window at distant objects to exercise your eyes.

• Listen to your body: if something starts to ache or is uncomfortable, it is time to make adjustments or to take a break.

• Keep your equipment clean and well maintained – sticky mouse rollers or a streaky or dirty monitor screen or keyboard can all add, in more or less subtle ways, to stress levels.

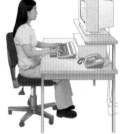

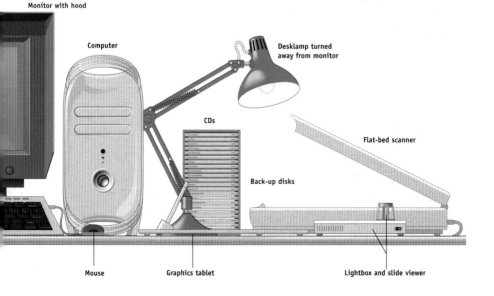

Monitor with hood

Computer

Desklamp turned away from monitor

CDs

Flat-bed scanner

Back-up disks

Mouse

Graphics tablet

Lightbox and slide viewer

2
Photography for the digital age

Technical skills

The trade secrets and techniques of basic photography – from handling camera movement to digital zooms, and working close-up.

Visualization

Composition – image orientation, proportions, and principles – and working with colour. Examples of images exploiting the use of vivid colour contrast.

Creative options

Working with silhouettes and backlighting are explained. The basics of lighting are also clearly presented.

Help on hand

Quick-fix sections help you with image distortion, how to correct leaning buildings, improve colour balance, and show you how to obtain the best results from flash.

Picture composition

Advice found in specialist photographic books and magazines concerning picture composition is often treated in a very proscriptive fashion – as if the adherence to a few "rules" can somehow bring about satisfactory outcomes. It may be better to think of any rules simply as a distillation of ideas about features that photographers – and, of course, painters and other artists in the centuries before the invention of the camera – have found useful in making effective pictures.

Any photographic composition can be said to work if the arrangement of the subject elements communicates effectively with the image's intended viewers. Often, the trick lying behind this is learning to recognize the key ingredients of a scene and then organizing your camera position and exposure controls to draw those elements out from the clutter of miscellaneous visual information that is the ruin of many photographs.

If you are new to photography, it may help to concentrate your attention on the scene's general structure, rather than concentrating too hard on very specific details – these, often, are only of superficial importance to the overall composition.

Symmetry

Symmetrical compositions are said to signify solidity, stability, and strength; they are also effective for organizing images containing elaborate detail. Yet another strategy offered by a symmetrical presentation of subject elements is simplicity. In this portrait of a Turkana man, there was no other way to record the scene that would have worked as well. The figure was placed centrally because nothing in the image justified any other placement – likewise with the nearly central horizon. The subject's walking stick provides the essential counterpoint that prevents the image appearing too contrived.

● Bronica SQ-A with 40 mm lens. ISO 100 film. Heidelberg Saphir II scanner.

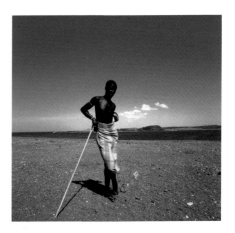

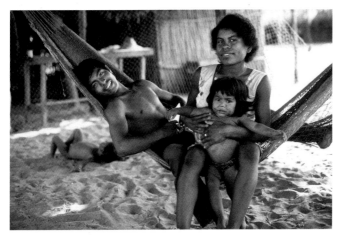

Radial

Radial compositions are those in which key elements spread outward from the middle of the frame. This imparts a lively feeling, even if subjects are static. However, in this family portrait, taken in Mexico, the radial composition is consistent with the tension caused by the presence of a stranger (the photographer), combined with the transfixing heat. The composition suggests that a modest wide-angle lens was used; in fact it was taken with a standard focal length.

● Nikon F2 with 50 mm lens. ISO 64 film. Microtek 4000t scanner.

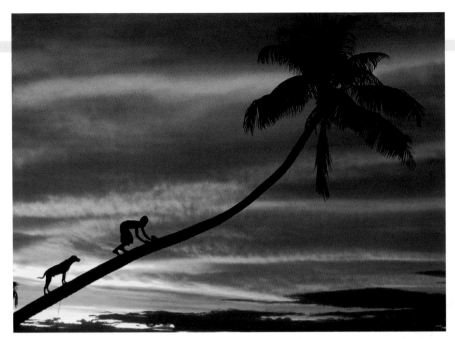

Diagonal

Diagonal lines lead the eye from one part of an image to another and impart far more energy than horizontals. In this example, it is not only the curve of the palm's trunk, but also the movement of the boy and his dog along it that encourage the viewer to scan the entire picture, sweeping naturally from the strongly backlit bottom left-hand corner to the top right of the frame.

● Canon EOS-1n with 80–200 mm lens. ISO 100 film. Microtek 4000t scanner.

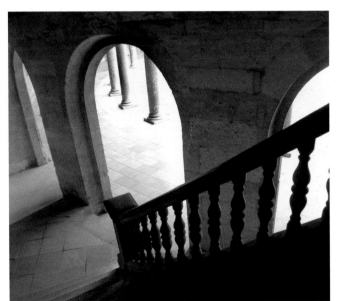

Overlapping

Overlapping subject elements not only indicate increasing depth perspective, they also invite the viewer to observe subject contrasts. In the first instance, distance is indicated simply because one object can overlap another only if it is in front of it. In the second, the overlap forces two or more items, known to be separated by distance, to be perceived together, with any contrasts in shape, tone, or colour, made apparent as a result. In this example, shot in Spain, overlapping architectural elements jostle for dominance.

● Nikon Coolpix 990.

Picture composition continued

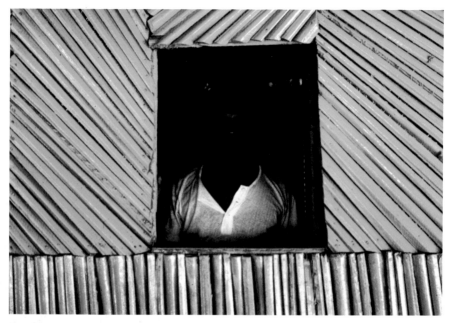

Framing

The frame within a frame is a painterly device often exploited in photography. Not only does it concentrate the viewer's attention on the subject, it often hints at the wider context of the subject's setting. The colours of the frame may also give clues about where the photograph is set. In this portrait, the colours of the painted wood suggest Central or South America, while the structure of the building and the subject himself lead you to expect the unexpected. In fact, the house is in an "African" village built in Mexico populated by descendants of escaped African slaves.

● Nikon F2 with 50 mm lens. ISO 64 film. Nikon LS-2000 scanner.

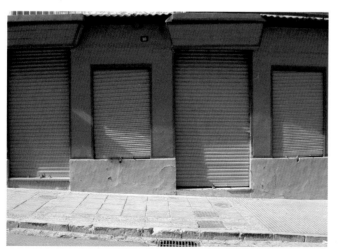

Geometric patterns

Geometrical shapes, such as triangles and rectangles, lend themselves to photographic composition because of the way they interact with the rectangle of the picture frame. Here, in this shuttered store in Spain, shapes from squares to thin rectangles and narrow triangles are all at work. In parts they are working harmoniously (the gaps between the shutters); in others (the thin wedges created by the sloping road), they create tension in the composition.

● Nikon Coolpix 990.

Irregular pattern

The imperfectly regular rows of sacks left out to dry in the hot, Mombassa sunshine lead your eye inexorably to the man who has authored the work. Both the pattern and the repetition are obvious, but the more thoughtful photographer learns to work with these elements rather than using them as the actual subject.

● Canon F-1n with 200 mm f/2.8 lens. ISO 100 film. Microtek 4000t scanner.

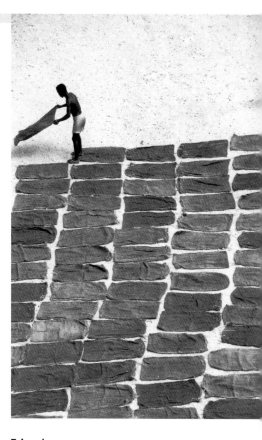

●TRY THIS

Look out for various types of pattern – squares, circles, triangles, swirls, and so on – whenever you have a camera readily to hand. When you find an interesting example, take several shots, shifting your camera position slightly between exposures. Examine the pictures carefully and you may discover that the shot you thought most promising at the time does not produce the best result. Try to think why this might be the case: often, it is because our response to a scene is an entire experience, while photographs have to work within the limits of the viewfinder and the proportions of the format.

Triangles

The windows of a building reflected in the curved glass of the front of a parked car in Andalucia, southern Spain, appear strongly distorted within the triangle implied by the frame of the windshield itself. The overall shape is not immediately apparent, but it is the framework on which all the elements – the repeated lines and rectangles, for example, and the bands of light and dark – are organized. The triangular shape in composition is most often encountered in scenes where parallel lines seem to converge, such as the sides of a road or the rails of railway lines, as they recede into the distance. In the two-dimensional photographic print or computer monitor image, this is powerfully suggestive of both depth and distance.

● Nikon Coolpix 990.

Image orientation

Since most camera formats produce rectangular pictures, you can change the way you hold the camera to give either horizontal or vertical results. Image orientation produces different emphases and so can alter the whole dynamic of a shot.

Picture shape should normally be dictated by the natural arrangement of subject elements – in other words, by the subject's own orientation. In portraits, for example, the subject will usually be sitting or standing, and so the camera most often is turned on its side to give vertical framing. As a consequence, vertical picture orientation is often called "portrait". Landscapes scenes, however, with their usually horizontal orientation, have given their name to horizontally framed pictures.

Landscape-shaped images tend to emphasize the relationship between subject elements on the left and right of the frame, while portrait-shaped pictures tend to relate foreground and background subject elements. And bear in mind that picture shape strongly influences what is included at the periphery of a scene, and so you can use image orientation as a useful cropping device.

Breaking the "rules"

If you decide to move away from these accepted framing conventions, or "rules", you then have an opportunity to express more of an individual vision. Simply by turning the camera on its side you could create a more striking picture – perhaps by increasing the sense of energy and movement inherent in the scene, for example. Using an unconventional picture orientation may, therefore, reveal to the viewer that you are engaging more directly with the subject, rather than merely reacting to it.

Think ahead

Another factor to consider is that since most printed publications are vertical in format, pictures are more likely to be used full-size if they are vertically framed. As a safeguard, commercial photographers often take vertically framed versions of important views or events, even if an image's natural orientation is horizontal.

A potential problem in this regard occurs with cameras having swivelling LCD screens (*see p. 16*), as these can be awkward to use vertically. Even if the camera has a viewfinder, if you attach any type of lens accessory you then have to use the LCD screen exclusively for viewing and framing.

If, however, your images are intended for publication on the Web, you need to bear in mind that the orientation of the monitor's format is more horizontal in shape, and so appropriately framed images will then be easier to use at full-size.

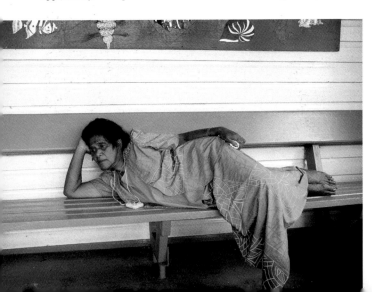

Reclining figure
The strong horizontal lines of both the bench and the metal cladding on the wall behind, as well as the elegant, reclining pose of this Fijian lady, all insist that horizontal framing is appropriate here.

● Canon EOS-1n with 17–35 mm lens. ISO 100 film. Microtek 4000t scanner.

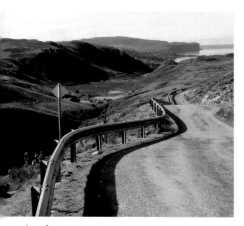

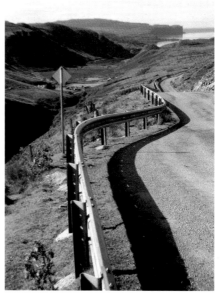

Landscape scenery

A horizontal, or "landscape", view (*above*) is often an obvious choice for a landscape subject. However, vertical, or "portrait", framing (*right*) can effectively suggest space, especially when some natural feature in the scene – the snaking crash barrier in this example – leads the eye right from the foreground through to the background.

● Nikon Coolpix 990.

Still-life

Different sets of lines that may be contained within a picture can be given additional prominence, depending on the framing you decide to adopt. Horizontal orientation (*above*) allows the strong, diagonally slanting plant stems to make a visual statement, while the vertical image orientation (*right*) allows the parallel slats of the blind to make their mark.

● Nikon Coolpix 990.

Image proportions

As you take more pictures you may start to notice that the proportions of the image have a subtle effect on the picture's ability to communicate. A square image, for example, more often than not evokes a sense of stability and balance. However, an image that is just slightly rectangular can communicate a sense of indecision or make subject matter look "uncomfortable" within its frame. This type of framing is, therefore, best avoided unless you have clear reasons for it.

Panoramas

The "panoramic" picture has been popularized most recently by its availability on APS (Advanced Photo System) cameras. In reality, this system simply crops the top and bottom off an ordinary image, changing it into a narrow one, and so it is not a true panoramic image.

Digital cameras, however, can produce true panoramas (in which the camera swings through the scene, from side to side or up and down), so

True panorama
A true panoramic camera uses a swinging lens to project its image onto a curved piece of film. The movement of the lens causes the typical curvature of lines away from the middle of the frame, as you can see in this example taken at an exhibition in a picture gallery.
⦿ Widelux. ISO 400 film. Heidelberg Saphir scanner.

Horizontal cropping
As you can see, the sofa pattern here competes strongly with the child and her collection of much-loved toys (*left*). A severe crop more clearly defines the image content (*below*).
⦿ Olympus OM-1n with 28 mm lens. ISO 100 film. Nikon LS-2000 scanner.

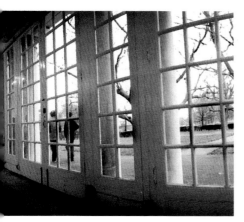

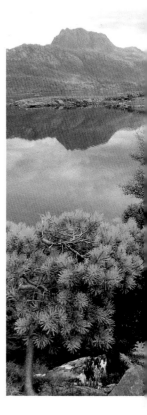

Vertical cropping
An attractively framed, if conventional, shot of a lake in Scotland (*above*) has been transformed into a sharper, more challenging composition (*right*) simply by cropping it into a narrower, more vertical shape, in imitation of a traditional silk wall hanging.
● Nikon Coolpix 990 with wide-angle attachment.

that the field of view of the image is greater than the field of view of the lens. This is achieved by taking a number of pictures that overlap and "sewing" them together.

To achieve best results, pivot the camera around a fixed point, such as a tripod, so that as you rotate the camera the image does not appear to move. To aid you, some digital cameras have a "panorama function", which indicates where the next pictures should be taken by showing you on the LCD screen the previous image as a guide.

Taking time to select just the right view to experiment with really pays dividends with panoramic images. For example, you need to be aware that panoramas made up of individual pictures that include subjects positioned close to the camera, or even in the near middle-distance, will show a perspective distortion that makes the scene appear bow-shaped once images are combined.

Exposure is another consideration when taking panoramas. If you swing your camera across a scene, you will see that the exposure settings in the viewfinder read-out alter as different areas of light and shade influence the changing picture area. If you were to take your panorama like this, you may find that, say, the foreground area fluctuates between dark and light from frame to frame. To prevent this occurring, take the camera off automatic and set the exposure manually.

Cropping

One of the simplest, and often one of the most effective, changes you can make to image proportions is to crop them – in other words, slicing portions from the sides, top, or bottom of the picture area. This can change the whole emphasis of a shot by, for example, removing unnecessary or unwanted subject matter or by changing the relationship between various subject elements and the borders of the frame. This can turn a mediocre picture into a truly arresting image.

Composition and zooms

Zoom lenses allow you to change the magnification of an image without swapping lenses. Zooms are designed to change the field of view of the lens while keeping the image in focus. When the field of view is widened (to take in more of the subject), the image must be reduced in order to fill the sensor or film area. This is the effect of using a short focal length lens or a wide-angle setting on a zoom. Conversely, when the field of view is narrowed (to take in less of the subject), the image must be magnified, again in order to fill the sensor or film area. This is the effect of using a long focal length lens or a zoom's telephoto setting.

Working with zooms

The best way to use a zoom is to set it to the focal length you feel will produce the approximate effect you are aiming for. This method of working encourages you to think about the scene before ever raising the camera to your eye to compose the shot. It also makes you think ahead of the picture-taking process, rather than zooming in and out of a scene searching for any setting that seems to work. This is not only rather aimless, it is also time-consuming and can lead to missed photographic opportunities.

A professional approach

Many professional photographers use zooms almost as if they were fixed focal length, or prime, lenses, leaving them set to a favourite focal length most of the time. They then use the zoom control only to make fine adjustments to the framing. Zooms really are at their best when used like this – cutting out or taking in a little more of a scene. With a prime lens, you have to move the camera backward or forward to achieve the same effect. Depending on the type of subject you are trying to record, you could leave the zoom toward the wide-angle or telephoto end of its range. On some digital cameras, however, zooms are stepped rather than continuously variable, and so cannot be used for making small adjustments.

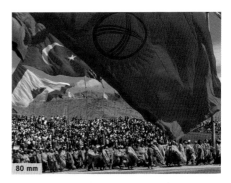

80 mm

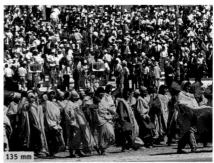

135 mm

200 mm

Zooms for framing
Zoom lenses come into their own when you find it difficult or time-consuming to change your camera position, as they allow you to introduce variety into what would otherwise be similarly framed images. In this large outdoor performance, one shot was taken at 80 mm (*top*), one at 135 mm (*middle*), and the other at 200 mm (*above*), all from approximately the same camera position.

● Canon EOS-1n with 80–200 mm lens. ISO 100 film. Microtek 4000t scanner.

Zoom movement

Colour and movement literally seem to explode out from this photograph of a simple tulip – an effect achieved by reducing the zoom lens's focal length during a long, manually timed exposure. And in order to emphasize the flower's blurred outlines, the image was also slightly defocused before the exposure was made.

● Canon F-1n with 80–200 mm lens. ISO 100 film. Microtek 4000t scanner.

Zooms for composition

Zooming from 80 mm (*above left*) to 200 mm (*above right*) produced an intriguing abstract image by allowing patterns of light and dark, colour and non-colour, to reveal themselves. But as the focal length increases, depth of field also diminishes, so select the lens apertures with care.

● Canon EOS-1n with 80–200 mm lens. ISO 100 film. Microtek 4000t scanner.

●POINTS TO CONSIDER

Distortion Most zoom lenses distort the image by making straight lines look curved. This is especially the case at wide-angle settings.

Camera shake At the very long effective focal lengths some digital cameras offer – such as a 35efl of 350 mm – there is a great danger that camera shake during exposure will reduce image quality. Make sure you hold the camera steady, preferably supported or braced, and use a short shutter time.

Lens speed As you set longer focal lengths, the widest available aperture becomes smaller. Even in bright conditions, it may then not be possible to set short shutter times with long focal lengths.

Lens movement Some lenses may take a few seconds to zoom to their maximum or to retract to their minimum settings. Don't be tempted to rush the action by pushing or pulling at the lens.

Digital zooms

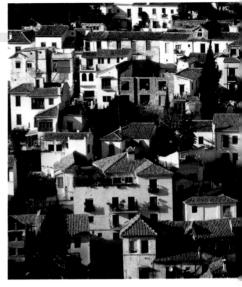

The term given to a computer-generated increase in apparent focal length is "digital zoom". Although the lens focal length does not increase, the image continues to be magnified.

It works by taking a central portion of an image and enlarging it to fill the format, using a process called "interpolation" – extra pixels are added, based on the existing one, to pad out the space. This does not add information; indeed, it may even mask it. Clearly you can obtain exactly the same effect – sometimes even better-quality effects – by altering the picture using image-manipulation software, but it is then an extra step and thus more work for you.

Long focal length settings on a zoom lens come into their own when you want to magnify a small part of a scene: a 35efl of 135 mm is ample for most purposes. This produces the characteristic "telephoto perspective", in which distant objects look compressed, or backgrounds in close-up shots are thrown strongly out of focus.

Nonetheless, some recent digital cameras offer focal lengths of 300 mm and more. Some models reduce the effects of camera shake by using image-stabilization technology. Even so it is worthwhile making every effort to reduce unwanted camera-movement problems at source.

Telephoto perspective

Even a modest telephoto shot of a distant scene depicts well-separated objects as if they are compressed and piled on top of each other. This is because the relative differences in distance within the picture are small when compared with the distance between the subject and the camera. In this photograph, houses that were in fact hundreds of metres apart look squashed together, and depth of field extends throughout the image.

● Nikon Coolpix 990 with tele-attachment.

Image stabilization

Technology to reduce the effect of camera shake takes two forms. One uses a motion sensor to control a lens or thin prism that shifts the image to counter camera movement. This form, pioneered by Canon, is most suitable for still images and is available in several of their 35 mm format lenses. Olympus offers image-stabilized digital cameras and it is likely to become standard in more sophisticated, higher-end equipment. The other method analyzes the signals from the sensor and filters out the slight repetitions in image structure typical of camera shake.

● This system is used mostly in video cameras.

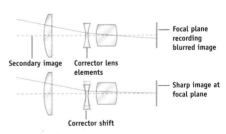

How it works

A blurred secondary image, represented by the dotted lines here, can result if the lens moves while the picture is being exposed (*upper diagram*). A corrector group of lens elements within the lens hangs from a frame, which allows these elements to move at right-angles to the lens axis. Motion sensors tell the frame which way to shift the corrector group to compensate for any movement of the lens (*lower diagram*).

Camera movement

While the generally available advice is that you should hold the camera completely steady when taking pictures, so that camera shake does not introduce unwanted movement that might spoil your image, there is a place for pictures that display a thoughtful or creative use of subject blur.

Experimentation

Experimentation with this technique is essential, as the effects of movement are unpredictable. They are, in fact, unique and no other recording medium represents movement in quite the same way. However, in order to produce the occasional winning shot you must be prepared to make a lot of exposures, and here the digital camera's ability to delete unwanted frames gives it a distinct advantage over film-based cameras.

While taking pictures from a moving vehicle is generally not recommended, it is nevertheless a technique worth experimenting with. In a fast-moving car or train, for example, even a short shutter time will not be able to prevent motion blur, especially of foreground objects. But you can introduce blur in almost any situation simply by setting a long shutter time – at least ½ sec – and then deliberately moving the camera during the exposure. Another possibility is again to set a long shutter time and then zoom the lens during the exposure. This gives the resulting image a characteristic "explosive" appearance (*see p. 47*).

As a bonus, digitally produced motion-blur images compress to a very high degree with little additional noticeable loss in clarity because of their inherently lower image quality.

Moving camera
The blur produced by taking a photograph from a speeding car streaks and blends the rich evening light in a very evocative and painterly fashion in this example. To the eye at the time of taking, the scene was much darker and less colourful than you can see here. It is always worth taking a chance in photography, as you never know what might come of it.

● Canon EOS-100n with 28–135 mm lens. ISO 100 film. Microtek 4000t scanner.

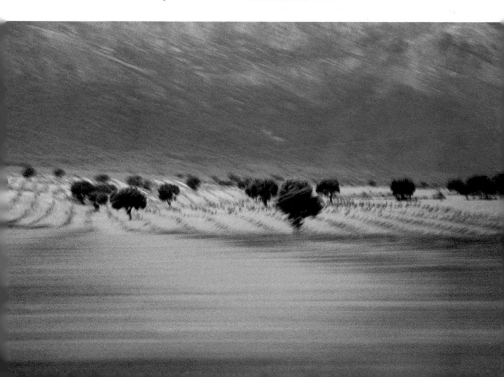

Digital close-ups

In the past, true close-up photography required specialist equipment and fiddly accessories. However, this situation has entirely changed thanks to the introduction of digital cameras. These cameras work at close-up subject distances as if they were designed for the job.

Digital's ability to handle close-ups is due to two related factors. First, because the sensor chips are small (*see p. 19*), lenses for digital cameras need have only short focal lengths. Second, short focal length lenses require little focusing movement in order to bring near subject into focus. Another factor, applicable to digital cameras with zoom lenses, is that it is relatively easy to design lenses capable of close focusing by moving the internal groups of lens elements.

In addition to lens design, there is another feature common to digital cameras that also helps: the LCD screen. This provides you with a reliable way of framing close-ups with a high degree of accuracy, all without the complex viewing system that allows traditional SLRs to perform so well.

There will be occasions when you need to keep a good distance between yourself and the subject – a nervous dragonfly, perhaps, or a bee-hive. In such cases, first set the longest focal length on your zoom lens before focusing close up. In these situations, an SLR-type digital camera (one that accepts interchangeable lenses) is ideal, due to the inherent magnification given by the small sensor chip working in conjunction with lenses designed for normal film formats.

Simple subjects

Learning just what to include and what to leave out of a picture is a useful skill to master – not only is the image itself usually stronger for being simpler in visual content, as in the example shown here, but it is also often easier to use it for a range of purposes, such as compositing. Subject movement is always a problem with close-ups, especially plants outdoors where they can be affected by even the slightest breeze. If you cannot effectively shield the plant from air currents, then set the shortest shutter time possible, consistent with accurate exposure, to freeze any subject movement.

 Nikon CoolPix 990.

Avoiding highlights

One of the secrets underlying good close-up photography is avoiding unwanted highlights intruding on the image. These usually appear as insignificant out-of-focus bright spots when you frame the shot, but in the final image they can appear far more prominent and be very distracting. To take this shot, I moved slowly around the subject, watching the LCD screen continually, and released the shutter only when the highlights were positioned just as I wanted.

● Ricoh RDC-5000.

Long close-up
A long focal length lens with close-focusing ability allows you to approach small, nervous subjects, such as this dragonfly, and so obtain a useful image size. In addition, the extremely shallow depth of field with such a lens throws even nearby image elements well out of focus. The central bright spot is in fact a flower.
- Canon D30 with 100–400 mm lens.

Safe distance
It was dangerous to get too near to this constrictor, so a close-focusing long lens was the best way to obtain good magnification in this case.
- Canon EOS-1n with 300mm lens.

Normal close-up
With static or slow-moving subjects, a normal focal length lens used at its macro setting will suffice.
- Nikon 775.

Digital depth of field

On the one hand, the closer you approach your subject the more rapidly depth of field diminishes, at any given lens aperture. On the other, depth of field increases rapidly as focal length decreases. So the question is whether the increase in depth of field with the short focal lengths typical of digital cameras helps make close-up photography easier than with film-based equipment? The calculations are not straightforward, partly because in order for the shorter focal length lens to produce a given magnification, it must approach closer to the subject than a longer lens, which works

against the increase in depth of field. Another confusing factor is that digital cameras, with their regular array of relatively large pixels, cannot be treated in the same way as film-based cameras, whose images are based on a random collection of tiny grains of light-sensitive silver. With many digital cameras, you do not have the option of setting apertures at all, and, even when you do, the minimum aperture may be relatively large – say, f/8. Nonetheless, taking all these factors into account, depth of field often appears greater with digital photographic equipment than with conventional cameras.

Quick fix Image distortion

Anybody whose photography involves taking accurate pictures of buildings or other prominent architectural, or even some natural, features is likely at some stage to come up against the problems associated with image distortion.

Problem

When using an extreme wide-angle lens, or an accessory lens that produces a "fish-eye" effect, the straight lines of any subject elements – such as the sides of buildings, the horizon, or room interiors – appear to be bowed or curved in the image. With ordinary lenses, this effect (known as distortion) is usually not obvious, though it is a feature of many zooms. Don't confuse this problem with converging verticals (see p. 111).

Analysis

Distortion is caused by slight changes in magnification of the image across the picture frame. Lenses that are not symmetrical in construction (in other words, the elements on either side of the aperture are not similar) are particularly prone to this type of imaging distortion, and the asymmetric construction of zoom lenses means that they are highly susceptible.

Solution

Corrections using image-manipulation software may be possible, but turning curves into straight lines is more difficult than adjusting straight lines. Try using the Spherize distortion filter. The implementation in Photoshop is not very usable, but those in some other software packages offer more control and a better chance of correcting distortion. You could try applying a succession of filters – first, slight Perspective Distortion, then Spherize, then slight Shear – or apply filters to just a part of, rather than to the entire, image.

Problem...

Barrel distortion

In the original shot (above), a wide-angle attachment has introduced barrel distortion. A combination of Pinch filter, to squeeze the image from all sides, with the Shear filter engaged (left) has partially helped to correct the problem (below).

● Nikon Coolpix 990 with wide-angle attachment.

...solution

How to avoid the problem

● Don't place straight lines, such as the horizon or a junction of two walls, near the frame edges.

● Avoid using extreme focal lengths – either the ultra-wide or the ultra-long end of a zoom range.

● Use a focal length setting that offers the least distortion, usually around the middle of the range.

● Place important straight line in the middle of the image – this is where distortion is usually minimal.

Quick fix Lens problems

Although many lens problems can be solved, or at least minimized, using appropriate software, prevention is always better than cure.

Problem: Lens blurring

The image looks unsharp, blurred, or smudged. Contrast is not high and the highlights are smeared.

Analysis

A dirty lens or lens filter, lack of sharp focus, damaged optics, camera shake, or subject movement may separately, or in combination, be the cause of blurred pictures.

Solution

You can increase contrast to improve image appearance using the Levels or Curves controls of image-manipulation software. Applying a Sharpen or Unsharp Mask filter is also likely to improve the image. The main subject can be made to appear adequately sharp if the background is made to look more blurred. To do this, select areas around the main subject and apply a Blur filter.

Camera movement
While trying to catch the light on the dust raised by a running zebra, the camera slipped a little, giving this blurred image – most evident in the highlights on the zebra's back and in the grass. However, blur can suggest mood and setting.

● Canon F-1n with 300 mm lens. ISO 100 film. Microtek 4000t scanner.

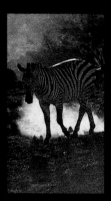

How to avoid the problem

Clean the lens or lens filter if it is marked; use a tripod to steady the camera for long shutter times or when using a telephoto lens or setting; if available, use an image-stabilization lens.

Problem: Lens flare

Bright spots of light, sometimes fringed with colour, can be seen in the image. Spots can be single occurrences or appear in a row, and stretch away from a bright point source of light in the scene. Similarly, a bright, fuzzily edged patch of light, known as veiling flare, fills part of the image area.

Analysis

These types of fault are most likely the result of internal reflections within the lens. Stray light entering the lens from a bright light source has reflected around the lens and then been recorded on the film or picked up by the sensor of a digital camera.

Solution

Working with a digital file, small spots of light can easily be removed by cloning or rubber-stamping adjacent unaffected areas of the image onto them. Large areas of flare, however, are more difficult to correct, since they cover a significant area of the picture and contain no information to work with.

Flare
An unobstructed sun in the frame causes light to reflect within the lens, resulting in flare. By changing camera position, it was possible to mask the sun with a column of the building, while allowing a little flare through to suggest the brilliance of the light. Some of the reflections may be removed, but probably not all of them.

● Leica R6 with 21 mm lens. ISO 50 film. Microtek 4000t scanner.

How to avoid the problem

Use a correctly designed lens-hood to stop light entering the periphery of the lens; even so, avoid pointing the lens directly toward bright light sources. If shot framing demands you include any intense light source in the image, select a small aperture to reduce the size of any resulting internal reflections.

Quick fix Lens problems continued

Problem: Black skies

A blue sky is rendered almost black. This type of effect seldom looks realistic or believable.

Analysis

This is probably the result of a polarizing filter on the lens combined with underexposure. This can reduce the sky to the point where most, or even all, colour is removed.

Solution

First, highlight the problem sky area and then use Replace Color in Photoshop, or a similar software package, to restore the colour. The best way to work is by making small changes repeatedly rather than a single, large change. Check that you do not introduce banding, or artificial borders, in the areas of colour transition. You can also try using a graduated layer (*see below*).

How to avoid the problem

Don't set a polarizing filter to produce maximum darkness: in the viewfinder you may still be able to see the blue of the sky but the recording medium may not have sufficient latitude to retain colour if the image is then underexposed.

1 Original image

The skies of Kenya seldom need a polarizing filter in order to emphasize their colour – indeed, it may even cause a portion of the sky to turn too dark, as you can see here in the top left-hand corner of the image.

● Canon F-1n with 20 mm lens. ISO 64 film. Microtek 4000t scanner.

2 Gradient Fill

To correct this, you need to re-move the dark gradient while leaving the rest of the image unaffected. This calls for a transparent-to-solid gradient that runs counter to the darkness. Here a Gradient Fill of black-to-transparent, with its Blend mode set to Screen, was applied. The gradient was adjusted until the dark corner was neutralized.

3 Sky correction

Once the new layer was applied to the image, the carefully positioned Gradient Fill restored the natural colour of the sky. Once you have made one adjustment you may find the image needs more work – for example, the top right-hand corner may now seem too dark. With digital photography it is easy to create perfect tonal balance.

Problem: Dark image corners

Corners of the image are shadowed or darkened, with a blurred edge leading to blackness, or the middle of the image looks significantly brighter than the periphery.

Analysis

Images showing dark corners with a discernible shape have been vignetted. This is usually caused by a filter with too deep a rim for use with a (usually) wide-angle lens, by stacking too many filters on a lens, or by an incorrectly aligned or overly deep lens-hood.

Solution

If the areas affected are small, vignetting can be corrected by cloning adjacent portions of the image. Light fall-off may be corrected using a Radial Graduate or Gradient Fill (*see opposite*) – experiment with different values of darkness and opacity. ·

Darkened corners
It is easy not to notice a lens-hood interfering with the image. The shadows in the corners here were not noticed until after film processing. Small apertures give deeper, sharper shadows.

● Canon F-1n with 20 mm lens. Nikon LS-1000 scanner.

How to avoid the problem

Vignetting is easy to avoid if you are careful with your filters and lens-hoods. Light fall-off, as an optical defect, can only be reduced, not eliminated altogether: use either smaller working apertures or a higher-quality lens.

Problem: Poor-quality close-ups

Images taken at the closest focusing distances are not sharp or lack contrast.

Analysis

Lenses usually perform best at medium or long distances: the degree of close-up correction depends on lens design.

Solution

Poor image sharpness may be improved by applying Sharpness or Unsharp Mask filters. Contrast will be improved with Levels or Curves. Try localized burning-in to improve contrast, which will also increase apparent sharpness without increasing visual noise.

How to avoid the problem

Small apertures are likely to improve sharpness. Try using different focus and zoom settings – there will be a combination that gives the best possible quality. An alternative solution is to attach a close-up lens to the main lens. This acts as a magnifying glass and can improve close-up performance.

Improving close-ups
The original image (*right*) shows the features characteristic of a low-quality close-up: poor sharpness and reduced contrast. Applying an Unsharp Mask filter and an increase in contrast significantly improves results (*far right*).
● Olympus 920.

Problem...

...solution

Influencing perspective

You can exercise control over the perspective of a photograph by changing your camera position. This is because perspective is the view that you have of the subject from wherever it is you decide to shoot. Perspective, however, is not affected by any changes in lens focal length – it may appear to be so but, in fact, all focal length does is determine how much of the view you record.

Professional photographers know perspective has a powerful effect on an image, yet it is one of the easiest things to control. This is why when you watch professionals at work, you often see them constantly moving around the subject – sometimes bending down to the ground or climbing onto the nearest perch; approaching very close or moving further away again. Taking a lead from this, your work could be transformed if you simply

become more mobile, observing the world through the camera from a series of changing positions rather than a single, static viewpoint.

Bear in mind that with some subjects – still-lifes, for example, and interiors or portraits – the tiny change in perspective between observing the subject with your own eyes and seeing it through the camera lens, which is just a little lower than your eyes, can make a difference to the composition. This difference in perspective is far more pronounced if you are using a studio camera or waist-level finder on a medium-format camera.

Using zooms effectively

One way to approach changes in perspective is to appreciate the effect that lens focal length has on your photography. A short focal length gives a

Alternative views

This classic wide-angle view (*above left*), tells of a flock of sheep grazing on the rolling moors of Scotland. It is a simple, effective, but essentially commonplace interpretation of the scene. However, when I stepped back a little and crouched down, I noticed tufts of wool caught on a wire fence (*above right*), which had been there all the time, literally right under my nose. A change to a long focal length setting on my zoom lens entirely

changed the perspective and delivered a very different, and entirely more engaging, account of this attractive rural scene. (*For another treatment of this view, see pp. 102-3*)

● Nikon Coolpix 990 with tele-setting (*above right*) and wide-angle attachment (*above left*).

perspective that allows you to approach a subject closely yet record much of the background. If you step back a little, you can take in much more of the scene, but then the generous depth of field of a wide-angle tends to make links between separate subject elements, as there is little, if any, difference in sharpness between them.

A long lens allows a more distant perspective. You can look closely at a face without being nearby. Long lenses tend to pull together disparate objects – in an urban scene viewed from a distance, buildings that are several blocks apart might appear to crowd in on top of each other. However, the shallow depth of field of a long lens used at close subject distances tends to separate out objects that may actually be close together (*see p. 48*) by showing some sharp and others blurred.

Perspective effects

Wide-angle lenses
- Take in more background or foreground.
- Exaggerate in close-ups the size of near subjects.
- Exaggerate differences in distance or position.
- Give greater apparent depth of field and link the subject to its background.

Telephoto lenses
- Compress spatial separation.
- Magnify the main subject.
- Reduce depth of field to separate the subject from its background.

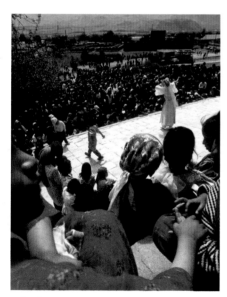

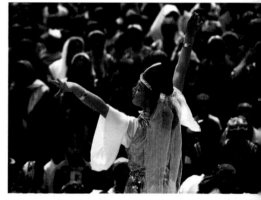

Telephoto perspective
Overlooking the action there is a sense of the crush of people at this festival in mountainous Tajikistan (*above*). Two children holding hands complete the scene. The long focal length version (*above right*) focuses attention on the dancer, but excludes all sense of setting beyond the crowd watching the traditional performance.
- Canon EOS-1n with 80–200 mm lens. ISO 100 film. Microtek 4000t scanner.

TRY THIS
For this exercise, leave your zoom lens at its shortest focal length setting. Look for pictures that work best with this focal length – ignore any others and don't be tempted to change the lens setting. This will help to sharpen your sense of what a wide-angle lens does. You may find yourself approaching subjects – including people – more closely than you would normally dare. The lens is making you get closer because you cannot use the zoom to make the move for you. Next, repeat the exercise with the lens at its longest focal length setting.

Changing viewpoints

Always be on the look-out for viewpoints that give a new slant to your work. Don't ignore the simple devices, such as shooting down at a building instead of up at it, or trying to see a street scene from a child's viewpoint rather than an adult's.

Your choice of viewpoint communicates subtle messages that say as much about you as they do your subject. Take a picture of someone from a distance, for example, and the image carries a sense that you, too, were distant from that person. If you photograph a scene of poverty from the viewpoint of a bystander, the picture will again have that distant look of having been taken by an aloof observer. Lively markets are popular photographic subjects, but what do they look like from a stall-holder's position? If you enjoy sports, shoot from within the action, not from the sidelines.

Practical points

Higher viewpoints enable you to reduce the amount of foreground and increase the area of background recorded by a lens. From a high vantage point, a street or river scene lies at a less acute angle than when seen from street or water level. This reduces the amount of depth of field required to show the scene in sharp focus.

However, from a low camera position subjects may be glimpsed through a sea of grass or legs. And if you look upward from a low position, you see less background and more sky, making it easier to separate your subject from its surroundings.

Less can say more

At markets and similar types of location, all the activity can be overwhelming – and the temptation is often to try to record the entire busy, colourful scene. If you look, however, at your feet could be images showing much less but saying so much more. In Uzbekistan I noticed next to a fruit stall a lady who had nothing to sell but these few, sad tulips.
● Ricoh RDC-5000.

Subjects and setting

By climbing up to a convenient vantage point overlooking the lawn, I could leave the classic wedding group pictures behind and record a more complex image, one that revealed not only the wedding party and guests, but also the surrounding to be the romantic ruins of a castle.
● Nikon F60 with 24–120 mm lens. ISO 100 film. Microtek 4000t scanner.

● In some parts of the world, it is a good idea to avoid drawing attention to your presence. Your search for an unusual camera viewpoint could attract the unwanted interest of officialdom. Even climbing onto a wall could land you in trouble in places where strangers are not a common sight or photographers are regarded with suspicion.

● As well as being discourteous, it might also be illegal to enter a private building without permission in order to take photographs. You may be surprised at how co-operative people generally are if you explain what you are doing and why, and then ask for their assistance.

● Try to be open and friendly with people you encounter – a pleasant smile or an acknowledging wave is often the easiest, and cheapest, way to elicit a helpful response from strangers.

● Prepare your equipment before making your move. Balancing on the top of a wall is not the best place to change lenses. With manual cameras, preset the approximately correct aperture and shutter time so that if you snatch a shot, exposure will be about right.

Changing viewpoint
This conventional view of the Mesquita of Cordoba, Spain (*above*), works well as a record shot, but it is not the product of careful observation. Looking down from the same shooting position, I noticed the tower of the building reflected in a puddle of water. Placing the camera nearly in the water, a wholly more intriguing viewpoint was revealed (*right*). An advantage of using a digital camera with an LCD screen is that awkward shooting positions are not the impossibility they would be with a conventional camera.

● Nikon Coolpix 990.

Quick fix Leaning buildings

Buildings and architectural features are always popular photographic subjects, but they can cause annoying problems of distortion.

Problem

Tall structures, such as buildings, lamp posts, or trees, even people standing close by and above you, appear to lean backward or look like they are about to topple over.

Analysis

The cause is a distortion of projection: for example, for a building to look as it is, the camera should be held level to its front, thus taking in too much of the foreground and not enough of the height of the subject.

Solution

- Stand further back and keep the camera level – you will still take in too much of the foreground, but you can later crop the image.
- Use a wider-angle lens or zoom setting, but then remember to hold the camera precisely level – wide-angle lenses tend to exaggerate projection distortion.
- Take the picture anyway and try to correct the distortion by manipulating the image (see p. 89).
- Use a shift lens or a camera with movements. This equipment is specialist and expensive, but technically it is the best solution.
- Exaggerate the leaning or toppling effect to emphasize the height and bulk of the subject.

Problem...

Tilting the camera
An upward-looking view of the spires of Cambridge, England makes the buildings lean alarmingly backward.
- Nikon Coolpix 990 with wide-angle adaptor.

...solution

Using the foreground
By choosing the right camera position, you can keep the camera level and include foreground elements that add to the shot.

Problem...

Losing the foreground
To record the red flags against the contrasting blue of the building there was no option but to point the camera upward, thus dismissing much of the foreground. As a result, the nearest building appears to lean backward.
- Canon EOS-1n with 20 mm f/2.8 lens. Microtek 4000t scanner.

...solution

Alternative view
Keeping the camera level, a shift lens was used, set to maximum upward movement. This avoided the problem of converging verticals. Although this is the best solution to optimize image quality, it does require a costly professional lens.
- Canon EOS-1n with 24 mm TS lens. Microtek 4000t scanner.

Quick fix Facial distortion

Distorted facial features can be a problem with portraits. To make the subject's face as large as possible, the temptation is to move in too close.

Problem

Portraits of people taken close-up exaggerate certain facial features, such as noses, cheeks, or foreheads.

Analysis

The cause is a perspective distortion. When a print is viewed from too far away for the magnification of the print, the impression of perspective is not correctly formed. This is why at the time you took the photograph, your subject's nose appeared fine, but in the print it looks disproportionately large.

Solution

● Use a longer lens setting – a 35efl of at least 80 mm is about right, so that for a normal-sized print viewed from a normal viewing distance, perspective looks correct.

● Use the longest end of your zoom lens. For many, this is a 35efl of 70 mm, which is just about enough.

● If you have to work close-up, try taking a profile instead of a full face.

● Avoid using wide-angle lenses close to a face, unless you want a distorted view.

● Don't fill the frame with a face at the time of shooting. Instead, rely on cropping at a later stage if you need the frame filled (see pp. 44-45).

● Don't assume you will be able to correct facial distortions later on with image-manipulation software. It is hard to produce convincing results.

● If you have a digital camera with a swivelling lens, it is fun to include yourself in the picture by holding the camera at arm's length – but your facial features will then be so close they will look exaggerated.

● Make larger prints. With modern ink-jet printers it is easy to make A4-sized images (substantially larger than the usual photographic snapshot), and at normal viewing distances they are far less prone to perspective distortion.

Profile
Taking portraits in profile avoids many of the problems associated with facial distortion in full-frontal shots. Make sure you focus carefully on the (visible) eye – other parts of the face may appear unsharp yet be acceptable to the viewer.
● Leica R-4 with 60 mm f/2.8 lens. Nikon Coolscan LS-2000 scanner.

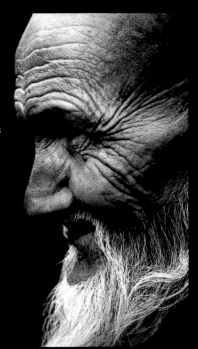

Full-frontal
To emphasize the friendly character of this man, several "rules" were broken: a wide-angle lens was used close-up; the shot was taken looking upward; and the face was placed off in one corner, thus exaggerating the distortion already present. But the total effect is amiable rather than unpleasant.
● Canon F-1n with 20 mm f/2.8 lens. Nikon Coolscan LS-2000 scanner.

Colour composition

Successful colour photography means learning to use colour as a compositional tool – as a form of visual communication in its own right – rather than just reproducing a scene or subject that happens to be in colour.

The importance of colour

Colour is far from being merely incidental, any more than is the surface texture of a subject or, indeed, the quality of the light illuminating it. Colour is an integral part of our experience of the subject, helping to determine both the mood and the atmosphere of the scene and our emotional responses to it. One way to come to terms with this is to record colours as if they were distinct entities, separate from the things displaying them.

Mental focus

Once you have made this change in mental focus, you could, for example, start evaluating scenes not in terms of vistas or panoramas, but in terms of colour content. Look at, say, the greens – are they as intense as you want? Is the light too contrasty for them to have real depth? Is your shooting position right in relation to the light in order to give the colour impact you want to record? Look at a city scene not because it is full of activity but because there, among the drabness, are flashes of red, or blue, or green. And if a neighbouring colour is distracting, change focal length or crop the final image to exclude it.

Working digitally

An advantage digital photographers have over their traditional counterparts is that it is easy, using image-manipulation software, to alter the colours of the recorded image. Not only are broad-stroke changes possible – such as whole areas of sky or foreground – you can also select very precise parts of a scene for the software to work on. And if radical changes are not appropriate, then it is just as easy to alter colour contrast, saturation, or brightness to emphasize a particular part of the image or suppress another.

Colour saturation

Red is such a strong colour that it inevitably draws attention to itself. In this image (*right*), the reds coupled with the green reflections in the water are so strong that the fish almost seem to blur before your eyes. Using the image-manipulation software's Color Picker option, however, all manner of colour adaptations become possible (*far right*).

● Nikon Coolpix 990.

Bright/pale contrast

A simple subject – floral table decorations in a restaurant (*below*) – has been transformed by an overhead camera angle and the contrast provided by the bright colours of the flowers with the far subtler tones contained in the rest of the image.

● Nikon Coolpix 990.

Colour wheel

Strictly, the colour wheel displays only hue and saturation: in the middle are the desaturated colours (those containing a lot of white); on the perimeter of the wheel are the most saturated colours. The colours are organized in the order familiar from the spectrum, with the degrees marks around the rim being used to help locate different hues.

Perception of colour

If a pale subject is seen against a complementary coloured background, its saturation seems to increase. Similarly, a neutral grey changes its appearance according to its background colour, appearing slightly bluish green against red, and magenta against green. If you compare the grey patches in the two coloured panels here (*below right*) you can see this at work. If you cut small holes in a piece of white card, so that only the four patches are visible, you can see that the blues are, in fact, identical, as are the greys.

Strong colour contrasts

Colour contrasts result when you include hues within an image that are well separated from each other on the colour wheel (*see p. 63*). While it is true that strongly coloured picture elements may have initial visual impact, they are not all that easy to organize into successful images. Often, it is better to look for a simple colour scheme as part of a clear compositional structure – too many subject elements can so easily lead to disjointed and chaotic pictures.

Digital results

Modern digital cameras are able to capture very vibrant colours that look compelling on your computer's monitor screen. Because of the way the screen projects colour, these are, in fact, brighter and more saturated than those film can produce. However, one of the advantages of using computer technology is that the colour range offered by film can be enhanced by the application of image-manipulation software, giving you the opportunity, first, to create and, then, to exploit an enormous range of vibrant colours.

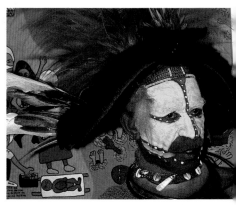

Distracting composition

Combine strong colours with an unusual and an appealing subject, and you would think that you have all the important elements for a striking photograph (*above*). In fact, there is far too much going on in this picture for it to be a successful composition. The painting in the background distracts attention from the man – himself an artist, from Papua New Guinea – while the white edge on the right disturbs the composition. A severe crop, to concentrate attention on the face alone, would be necessary to save the image.

● Nikon Coolpix 950.

Lighting for colour

The unbelievably strong colours seen in this image, recorded on an isolated Scottish shoreline, are the result of shooting in the bright yet diffused light from an overcast sky, which has had the effect of making all the colours particularly intense. The palette of contrasting dark reds and blues not only looks good on screen, it also reproduces well on paper. This is because the particular range of colours in this image happen to be those that print well. A range containing, say, bright purples or open blues would not be so successful.

● Nikon Coolpix 990.

Simple composition

Bright colours are attractive in themselves but they tend to be most effective when they are arranged in some type of pattern or sequence. This arrangement imposes a structure on them and, hence, suggests a meaning or order beyond the mere presence of the colour itself. The main problem I encountered when taking this photograph of brightly coloured fabrics was avoiding the reflections from the shop window in front of them.

● Nikon Coolpix 990.

Colour gamut

The intensity of computer-enhanced colours gives them real appeal, but it is in this strength that problems lie. Strong colours on the page of a book or Web-site will compete with any text that is included; they are also likely to conflict with any other softer image elements. In addition, you need to bear in mind that even if you can see intense, strong colours on the screen, you may not be able to reproduce them on paper. Purples, sky blue, oranges, and brilliant greens all reproduce poorly on paper, looking duller than they do on screen. This is because the colour gamut, or range of reproducible colours, of print is smaller than that of the monitor.

Of the many ways to represent a range of colours, this diagram is the most widely accepted. The rounded triangle encloses all colours that can be perceived. Areas drawn within this, the visual gamut, represent the colours that can be accurately reproduced by specific devices. The triangle encloses the colours

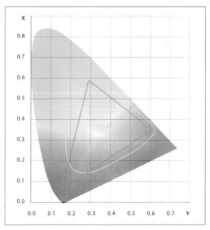

(the colour gamut) of a typical RGB colour monitor. The quadrilateral shows the colours reproduced by the four-colour printing process. Notice how some printable colours cannot be reproduced on screen, and vice versa.

Quick fix Colour balance

Correct colour rendition depends on many different factors, one of which is ensuring that the recording media and light sources match.

Problem

Pictures taken indoors have a distinct colour cast – either orange or yellow – and images appear unnaturally warm-toned. A related problem occurs in outdoor shots – there is a blue cast and images appear unnaturally cold. In other situations, pictures taken under fluorescent lamps appear greenish overall. Problems are compounded if you work in mixed lighting, such as daylight from a window and light from a table lamp. If you correct for the orange cast of the lamp, the window light looks too blue; if you correct for the window light, the lamp looks too orange.

Analysis

All imaging systems, whether film-based or digital, assume that the light falling on a scene contains the full spectrum of colours. This produces the "white" light of daylight, often called 6,500 K light – a reference to its colour temperature (see p. 114). If, however, the light is deficient in a specific band of colours, or is dominated by certain colour wavelengths, then everything illuminated by it will tend to take on the strongest colour component. We do not experience indoor light, for example, as being unduly orange because our eyes adapt to the dominant colour and our brains "filter" it out. Likewise, we seldom notice the blue colour cast that is often present in the shadows on sunny days because our eye/brain mechanisms compensate for the colour cast – and so we see the colours we expect to be there.

Solution

There are various solutions, depending on whether you are using a film-based system or digital technology.

Film-based systems

● Use the correct film type for the principal source of illumination in the scene. For indoor photography, shooting under incandescent lights, use tungsten-balanced film. This advice, and that following, applies principally to slide film, as the film image is usually the final result. With colour negatives, however, at least some colour correction can often be made at the printing stage.

1 Orange domestic tungsten
Photographs taken of rooms by domestic tungsten light often display an orange cast because the film used is intended to be exposed by daylight, which has a higher colour temperature.
● Sinar P with 90mm lens. ISO 100 film. Umax Powerlook 3000 scanner.

2 Color Balance screen shot
Tones lighter than mid-tone are strongly yellow-red. To correct for this, "Highlights" was selected in Color Balance, and blue increased using the lowest slider.

3 Corrected colour
Notice that the corrected image has retained a hint of the orange cast – removing it completely would have destroyed the mood of the shot.

- Attach a colour-balancing filter to your lens so that the light reaching the film corresponds to that film's colour balance. Use an 85B for daylight-balanced film exposed indoors under tungsten light; an 80B for tungsten-balanced film exposed in daylight. Pink or light magenta filters help to correct the colour casts produced by fluorescent lamps.

Scanned images
- Scanner software can make corrections while it is scanning. If you have many images to correct, apply the settings that give the best results to all of them.
- Or make corrections using image-manipulation software. This may be more accurate since you will then be working with the full image data.

Digital cameras
- Most digital cameras automatically correct for the white balance – they analyze the colours of the light and remove the colour cast. In some situations, however, you will obtain more accurate results if you present the camera with a neutral colour and set white balance manually.
- Images recorded by a digital camera showing an unwanted colour cast can be corrected using image-manipulation software (see pp. 113-5).

It is worth bearing in mind that you may not always want to correct a colour imbalance, or at least not fully correct it. In some situations, the colour cast may be helping to set the atmosphere of a scene or be providing the viewer with additional information about the subject.

How to avoid the problem

- **Don't choose to photograph in mixed lighting conditions unless you specifically want the image to display unpredictable colours.**

- **Don't take colour-critical shots under fluorescent lamps – it is very difficult to correct precisely the resulting cast.**

- **Don't rely on colour-balancing filters as they make only approximate corrections. But partial correction does make later refinements – when printing or using image-manipulation software – far easier.**

1 Blue dawn light
Taken at dawn, this shot displays a distinct blue bias, suppressing the warm colours I perceived at the time. With film, the blue cast would have been more pronounced – but, as you can see, even the digital camera's white balance did not fully compensate for the distortion.
- Nikon Coolpix 990.

2 Levels screen shot
The quickest way to correct the image was to use Levels. The Highlight Dropper (far right tool) was applied to the area to be rendered a neutral white (the white walls of the foreground building). The Shadow Dropper was then selected and a deep shadow chosen.

3 Corrected colour
The finished result shows greatly improved colour overall, but note that the blue hills in the far distance have now been lost.

Silhouettes/backlighting

Although images may look different, silhouetted and backlit shots are variations on the same theme. In terms of exposure, they differ only in how much light is given to the main subject.

Silhouetted subjects

To create a silhouette, expose for the background alone – whether the sky or, say, a brightly lit wall – so that foreground objects are recorded as very dark, or even black. Make sure the exposure takes no account of the foreground. For this technique to be most effective, minimal light should fall on the subject, otherwise surface details start to

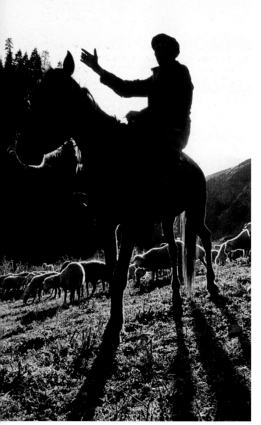

record and shape becomes less prominent. The main point is to exploit outline and shape, and to help this a plain background is usually best.

When taking pictures into the light, you need to be aware of bright light flaring into the lens. Try to position yourself so that the subject itself obscures the light source, though it can be effective to allow the sun to peep around the subject to cause a little flare. Using a small aperture helps reduce unwanted reflections inside the lens.

Backlit subjects

The classic backlit subject is a portrait taken with a window or the sky filling the background, or figures on a bright, sandy beach or on a ski slope.

The challenge in terms of exposure in these types of situation is to prevent the meter from being over-influenced by the high levels of background illumination. If you don't, you will end up with a silhouette. To prevent this, either override the automatics or manually set the controls to "overexpose" by some 1½–2 f/stops.

Another approach is to set your camera to take a selective meter reading. Alternatively, with a centre-weighted averaging meter reading, fill the viewfinder with the shadowy side of your subject, note the reading, or lock it in, move back, and recompose the image.

Backlit scenes are prone to veiling flare – non-image-forming light – which is aggravated by the need to increase exposure for the subject. In strong backlighting, however, it is hard to prevent light spilling around the subject edges, blurring sharpness and reducing contrast.

Conflicting needs

In this strongly backlit portrait of a Kyrgyz shepherd (which has been cropped from a wide-angle shot), I positioned myself so that the subject shielded the lens from the direct rays of a bright sun. It is very difficult to achieve the right balance of exposure – if the horse is fully exposed, the sheep will be too light. This is clearly the type of situation that would benefit from a little fill-in flash (*pp. 70-3*). However, there was just enough light to pick out the colour of the horse when the sheep were correctly exposed.

● Canon EOS-1n with 20 mm lens. ISO 100 film. Nikon LS-4000 scanner.

Dealing with flare

As the sun sets on a market in Tashkent, Uzbekistan, the dust raised by street cleaners fills the air, catching and spreading the still bright sunlight. The lower the sun is in the sky, the more likely is it to become a feature in your composition. In the example here, the flare has been caused as much by the atmospheric dust as by any internal reflections within the lens itself. A normal averaging light reading taken in these conditions would be massively over-influenced by the general brightness of the scene, and so render the backlit subject as featureless silhouettes. Therefore, what may seem like a gross overexposure – an additional 2 f/stops – is needed to deal with this type of lighting situation.

● Canon EOS-1n with 80–200 mm lens. ISO 100 film. Nikon LS-4000 scanner.

Sky exposure

Strong light from the front and a symmetrical foreground shape immediately suggest the potential for a silhouette. A passing windsurfer, in the Penang Straits of Malaysia, completes the picture. Simply by exposing for the sky, all the other elements fall into their correct place – the black, shadowy palm, the sparkling water, and the surfer are transformed. Using a catadioptric (mirror) lens produces the characteristic "hollow" look of the out-of-focus palm.

● Canon F-1n with 350 mm lens. ISO 64 film. Nikon LS-2000 scanner.

Virtue of necessity

When shooting into a fierce, tropical sun, you may have no choice other than to produce a silhouette. If so, the strategy then becomes a search for the right type of subject. Here, on Zanzibar, dhows and beachcombers are complementary in terms of tone, yet contrasting in shape. Notice how the central figure seems diminished in size as his outline is blurred by the light flaring all around his body.

● Canon EOS-1n with 100–400 mm lens. ISO 100 film. Nikon LS-2000 scanner.

Accessory flash

Digital cameras, almost without exception, are equipped with built-in electronic flash. What makes modern flash so universal is that it is both highly miniaturized and "intelligent". Most units, for example, deliver extremely accurate computer-controlled dosages of light to suit the amount of available, or ambient, light in the scene.

Making flash work for you

Whatever you might gain in terms of convenience by having a ready source of extra light built into the camera, you lose in terms of lighting subtlety. To make flash work for you, you need to exploit what limited control facilities your camera offers.

First, use the "slow-synch" mode if your camera offers it. This allows the ambient exposure to be relatively long, so that areas beyond the range of the flash can be recorded as well as possible, while the flash illuminates the foreground (*see below*). This not only softens the effect of the flash, it can

also give mixed colour temperatures – the cool colour of the flash and the often warmer colour of the ambient light – which can be eyecatching.

Second, try using a reflector on the shadow side of the subject. If angled correctly, it will pick up some light from the flash and bounce it into the shadows. Any light-coloured material can be used as a reflector – a white sheet of paper or card, a white sheet, or a shirt. Professional photographers like to use a round, flexible reflector that can be twisted to a third of its full size. It is very compact, lightweight, and efficient, and it usually has two different surfaces – a gold side for warm-coloured light and a matte side for softly diffused effects.

Third, an advanced option is to use slave flash. These are separate flash units equipped with sensors that trigger the flash when the master flash (built into or cabled directly to the camera) is detected. If you have a flash unit, then adding a slave unit is not expensive. However, you need to experiment with your camera to check if the synchronization of the multiple flash units is correct.

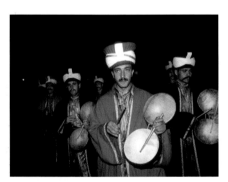

Flash limitations
Dusk in Istanbul, Turkey, and traditional musicians gather. The standard flash exposure used for this image lights only the foreground subjects and the rapid light fall-off, characteristic of small light sources, fails to reach even a short distance behind the first musician. Adding to the problems, camera exposure is

not long enough for the low ambient, or available, light levels prevailing at the time. As a consequence, the background has been rendered black. This type of result is seldom attractive, nor does it display any sound photographic technique.
 ● Canon EOS-1n with 28–70 mm lens. ISO 100 film. Microtek 4000t scanner.

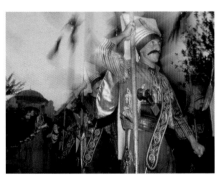

Effective technique
When illumination is low, make the most of what light is available rather than relying on electronic flash. Here, exposure was set for the sky: this required a shutter of ¼ sec, giving rise to the blurred parts of the image. At the same time, the flash was brief enough to "freeze" the soldier in the foreground, so he

appears sharp. Utilizing all ambient light ensures that the distant part of the scene is not wholly underexposed – some colour can even be seen in the background building. Compare this with the image in which flash provided all the illumination (*above left*).

Using any set-up with more than one flash means trying out different levels of flash output to discover the best results. Start by setting the slave to its lowest power output, bearing in mind that the task of this unit is to relieve subject shadows, not act as the main light. Some models of camera are designed for multiple-flash photography.

Flash synchronization

Because the pulse of light from electronic flash is extremely brief, even when compared with the shortest shutter time, it is crucial that the shutter is fully open when the flash fires. Only then will the entire film area be exposed to the flash light reflected back from the subject. There is usually a limit to the shortest shutter time that synchronizes with the flash, often known as "x-synch". For most SLRs, this is between ¹⁄₆₀ and ¹⁄₂₅₀ sec. In some of the latest cameras, x-synch corresponds to the shortest available shutter time, which may be ¹⁄₈₀₀₀ sec. To obtain this, however, you must use flash units dedicated to that particular camera model.

Flash exposure

All flash exposures consist of two separate processes occurring simultaneously. While the shutter is open, or the light sensor is receptive, light from the overall scene – the ambient light – produces one exposure. This ambient exposure takes on the colour of the prevailing light, it exposes the background if sufficient, and it is longer than that of the flash itself.

The second exposure is in addition to the ambient one. The burst of light from a flash is extremely brief, possibly less than ¹⁄₁₀,₀₀₀ sec (though studio flash may be as long as ¹⁄₂₀₀ sec) and its colour is determined by the characteristics of the flash tube (which can be filtered for special effects).

The fact that there are two exposures means that it is necessary to balance them in order to produce good results. But it also allows you to make creative use of the process by, for example, allowing the flash exposure to freeze subject movement, while the longer ambient exposure produces blurred results.

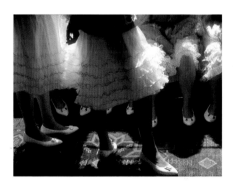

Without flash
Bright, contrasty sunshine streaming in through large windows behind the subjects – a troupe of young singers dressed in traditional costume from Kyrgyzstan – produced a strongly backlit effect. Without the use of flash, the shadows would appear very dark, but in this case a wall behind the camera position reflected back some light from the windows to relieve the contrast a little, and so retain some subject details.

● Canon EOS-1n with 28–70 mm lens. ISO 100 film. Microtek 4000t scanner.

With flash
In this interpretation of the previous scene (*above left*), flash has been used. This produced enough light to fill most of the shadows. Now we can clearly see the girls' costumes, but note the shadows that still remain on the carpet. It is important to set the camera to expose the background correctly: since in this example it was very bright, a shutter time of ¹⁄₂₅₀ sec was needed. The f/number dictated by the exposure meter was set on the lens, and the flash was set to underexpose by 1⅓ stops. This ensured that the foreground was exposed by both the flash and by the available window light.

Quick fix Electronic flash

Modern electronic flash units are versatile and convenient light sources, ideal for use when light levels are low (and the subject is relatively near-by), or when image contrast is high and you want to add a little fill-in illumination to the shadow areas. However, due to the intensity of their output as well as their limited range and covering power, obtaining naturalistic lighting effects and correct exposure can be problematic.

Problem

Common types of problem that are encountered when using electronic flash include overexposed results – particularly of the foreground parts of the image – and underexposed results – particularly of the image background. In addition, general underexposure of long-distance subject matter is very common, as is uneven lighting, in which the corners or foreground are less bright than the centre of the image.

Analysis

Modern electronic flash units have their own light-sensitive sensor to measure automatically the light output from the flash or the amount of light reflecting back from the subject and reaching the film or camera sensor. As a result, they are as prone to error as any camera exposure meter. Furthermore, the light produced by a flash unit falls off very rapidly with distance (*see above right and p. 70*).

Overexposed flash-illuminated pictures are usually caused by positioning the flash too close to the subject or when the subject is the only element in an otherwise largely empty space.

Flash underexposure is caused by the unit having insufficient power to cover adequately the flash-to-subject distance. For example, no small flash unit can light an object that is more than about 10 m (33 ft) away, and even quite powerful flash units cannot adequately light an object that is more than about 30 m (100 ft) distant.

Uneven lighting is caused when the flash is unable to cover the angle of view of the lens – a problem most often experienced with wide-angles. And another problem occurs when an attached lens or lens accessory blocks the light from a camera-mounted flash.

Light fall-off
Light from a flash unit mounted on the camera falls off, or loses its effectiveness, very rapidly as distance increases. This is evident in this close-up image of a bride holding a posy of flowers. The subject's hands and the roses nearest the flash are brightly illuminated but even just a little bit back, the image is visibly darker. This is evident if you look at the back edge of the wedding dress, for example. The effects of this light fall-off can be greatly minimized by using a light source that covers a larger area – hence the very different lighting effect you get when using bounced flash (*opposite*).
● Nikon Coolpix 990.

Solution

For close-up work, reduce the power of the flash if possible. When photographing distant subjects in the dark – landscapes, for example, or at concerts, using flash is usually a waste of time and is best turned off. A better option is to use a long exposure and support the camera on a tripod or rest it on something stable, such as a wall or fence. With accessory flash units – not built-in types – you can place a diffuser over the flash window to help spread the light and so prevent darkened corners when using a wide-angle lens.

Bounced flash

Direct flash used at this close distance would produce a harshly lit subject and a shadowy background. In this shot, the flash was aimed at the wall opposite the child. In effect, the light source then becomes the wall, which reflects back a wide spread of light. Not only does this soften the quality of the light, it also reduces the rapid light fall-off characteristic of a small-sized source of light. But bounced flash is possible only if you use an auxiliary flash unit. Note, however, that the background is rather darker than ideal – to overcome this, there must be sufficient ambient light to mix with the flash illumination to provide correct exposure overall (*above right*).

● Olympus OM-1 with 50 mm f/1.4 lens. ISO 64 film. Microtek 4000t scanner.

Mixed lighting

The result of balancing flash with an exposure sufficient to register the ambient light indoors delivers results like this. The lighting is soft but the colour balance is warmed by the ambient light. As well, the background is bright enough for it to appear quite natural. If a greater exposure had been given to the background, there would have been an increased risk of subject movement spoiling the image.

● Olympus OM-1 with 50 mm lens. ISO 100 film. Microtek 4000t scanner.

How to avoid the problem

The best way to obtain reliable results with flash is to experiment in different picture-taking situations. With a digital camera you can make exposures at different settings in a variety of situations to learn the effects of flash without wasting any film. Some flash units feature a modelling light, which flashes briefly to show you the effect of the light – this is a useful preview, but it can consume a good deal of power and is likely to disturb your subject.

Uneven light

On-camera flash typically delivers these unsatisfactory results. The lighting is uneven, the shapes the flash has illuminated look flat, and there are hard, harsh reflections on all shiny surfaces. In addition, the flash has created unpleasant shadows (note the shadow of the lip-brush on the background woodwork). Always be aware of any flat surfaces positioned behind your subject when using flash from the camera position.

● Pentax MX-5 with 35–70 mm lens. ISO 100 film. Nikon Coolscan LS-1000 scanner.

3

Radical conversions

Assessing resources

Photographs or prints are an invaluable resource for the digital photographer. Here you will see how to resurrect faded memories and incorporate them into current projects.

Secrets of scanning

This chapter tells you how to use a scanner and achieve top-class results with minimal effort. It provides you with all you need to know about the intricacies of image resolution and different file formats.

Managing files and colour

Here, the basics of colour management and how to go about dealing with numerous image files are explained.

Help on hand

Quick-fix sections help you with any scanning problems you are likely to encounter, unravel your questions concerning resolution, and advise on what to do when scans are less than satisfactory.

Scanning: The basics

Scanning is the bridge taking film-based negatives and transparencies or printed images into the digital world. The process converts all colour, brightness, and contrast information into digital data for your software to use. The quality of the scanner and the skill with which it is used are the key factors that determine the quality of the digital information and, hence, the quality of the image you have to work with (*see pp. 80–1*).

Scanning steps

You can think of scanning as a three-stage process:
- Gather together originals for the job in hand. You may have to make prints of family portraits, say, or collect images for your club's Web site.
- Next is the actual scanning. To do this, the scanner makes a prescan to allow you to check that the original is correctly oriented, or to set the scanner so that it scans only as much of the original as you want, or to set the final image size and resolution. You then make the real scan and save the result onto the computer's hard-disk.
- The final stage is basic "housekeeping" – put your originals somewhere safe, somewhere you

can readily find them again, and, if the work is critical, create a back-up copy of the scans.

Basic procedures

To get the most from scanning, it is a good idea to follow some commonsense procedures designed to help streamline your working methods.
- Plan ahead – collect all your originals together before starting.
- If you have a lot of scans to make from a variety of different types of original, sort them out first. If, for example, you scan all black and white originals and then all colour transparencies you will save a huge amount of time by not having to alter the scanner settings continually.
- Scan landscape-oriented images separately from portrait-oriented ones. This saves you having to rotate the scans. And you will minimize visits to dialogue boxes if you classify originals by the final file size or resolution you want.
- If you are using a flat-bed scanner, clean your scanner's glass plate, or platen, before starting.
- Make sure originals are clean. Blow dust off with compressed air or a rubber puffer. Wipe prints carefully to remove fingerprints, dust, and fibres.

Setting up a scanner

Many scanners give excellent results with practically no adjustment at all. However, it pays to calibrate your scanner carefully right from the outset.

1 Obtain a standard target, such as that illustrated opposite. The IT 8.7/1 is intended for use with colour transparency film, and the IT 8.7/2 is for colour prints. These targets may be supplied with your scanner; if not, a camera store may be able to order them. Alternatively, choose an original for scanning that is correctly exposed and contains a good range of colours and subject detail.

2 Make an initial scan using the machine's default settings – those set at the factory.

3 Check the image produced by the scan with the original. If necessary, make changes using the scanner

driver's controls so that the scan matches the original. Some scanners require you to make these changes in the preview window. However, you need to be aware that on some scanners the preview image is not really an accurate representation of the final scan. You need to experiment with your particular equipment. For the best results, you also need to calibrate your monitor (*see pp. 88-91*).

4 Once you have a scan you are happy with, save or note down the settings. Call it by the name of the film used – such as "Kodak Elite 100" or "Fuji Provia".

5 Repeat these steps with all the various types of film you scan – colour negatives and transparencies use different scanner settings.

6 Then, for all subsequent scans, load the relevant saved settings as your starting point.

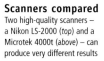

Scanners compared

Two high-quality scanners – a Nikon LS-2000 (*top*) and a Microtek 4000t (*above*) – can produce very different results from an identical standard target image. This demonstrates just how important it is to set up your scanner controls carefully.

- Align originals on the scanner as carefully as you can: realigning afterwards may blur fine detail.
- Scan images to the lowest resolution you need. This gives you the smallest practicable file size, which, in turn, makes image manipulation faster, takes up less space on the hard-disk or other storage media, and gives quicker screen handling.
- Use file names that are readily understood. A file name you choose today may seem obscure in a few months' time.
- When scanning, crop as much extraneous image detail as is sensible in order to keep file sizes small, but allow yourself room to manoeuvre in case you decide to crop further at some later stage.
- You may need to make your output image very slightly larger (say, an extra 5 per cent all around) than the final size. This may be essential if, for example, you want your image to "bleed", or extend to the very edge of the paper so that no white border is visible.

Preview window

All scanners show a representation of the image in a preview window (*above*) prior to the final scan (*top*). This gives you a chance to make improvements before committing to a final scan. While it will save you time and effort later if you make the preview image as good as you can, bear in mind that it is only a general indication of the final scan. With some scanners, the preview may actually be rather inaccurate: if yours is one of these, you may need to experiment in order to learn how to compensate for its quirks.

Using flat-bed scanners

Flat-bed scanners are intended primarily for two-dimensional artwork and printed material, but you can also use them with small, solid objects. For scanning small-format film, such as 35 mm, it is best to use a dedicated film scanner: only the larger, costlier flat-bed scanners are suitable for these miniature formats. You can satisfactorily scan medium-format and larger films on flat-bed scanners, which makes them very versatile pieces of equipment.

Getting the best from your scanner

One way of thinking of what a scanner does is to regard it as a type of camera. Just as taking care when capturing an image via a camera increases your chances of a high-quality image, so careful scanning ensures that you have a good-quality digital image to manipulate – and it also cuts out unnecessary correction time on the computer.

● Keep the scanner's glass bed spotless. If you have a transparency adaptor, make sure that is also clean. Lint-free, microfibre cloths are available from camera stores or opticians to clean the glass without the risk of scratching it.

● Check that the colours you have seen on the prescan match those of the final scan.

● Be systematic about your filing and the names you give your images.

● Allow the scanner to warm up for at least five minutes before making your best-quality scans.

● If you are scanning, say, a large book, don't damage the hinge of the scanner lid by forcing it down. Use a heavy weight, such as another book, to hold down and flatten the original against the scanner's glass.

● Save your scanned images to the file format that is easiest for your software to access and use. It is a waste of your time having to change file formats more than is absolutely necessary.

● Line up any rectangular originals as carefully as you can on the scanner glass. Rotating the image after scanning in order to square it up (to correct a sloping horizon, for example) can significantly degrade image quality – especially of line art, such as black and white artwork.

Scanning photographic prints

There may be occasions when you get better results by, first, making a print in the darkroom from a negative and then scanning the print, rather than scanning the negative directly and working on that in the computer. Certain manipulations, such as the local contrast controls known as burning-in and dodging (*see pp. 102–3*), are often far easier to achieve in the darkroom than by manipulating a scanned image.

However, if the print intended for scanning has a glossy surface, take care to clean it carefully – every speck of dust, fibre, or loose hair will show up sharply on the resulting scan.

Scanning printed material

There is a wealth of printed material in general circulation, in books, magazines, posters, album covers, and so on, that appears ideal for scanning. But the likelihood is that most of it will be protected by copyright restrictions, and you are likely to be in breach of these restrictions if you scan such material without the copyright holder's written consent (*see pp. 194–5*).

However, in general, if you scan for the sole purpose of study or research, or you intend to make no commercial use of the material, then your actions will probably be exempted.

Scanning stamps and coins

Flat-bed scanners are ideal pieces of equipment for making records of valuable items, such as stamp collections (*see opposite*) and coins. The main advantage that a scanner has over a conventional camera is that the scanner is capable of making very accurate records of objects with very little distortion. In addition, a scanner will record the real size of items extremely precisely, and this could be a crucially important consideration for some collectors.

Another factor you might want to consider is that the relatively low light-levels needed for scanning are less likely to harm the delicate colouring of, say, stamps than photographic tungsten lamps, which burn very bright and hot.

Hobbyists

Scanners are perfect for many hobbies, including stamp and coin collecting and autograph hunting, as well as for studies such as graphology. Scanners not only make precise 1:1 (life-size) copies, they also make excellent enlargements of, for example, the slight imperfections that can be so important to aficionados of some hobbies. The magnified view of these stamps (*left*) shows the enlarged "L" that distinguishes this batch.

● Heidelberg Saphir II scanner.

Starting from a print

Sunlight reflecting off these nurses' white uniforms created a contrasty negative. Working digitally, by scanning the original negative, would have meant losing the attractive graininess of the image. In this example, the negative was first printed conventionally, and the resulting print scanned. The digital equivalent was then worked on – principally by slightly warming up the image tones.

● Leica M6 with 35 mm lens. ISO 400 film, printed on Ilford Multigrade. Heidelberg Saphir II scanner.

Optical character recognition

If you scan text documents, such as letters or pages from a book, to create image files, you can edit them only as images. However, by using optical character recognition (OCR) software, which is often bundled with scanners, you can scan text documents to create word-processor files. This gives you the option of editing the text directly. For documents that are clearly printed, such as those from a laser printer, inexpensive OCR software is adequate. You will need a small piece of software to bridge the OCR with your scanner, which is usually available free from the scanner manufacturer's Web site. Once it is installed, operation is normally very simple, and you may be able to fax, print out, or save documents directly from the OCR application.

Quick fix Scan resolution

Often, one of the most important decisions you normally have to make when it comes to scanning an image is determining the most appropriate resolution to set.

Problem

When scanning, you may be tempted to set a low resolution in an attempt to keep file sizes as small as possible – especially if your computer has inadequate RAM or hard-disk space is tight. If, however, you set too low a resolution figure, then the resulting image will look unsharp, image detail will be missing, or the image will appear pixelated.

Setting a higher resolution holds out the promise of higher-quality digital output, but if file sizes become too large, then there is a price to pay – images will take longer to scan, the resulting files will need more storage space, they will take longer to load or transmit, and they will need more memory to manipulate on screen. And files can grow very large, very quickly, when you start to work with multiple layers. Yet higher resolutions do not even guarantee better-quality results.

Analysis

Two approaches are possible. First, you could scan every image at the highest resolution you are ever likely to need, producing files of, say, 25–30 MB in size. You can then make copies, adapting image resolution to each task while copying. This saves you having to scan an image each time you want to use it for a different job. This way of working uses a lot of data capacity, but it is a good solution for, say, a busy studio.

Alternatively, you scan specifically for the task in hand, and if a new use of the image calls for a higher or lower resolution, then you need to make a new scan. This is the most economical method of working if throughput is not particularly great.

Solution

Check image size The simplest method is to work by the size of the image file: use the table here (see *opposite*) as a guide for colour images. For black and white images, use files a third of the size – instead of 1.9 MB for a 7.5 x 12.5 cm (3 x 5 in) print, use 0.6 MB. When you make the prescan and crop to the part of the scan that you want (see pp. 76-7), tell the scanner driver the size of the print-out required. The driver will then tell you the size of file you will obtain after scanning. If it is not right, simply change the resolution settings until you obtain the approximate file size suggested by the table.

Bear in mind that when you calculate the file size of an image, the size of the original is irrelevant. Whether you reduce a poster to fill a monitor screen or enlarge a postage stamp to fill the same area, the correct file size is exactly the same.

Calculate resolution The more rigorous approach is based on the fact that the number of pixels needed to be input from the scanner equals the total number of pixels needed for output. The calculation is as follows:

input resolution = (size of output x output resolution)/size of original

Ensure that the size of output and size of original are in the same units – both inches or centimetres – then the input and output resolutions will be the same. Another formula giving the same result is the following:

input resolution = percentage increase in size x output resolution

You may take the size of the output and the size of the original as one dimension – say, length. Suppose your original is 2 in long and the print you want is 10 in. If you need an output resolution of 300 lpi (lines per inch), then you need 300 x 10 pixels – a total of 3,000 pixels – for output. The input resolution must, therefore, be 3,000 divided by 2 in (the size of the original), which gives the required scanner resolution of 1,500 ppi (points per inch).

The key is to determine the correct output resolution.
- For ink-jets, use anything between 80 and 200 lpi, depending on paper quality.
- For screen-based work, use 72 dpi or 96 dpi.
- For reproduction in print, first determine the screen frequency – it is commonly 166 lpi for good-quality magazines and books but it can vary from 96 to 300 lpi. Then multiply the screen frequency by a "quality factor" of 1.5. For example, if the screen frequency used is 150 lpi, the output resolution required is 1.5 x 150 = 225 ppi.

Here are some examples to illustrate these principles. Note that although the final settings are in lines, pixels, or dots per inch, you can work the early parts of the

Screen shot – film scanner

A dialogue box for a film scanner may ask for output sizes: the proportions of length to width is often set by cropping the image or it may be typed in. The resolution setting can also be entered by hand or by setting the scale and letting the software calculate resolution. A useful check is file size: high resolution (2,500 ppi) and a 7 MB file size suggest the image is black and white.

Screen shot – flat-bed scanner

Complicated-looking dialogue boxes, such as the one here for a flat-bed scanner, are usually not that difficult to use. Here, you must set an output ruling (166 lpi in this example) and the scaling is set to "Factor", which is indicated at 100 per cent. From the dimensions of the frame for the cropping, the scanner calculates the rest, including the resolution – given here as 400 dpi. The expected file size is shown at the top of the box.

calculations using metric measurements if you wish:

1 Your original image is 35 mm long, and you want to make a print that is 250 mm long, and the assumption is that you using an ink-jet printer with an output resolution of 120 lpi.

Input resolution = (120 x 250)/35

= 30,000/35

= 857 pixels per inch

Since the original is 35 mm (1.4 in) long, there will be a total of 857 x 1.4 = 1,200 pixels on its long side.

2 Your original is 35 mm long and you want a scan of sufficient quality to be suitable for magazine reproduction up to 250 mm long. Working on the assumption that the magazine prints to a 150 lpi line screen, and with a quality factor of 1.5, the output resolution needed, therefore, is

150 x 1.5 = 225 lpi.

Input resolution = (225 x 250)/35

= 56,250/35

= 1,607 pixels per inch or, say, 1,600 ppi

Since the original is 35 mm (1.4 in) long, there will be a total of 1,600 x 1.4 = 2,240 pixels on the long side of the image.

Determining file size

Look up the file size for the output you desire, then ensure the scanned file is about the same size by adjusting the dpi or resolution in the scanner driver.

Ink-jet print	7.5 x 12.5 cm (3 x 5 in)	1.9 MB
	10 x 15 cm (4 x 6 in)	2.7 MB
	20 x 25.5 cm (8 x 10 in)	5 MB
	A4	6.9 MB
	A3	12.6 MB
Image for	480 x 320 pixels	0.45 MB
Web page	600 x 400 pixels	0.7 MB
	768 x 512 pixels	1.12 MB
	960 x 640 pixels	1.75 MB
Book/	A4	18.6 MB
magazine	20 x 25.5 cm (8 x 10 in)	13.6 MB
printing	A5	9.3 MB
	12.5 x 17.5 cm (5 x 7 in)	6.7 MB

How to avoid the problem

Experiment with using the lowest resolutions you can manage that do not compromise the quality of the image. The exercise is most valuable when you are using an ink-jet printer. Working with the smallest possible files will help to save you both time

and money. Your work is likely to fall into a pattern after a while: keep a note of the settings that produce satisfactory results and reapply them to your new work. If you are outputting using commercial printers, ask them for their recommendations.

File formats: A summary

Most types of data file are produced by application software to be used specifically by that software, and so there is only limited potential for interchange with other programs. However, image files are different, as they can be accessed and used by a range of programs. This is achieved by building them in widely recognized data-structures, or formats. The following are commonly supported.

TIFF

(Tag Image File Format) A method of storing image data, the best choice for images used in print reproduction, and a de facto standard. A bit-mapped or raster image file format supporting 24-bit colour per pixel, with such data as dimensions and colour look-up tables stored as a "tag" and added to the header of the data file. A variety of tag specifications give rise to many types of TIFF, leading to compatibility problems. The format can be compressed without loss (or losslessly) using LZW compression. This reduces file size by about half on average, but slightly slows down file opening. It is always safe to compress TIFF files, although some bureaus may specify un-compressed files. The Windows suffix is .tif.

JPEG

(Joint Photographic Expert Group and pronounced "jay-peg") A format based on a data-compression technique that can reduce file sizes to as little as 10 per cent of the original with only a slight loss of quality. This is the best choice for photographs intended for use on the Internet. When files are saved as JPEGs you will be offered different levels of quality. For general use, a middle setting (5 or 6) is sufficient, as it gives very good reductions in file size without noticeable loss in image quality. A high setting of 9 or 10 is the level you should choose for high-quality work – the file size is still smaller than that possible with LZW compression and loss of quality is all but invisible. The Windows suffix is .jpg.

Photoshop

This is an application-native format that has become so widespread that it is now almost a standard. Photoshop supports colour management, 48-bit colour, and Photoshop layers. Many scanners will save directly to the Photoshop format, and the format used on other types of scanner may, in fact, be Photoshop, albeit under a different name. The Windows suffix is .psd.

GIF

(Graphic Interchange Format) A compressed file format designed for use over the Internet, comprising a standard set of 216 colours. It is best for images with graphics – those with larger areas of even colour – but not for photographic images with smooth tone transitions. It can be compressed losslessly using LZW algorithms. The Windows suffix is .gif.

PDF

(Portable Document Format) A file format native to Adobe Acrobat based on PostScript. It preserves the document text, typography, graphics, images,

"Save as" screen shot
Whenever you save a digital picture file you need to make a decision about which format to save it in. The safest choice is TIFF, which is very commonly recognized, but specific picture needs, perhaps for publication on a Web site for example, may demand that you use another type of format. You can use this dialogue box to change from one format to another. To preserve the original, save your new file under another name when choosing a different format.

and layout. There is no need to embed fonts. It can be read, but not edited, by Acrobat Reader. The Windows suffix is .pdf.

PhotoCD

Kodak's Photo Compact Disc is a format with a pyramidal structure that is used for transferring files from scanners onto CDs. The format supports compressed versions of each image stored at different resolutions – from 128 x 192 pixels to 2,048 x 6,144 pixels. The Pro version accepts resolutions up to 4,096 x 6,144 pixels. To open PhotoCD files you need the appropriate plug-in or filter in your software (this is best saved for further use as a TIFF or JPEG). The Windows suffix is .pcd. Don't confuse PhotoCD with PictureCD, which is more a service than a format.

PICT

(Macintosh Picture) This is a graphics format for Mac OS. It contains raster and vector information but is nominally limited to 72 dpi, being designed for screen images. PICT2 supports colour to 24-bit depth, and it can be opened by very simple programs, such as SimpleText.

PNG

(Portable Network Graphics) A file format for losslessly compressed Web images. It supports indexed-colour, greyscale, and true-colour images (up to 48 bits per pixel), plus one alpha channel, with sample bit depth of up to 16 bits. It is intended as a replacement for GIF and may well also replace TIFF on the Web. However, it does not support CMYK colour space.

JPEGs in detail

JPEG compression is efficient due to the fact that several distinct techniques are all brought to bear on the image file at the same time. Although it sounds complicated, thankfully modern computers and digital cameras have no problem handling the calculations. The technique, known as "jay-pegging", consists of three steps:

1 The Discrete Cosine Transform (DCT) orders data in blocks measuring 8 x 8 pixels, which creates the characteristic "blocky" structure you can see in close-up (*see right*). Blocks are converted from the "spatial domain" to the "frequency domain", which is analogous to presenting a graph of, say, a continuous curve as histograms that plot the frequency of occurrence of each value. This step compresses data, loses no detail, and identifies data that may be removed.

2 Matrix multiplication reorders the data for "quantization". It is here that you choose the quality setting of an image, balancing, on the one hand, your desire for small-sized files against, on the other, the loss of image quality.

3 In the final stage of jay-pegging, the results of the last manipulation are finally coded, using yet more lossless compression techniques.

JPEG artefacts

This close-up view of a JPEG-compressed image shows the blocks of 64 pixels that are created by the compression feature. This can create false textures and obscure detail, but on areas of even tone, or where image detail is small and patterned, such artefacts are not normally visible – even with very high levels of compression. Note how the pixels within a block are more similar to each other than to those of an adjacent block.

The effect of these compressions is that JPEG files can be reduced by 70 per cent (or, reduced to just 30 per cent of their original size) with nearly invisible image degradation; you still have a usable image even with a reduction of 90 per cent. However, this is not enough for some applications, and so a new technology, known as JPEG2000, based on another way of coding data, offers greater file compression with even less loss of detail.

Quick fix Problems with scans

Scanning turns your film-based work into digital form, which you can work with in your computer. The quality of the digitization is crucial to the quality of everything you subsequently do with your images, so you can see that it is important to take considerable care at this stage of the process. You do not want to work at an image for days only to discover it was scanned at too low a resolution or that it has defects that are too deep to remove without undoing all your work.

Problem: File size is too small

The commonest error is working on a file size that is too small for the intended task (*see pp. 80-1 for details on how to calculate the optimum file size*). Always check your image's file size before you do any work on it: you want it to be neither too large (as it will slow your work down unnecessarily), nor too small (as output quality will then be too low).

Solution

If you discover that the file size you are working on is too small for what you want to do with it, then you have no option other than rescanning and starting again. The quicker you come to this decision the less of your work you will have to redo.

Image size screen shot

The settings on this dialogue box are something you should never see in reality. They show that a small image of 3.2 MB in size is about to be enlarged to a normal page-size print. For the resolution required, however, the resulting file size will grow to more than 16 MB (shown in the top line) — five times larger than the original. With this level of interpolated enlargement, the result will show broken-up detail. It will be best to rescan the image to the required 16 MB.

Problem: Newton's rings

When you place a film strip directly on the glass surface of your flat-bed scanner, although you may not realize it you are also trapping a thin layer of air beneath the film. This layer of air acts like an oil film — of the type you often see on a road surface — that causes the light to split into rainbow-coloured patterns, known as "Newton's rings". These coloured distortions are extremely troublesome to remove from the image and it is best to avoid them occurring in the first place.

Solution

Avoid placing film strips directly on the scanner's glass surface. Most scanner manufacturers provide special holders for film strips or individual frames. If this is not the case with your machine, then make certain that the scanner is well warmed up before starting — hot, dry air seems to reduce the incidence of Newton's rings.

Newton's rings

This film (only a portion of which is seen here) was scanned on a flat-bed scanner because, having been produced by a panoramic camera, it was too long to fit into a normal film scanner. When held down by the scanner's lid, the trapped air created these tree-ring-like patterns (which have been slightly exaggerated for reproduction purposes). They are extremely difficult to remove as they cover a large area and are also coloured.

Problem: Jitter and other artefacts

Before starting work on an image, examine it closely for signs of any features that are not part of the original. Even the most expensive scanners can introduce artefacts, or imperfections, such as tiny black dots in light areas. These may be so small that they are invisible at normal size; some other errors, however, such as jitter, or the uneven movement of the scanner head, cause defects that are obvious at normal print sizes (*see right*) – although they may be invisible at screen resolution. Defects may result from movement of the original during scanning – for example, if your book slips slightly, then the image will appear slightly stretched or smeared.

Solution

Rescanning on the same or on a better-quality scanner will solve the problem, unless the defect is due to the movement of the original.

Scanner jitter
A scan from an inexpensive scanner produced these streaks, which are due to the uneven movement of the scan head. The streaks have been exaggerated for reproduction purposes, but would be visible anyway when printed. Small areas could be improved by cloning, but essentially a better scanner is required.

Problem: Moiré from printed material

This problem arises when there is a clash between the regular pattern of the dots on the printed page of a book or magazine, say, and the regular raster pattern of the scanner. This conflict can cause a new pattern – known as a moiré pattern – to be superimposed over the image, usually with unsightly results.

Solution

There are several methods of dealing with moiré. You can rescan the original using a slightly different resolution setting, or you could try aligning the page slightly differently on the scanner's platen – just a small change of angle may be enough to do the trick. Some scanner software offers filters designed to remove, more or less successfully, such moiré patterns, but this is often at the cost of critically sharp image detail. Bear in mind that using sharpening filters (*see pp. 104-7*) may bring out a moiré pattern.

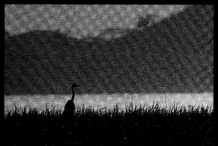

Moiré patterns
Just a small area of a photograph of a heron printed in a book was scanned for this example. You can readily see that the resulting image has picked up the array of half-tone dots that make up the printed original. The pattern of these dots has clashed with the regular array of pixels, resulting in the creation of another pattern. Seen here, it gives the impression of looking at the scene through an intervening fence of chicken-wire.

Quick fix **Problems with scans** continued

Problem: Noisy shadows

Image "noise", or pixels with random values, are encountered in scanned images most frequently in the shadow regions of the image. In the example shown here (*see below*), the dark areas should be black with smooth transitions to the lighter areas, but the speckled appearance shows a very noisy scan,which was produced by an inexpensive scanner.

Solution

Scans may be improved by increasing the overall brightness of the image, but that may be at the cost of losing highlight detail. If the shadows are of very high density – for example, those in high-definition transparency film – you may need to scan on a better-quality machine.

Problem: Underexposure

You may have set the brightness level too low – often occurs as a result of compensating for a previous original that was too bright. You may also have assessed the prescan with the monitor screen incorrectly adjusted. The result is a scan with all the data skewed toward the shadow regions. An underexposed scan can, of course, also result from an underexposed camera original.

Solution

Make a new scan. If the original is underexposed, improve it as far as possible at this stage rather than in post-scanner processing. It may help to scan at the highest bit-depth available (say, 36- or 48-bit), make the tonal corrections, and then convert to normal 24-bit.

Levels screen shot
The numerous gaps between the columns seen here indicate lack of data, while the way they are interspersed between very tall columns points to extremely noisy shadows. At the same time, data-challenged (very short columns) further indicate poor image quality.

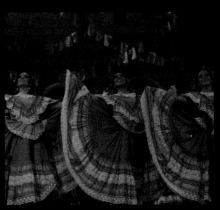

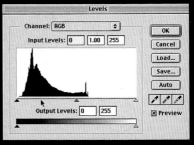

Levels screen shot
The Levels histogram seen here (*above*) confirms the underexposure seen in the image (*top*) – subject data is skewed, leaving many empty values.

Quick fix Inaccurate printer colours

The basic problem of colour reproduction is that monitors produce colours in a very different way to printers. Bearing this in mind will avoid you harbouring unrealistic expectations. You can see from any diagram comparing the colour spaces enclosed by printers compared with the colour space of monitors (*see p. 65*) that the deeper blues, greens, and reds seen on a monitor cannot be reproduced in print. These colours are the typical hues that are "out-of-gamut" for printers – in other words, cannot be printed.

Problem: Screen/printer colours don't match

If image colours look correct on the screen but not when they are printed, there is a failure of communication between your software, monitor, or printer. Assuming that your monitor, software, and printers are correctly set up, you may need to alter the printer's advanced settings or options. You can usually change colour balance by dragging the sliders provided: change these by small increments, note the settings ("capture", or save, them if the facility is available), and then reprint. Repeat this procedure until you obtain the results you want.

Problem: Bright colours merge

You have oversaturated colours. Although they appear distinct on screen, they are out-of-gamut on the printer. As a result, what were different colours blend into one hue. Try to reduce saturation overall by, say, 10 per cent a time until you start to see the separation of colours in the print. If this makes the other colours in the print too dull, try selecting the most vivid colours using, for example, Photoshop's Replace Color function, and then reduce the saturation of a limited range of colours. Colour gamut of printers is usually largest if you use the best quality of glossy paper and the manufacturer's own inks. Change the paper if you are not using the best quality.

Problem: Weak colours with patterns

You have chosen a regular dither pattern. "Dithering" is a method of simulating a wide range of colours from a limited choice. For photographic images, you need a random dither pattern, while a regular one is better for business graphics (and it prints much faster, too). Choose random, or diffuse, dither in your printer driver options.

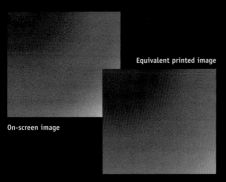

Equivalent printed image

On-screen image

Print brilliance
These images simulate the change you could see when printing out a highly saturated screen image on paper. The loss of depth and richness of colour is dramatic when you compare them side by side in this fashion. Fortunately, most people looking at your prints will never see the screen image for comparison – as a result, they would accept the print on its own terms.

Dither patterns
What should be a smooth transition from pale blue to violet here appears banded and patterned. This is not because a small number of colours was used to simulate what really required hundreds of colours for accurate reproduction, but because the colours were ordered into regular patterns. If distribution were more random, the gradient would look much smoother.

Basic colour management

Colour management is a method of ensuring that the reproduction and display of colour is as consistent as possible along the entire imaging chain. There are two key elements: first, the calibration of each item of equipment to ensure they are working to specification or to a known standard; second, the exchange of colour profiles (a small piece of data) between key parts of the imaging chain, particularly between the image file and monitor, and between the monitor and output device, such as a printer. It is not necessary for you to work to industry standards, but if you work in a colour-managed system on your own desktop, you will enjoy reliable, trouble-free image-making.

First steps

The simplified procedure explained on these pages (*see also pp. 90–1*) will help you start a basic system. The key step is to calibrate your monitor – or make it comply with a standard. This does two things: first, it ensures your monitor is properly set up for brightness, colour balance, and so on; second, this set-up information is then used to characterize the monitor – in other words, a colour profile of the monitor is created that software, such as Photoshop, can use.

Apple Mac users can use the ColorSync utility, which is supplied as part of Mac OS, or Adobe Gamma, which is supplied with all versions of Photoshop, including free trial versions (*see opposite*). Once the calibration is completed, save it and use it as the monitor profile. During calibration, choose D50 as the white point and a gamma of 1.8. Note that using the software utilities relies on judgements made by eye.

In digital photography, the greatest difficulty in the control of colour is that in many situations the photographer judges colour balance by comparing two very different samples – for example, the image on a monitor screen and the same image printed out by, say, an ink-jet printer. Now, you would not be surprised to see differences in colour reproduction from two printers – even if they were the same model from the same manufacturer. So how much greater is the difference between a monitor, which presents colours with glowing red, green, and blue phosphors, and a printer, which reproduces colours using dots of differently coloured inks?

Manufacturing standards

It is an achievement to produce a print from an ink-jet printer that looks the same as one printed on, say, photographic paper or in a book. This can happen without any intervention from you if, for example, your scanner or digital camera was properly calibrated at the factory, your colour settings for the printer were left untouched, and you printed without altering the image. This is so because the industry works to common standards and modern control of quality is extremely high.

Nonetheless, the weak link in this chain is the monitor: it is possible, despite an accurate print being produced by your printer, that the image on your monitor does not look correct. If you were to change the image until it did look right on screen, then it follows that the resulting print would be incorrect. This explains the central importance of calibrating your monitor. Fortunately, most of today's monitors are also built to extremely high standards of consistency, so the settings straight out of the box are often as good a starting point as any. (*For further details on setting up your printer, see pp. 174-7*).

Soft proof

A monitor that is correctly calibrated is one that gives an accurate soft proof – in other words, it does not need to be printed out for confirmation. You should observe sensible precautions such as not shining a desk lamp onto the screen. If your work area is bright during the day but dark at night, you could use two profiles according to the brightness of the room. Finally, avoid using garish screen backgrounds with coloured patterns or, indeed, backgrounds (also called desktop patterns or pictures) with any colour at all. Expert image manipulators work on neutral and mid-tone grey backgrounds. Strong colours on your monitor's desktop could upset your colour judgement.

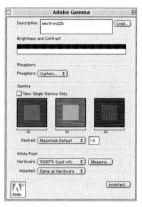

Basic monitor calibration

Use the Adobe Gamma control panel or settings available on Macs and PCs. The first step in calibrating any monitor is to make the screen image as bright as possible, using the monitor controls. Then adjust the contrast, still using monitor controls, until you can just see alternate bars in the Brightness and Contrast strip near the top of the control panel. In the Gamma section, click on the drop-down window next to "Desired:" for the Mac or the Windows default. Then adjust the slider above this so that the central square merges as well as possible with its striped frame. For the white point, set standard daylight of 5,000 K, although many experts use the 6,500 K, as this gives a more pleasant screen image. You are then ready to quit this panel, at which point you will be prompted to save the settings.

Colour balance

If you uncheck the box "View Single Gamma Only", you will see three targets. This enables you to adjust colour balance. Each of the central squares should merge into its background when the monitor is balanced neutrally with respect to colour. It helps to squint when adjusting the sliders underneath (click on them one at a time with the mouse and hold down the mouse button as you drag the control) – it is particularly difficult to judge when the green merges best. If you are not sure what to do, you can click on "Assistant" and you will be guided. Note that for the resulting settings to be operational, you need to tell the computer that these settings are to be used – this is done in various control panels and in your image-manipulation software: consult your computer manuals for the latest instructions.

How often should you calibrate?

Professional users, whose work relies on consistency from day to day, should calibrate their monitors about once a week, or at least every month. Monitors should be recalibrated if moved (even a small distance), if new electrical equipment is installed nearby (due to the effect of magnetic fields), or following any changes to screen resolution or colour depth. It follows that frequent changes to screen resolution are not recommended. Other equipment should be calibrated following any major change, such as when, for example, ink supplies are changed, a new type of paper is used, the printer is transported any distance from its normal position, or if the printer drivers are up-dated.

Screen image

Reflections on the screen or ambient lighting can affect your perception of screen colour, problems that can be lessened by adding a side and top hood.

Basic colour management continued

Step-by-step monitor calibration

1 Find the controls
In your operating system's control panel or settings folder you should be able to find the controls for your monitor. This is an example for the Mac OS, which takes you logically through the process, giving full explanations on the way. If you have a profile you can choose it from the list offered, or else click "Calibrate…" to check your monitor. It is usually best to create your own profile.

2 Monitor brightness
As with the Adobe Gamma control (see p. 89), you first increase the contrast of your monitor image to the highest, then adjust the brightness to a standard defined by the dark target. You may find that your monitor is uncomfortable to look at when its contrast is set to highest, but it will look better once you adjust the brightness.

4 Setting screen gamma
The monitor's gamma should not be confused with photographic gamma: it is a correction factor that makes the screen darker as it increases. So the standard Mac gamma of 1.8 produces a brighter screen image than the 2.2 for Windows or PC machines, while the uncorrected gamma gives a very bright screen.

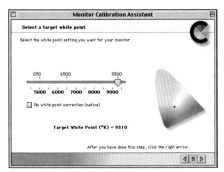

5 Setting the white point
The target white point establishes the overall colour balance of the screen. The professional preference is 5,000 K which is the equivalent of the colour of white paper viewed under daylight – in other words, somewhat warm. When you first adjust this, the colours look quite unacceptable, but your eyes adjust in time. The setting of 9,300 K gives a bright, cool white, which is the easiest to work with, but not suitable for image manipulation.

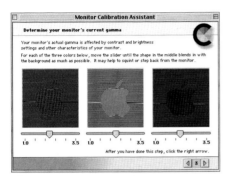

3 Colour balance settings
The next dialogue box takes you to the colour-balance settings. You need to merge the apple shapes into their backgrounds as well as you can using the slider controls under each panel. Half closing your eyes will help. It is important that you do all this against as dark or neutral a background as possible.

Warm white

This dialogue box shows the result of setting the target white point to a low setting of 4,500 K: whites are turned to a distinct yellow, with consequent distortion of all other colour values.

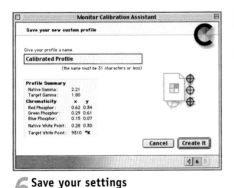

6 Save your settings
Finally, you need to save all the settings (which make up the profile). These can be saved with your image files, where it can be consulted by hardware such as another person's monitor. In this way, an image seen on your monitor will look the same on that other monitor, provided it has been set up correctly. Remember to give the calibration a name, one you can easily identify. Including a date in the name is always a good idea.

Colour unbalanced

If you send the colour slider controls to extreme positions you obtain an extreme colour balance: notice how the apple shapes are very distinct. The overall colour is blue, naturally, when the red and green controls are set to their minimum settings and blue is maximized.

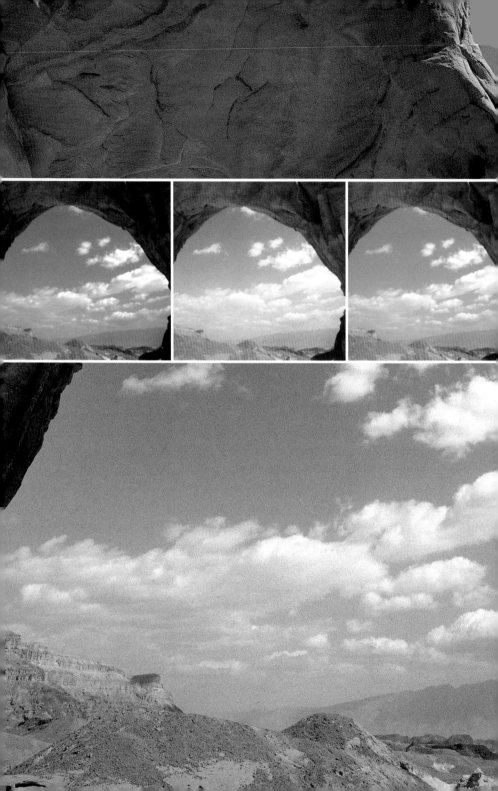

4
All about image manipulation

Software insights

Filters, image effects, distortions, colour control, manipulations, and much more – this chapter presents you with a detailed round-up of the spectrum of possibilities that modern image-manipulation software makes available to today's digital photographer.

Learning by example

Step-by-step guides and explanatory screen shots give precise information on how to achieve similar results using your own imagery. From burning-in and dodging to image sharpening, and darkroom effects such as hand-tinting and cross-processing. Carefully written and designed to be accessible to the beginner, you will quickly discover how even simple techniques can produce advanced, eye-catching effects.

Help on hand

Quick-fix sections help you deal with poor subject detail and colour, remove distracting subject elements, frame images, and remove unwanted backgrounds.

First steps

The usual way to open a file is to double-click on it; you place the cursor over the icon for the file and quickly click the mouse twice. The computer's operating system then checks to see what type of file it is and launches a suitable software application. This, though, is not the best way, as the wrong software application may start up. The computer may also put up a warning saying the file could not be opened (*see below right*). A better method is to start the application first and then open the file from within it. This often succeeds when files have lost their association with an application and so cannot be opened with a simple double-click.

Image sources

Certain sources of images, such as Photo CDs and images taken with professional Kodak cameras, should be opened from within the application recommended by the manufacturer. This is because the files may need to be uncompressed or otherwise processed to extract the best image quality before they are used.

Internet downloads

Images from an Internet site are usually in JPEG format (*see pp. 82–3*). If you expect to work on an image and then save it for extra treatment later on, it is good practice to perform a Save As on the file into a different format – for example, Photoshop or TIFF. Each time you save and close an image in JPEG, it is taken through the compression regime – the file size may not reduce greatly, but quality progressively degrades.

Copyright and watermarks

Images from picture-agency CDs, the Web, or those on CDs given away with magazines may show a "watermark" – the company's or photographer's name – printed across the image. This prevents piracy and asserts the copyright holder's rights. Images may also be invisibly marked – although there is no printing overlaying the images, they resist all but the most destructive changes to the files and suitable software can readily detect the invisible identification watermark.

Image degradation
This original portrait (*top left*) was saved several times with maximum JPEG compression (*top right*). Used small like this, the image is acceptable but, in fact, the original is far better, with smoother tones and more accurate colour. A close-up look at the original image (*above left*) shows continuous tones and unbroken lines, while the damage to the compressed version (*above right*) is obvious. A large print made from the JPEG image would simply not be acceptable.

● Canon EOS-1n with 28–70 mm lens. ISO 100 film. Microtek 4000t scanner.

The document "commex.vcf" could not be opened because the application program that created it could not be found.
Could not find a translation extension with appropriate translators.

OK

"Could not be opened" screen shot
If you see this warning box on your screen, or one like it, don't worry. You should be able to open the file concerned from within an application. To do this, launch the application first and then try to open the file using the menu options provided.

Colour mode

Automatic Levels can lead to various results, depending on colour mode. The initial RGB scan of this picture was dark and too warm in colour (*above left*). Still in RGB (*p. 115*), the first correction was too bright (*above right*). This is because invoking Automatic Levels indiscriminately spreads values evenly in each channel. But after turning

the image into LAB mode (*p. 125*), automatic correction produced a very accurate outcome (*right*).

● Canon EOS-1n with 80–200 mm lens. ISO 100 film. Microtek 4000t scanner.

> ⚠ Could not find the application program that created the document named "microtk settngs".
>
> To open the document, select an alternate program, with or without translation:
>
> | 🖼 Photoshop® 6.0 |
> | 🗎 Adobe GoLive 5.0 with QuickTime translation |
> | 🗎 Adobe Illustrator® 9.0 |
> | 🗎 Appearance |
> | ⦿ Apple DVD Player with QuickTime translation |
> | 🗎 CanoScan Toolbox |
>
> ☑ Show only recommended choices
>
> [Cancel] [**Open**]

"Could not find" screen shot

If you see this warning, or one like it, just look for the appropriate application on the list and click on it. If your application does not appear, don't panic: it is still in the computer. Start the application first, then try to open the file from within it.

Checking the image

● Check colour mode. Some scanners produce LAB files or may have been incorrectly set. Most image-manipulation software works in 24-bit RGB colour, and if the image is not in the correct mode many adjustments are not available or give odd results.

● Assess image sharpness. Are the colours clear and accurate? If not, you may have scanned it incorrectly or opened up a low-resolution version.

● Check there is no excess border to the image

caused by inaccurate cropping during scanning (*see pp. 96-7*). If there is, remove it with the Crop tool. Unwanted black or white regions will distort tonal calculations.

● Check the file size. It should be adequate for your purposes but not much larger. If it is too small, you could work on it for hours only to discover that it is not suitable for the output size desired. If it is too large, you will waste time as all manipulations take longer than necessary to complete.

Cropping and rotation

Always check that scanned images are correctly oriented – in other words, that left-to-right in the original is still left-to-right after scanning. This is seldom a problem with images taken with digital cameras, but when scanning a film original it is easy to place the negative or transparency the wrong way around – emulsion side either up or down, depending on your scanner – so that the scanned results become "flipped". Getting this right is crucially important if there is any writing or numbering in the image to prevent it reversing, as in a mirror image.

Image cropping

The creative importance of cropping, to remove extraneous subject detail, is as crucial in digital photography as it is when working conventionally. But there is a vital difference, for not only does digital cropping reduce picture content, it also reduces file size. Bear in mind, however, that you should not crop to a specific resolution until the final stages of image processing, as "interpolation" may then be required. This reduces picture quality, usually by causing a slight softening of detail. Image cropping without a change of resolution does not require interpolation.

In general, though, at the very least you will want to remove the border caused by, for example, inaccurate cropping when making the scan. This

area of white or black not only takes up valuable machine memory, it can also greatly distort tonal calculations, such as Levels (*see pp. 100–1*). If a border to the image is needed, you can always add it at a later stage using a range of different applications (*see p. 110*).

Image rotation

The horizon in an image is normally expected to run parallel with the top and bottom edges of the image. Any slight mistakes in aiming the camera, which is not an uncommon error when you are working quickly or your concentration slips, can be corrected by rotating the image before printing. With film-based photography, this correction is carried out in the darkroom during the printing stage. But since it is a strictly manual process you should not expect this type of correction to be an option available from the fully automatic printers found in minilabs.

In digital photography, however, rotation is a straightforward transformation, and in some software applications you can carry out the correction as part of the image-cropping process.

Note that any rotation that is not 90°, or a multiple of 90°, will need interpolation. Repeated rotation may cause image detail to blur, so it is best to decide exactly how much rotation is required, and then perform it all in a single step.

Fixed-size cropping

Some manipulation software, such as Photoshop, allows you to crop to a specific image size and to a specific output resolution – for example, 13 x 18 cm (5 x 7 in) at 225 dpi. This is useful as it combines two operations in one and is very convenient if you know the exact size of image needed – perhaps a picture for a newsletter. If so, enter the details in the boxes, together with the resolution. The crop area will then have the correct proportions, allowing you to adjust the overall size and position of the image for the crop you require. Cropping to a fixed size is useful for working rapidly through a batch of scans.

Crop Options screen shot

By clicking on "Fixed Target Size" you can crop to a specific size and resolution. This is a convenient way to change not only the image size but also to change the resolution of your image.

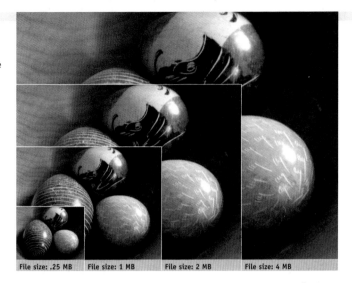

Image size and memory

Reducing the size of an image by half reduces its file size by three-quarters. In this series, the size of the third-largest image is half that of the largest, but its file size is a quarter. The smallest image here has a file size a full 16 times smaller than the size of the original. This is why even a small crop can cause a significant saving in machine memory.

● Nikon Coolpix 990.

| File size: .25 MB | File size: 1 MB | File size: 2 MB | File size: 4 MB |

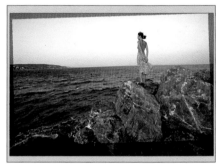

Sloping horizon

A snatched shot taken with a wide-angle lens left the horizon with a slight but noticeable tilt, disturbing the serenity of the image. But by rotating a crop it is possible to correct the horizon, although, as you can see from the masked-off area (*above left*), you do have to sacrifice the marginal areas of the image. Some software allows you to give a precise figure for the rotation; others require you to do it by eye. Some scanner software gives you the facility to rotate the image while scanning.

● Canon EOS-1n with 17–35 mm lens. ISO 100 film. Microtek 4000t scanner.

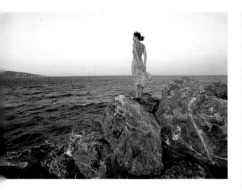

Saving as you go

Adopt the habit of saving your working file as you proceed: press Command + S (Mac) or Control + S (PC) at regular intervals. It is easy to forget in the heat of the creative moment that the image on the monitor is only virtual – it exists just as long as the computer is on and functioning properly. If your file is large and what you are doing complicated, then the risks of the computer crashing are increased (and the resulting loss of the work more grievous). A good rule to remember is that if your file is so large that making frequent saves is an inconvenient interruption, then you definitely should be doing it, inconvenient or not.

Quick fix Poor subject detail

Although in most picture-taking situations the aim is to produce the sharpest possible image, there are situations where blur is desirable.

Problem
Images lack overall "bite" and sharpness and subject detail is soft or low in contrast overall.

Analysis
Unsharp subject detail and low contrast can have many causes: a poor-quality lens; inaccurate focusing; subject movement; camera movement; dust or scratches on the lens; an intervening surface, such as a window; and over-magnification of the image.

Solution
One of the great advantages digital photography has over film-based photography is that unsharpness can, to varying extents, be reduced using image-processing techniques. The main one is unsharp masking (USM). This can be found on nearly all image-manipulation software: in Photoshop it is a filter; it is provided by software such as Extensis Intellihance; and the software drivers for many scanners also provide it. Some digital cameras also apply USM to images as they are being recorded (*see pp. 104-7*).

However, while USM can improve the appearance of an image, there are limits to how much subject information it can retrieve. In particular, unsharpness caused by movement usually shows little or no improvement with USM. At times, a simple increase in image contrast and colour saturation can help to improve the appearance of image sharpness.

Turning the tables
Blurred, low-contrast images are not necessarily failures. This portrait was taken through a dusty, smeary window. The diffusion has not only softened all image contours, it has also reduced contrast and introduced some flare into the shadow areas. These are usually fatal image flaws, but if they appear in association with the right subject they can add a degree of character and atmosphere, rather than detract from picture content.

● Canon EOS-1n with 80–200 mm lens. ISO 100 film. Microtek 4000t scanner.

How to avoid the problem

● Keep the front surface of your lens and any lens filters clean. Replace scratched filters if necessary.

● Focus as precisely and carefully as possible.

● Release the shutter smoothly, in a single action. For longer hand-held exposures, take the picture as you breathe out, just before you start to breathe in.

● For long exposures, use a tripod or support the camera on some sort of informal, stable support, such as a table, window ledge, wall, or a pile of books, to prevent camera movement.

● Experiment with your lens – some produce unsharp results when they are used very close-up, or at the extreme telephoto end of the zoom range.

Quick fix Poor subject colour

If, despite your best efforts, subject colour is disappointing, there is still a range of image-manipulation options to improve results.

Problem

Digital images are low in contrast, lack colour brilliance, or are too dark. Problems most often occur in pictures taken in overcast or dull lighting conditions.

Analysis

Just like film-based cameras, digital cameras can get the exposure wrong. Digital "film" 1s, if anything, more difficult to expose correctly, and any slight error leads to poor subject colour. Furthermore, high digital sensitivities are gained at the expense of poor colour saturation; so, if the camera's sensitivity is increased to cope with low light levels, colour results are, again, likely to be poor.

Overcast light tends to have a high blue content and the resulting bluish colour cast can give dull, cold images.

Solution

An easy solution is to open the image in your image-manipulation software and apply Auto Levels (see pp. 100-1). This ensures your image uses the full range of colour values available and makes some corrections to colour casts. Although quick, this can over-brighten an image or make it too contrasty.

Some software, such as Photo Soap, Digital Darkroom, and Extensis Intellihance, will analyze an image and apply automatic enhancement to, for example, concentrate on increasing the colour content or correcting a colour cast.

The handiest single control is the universally available Saturation (see pp. 108-9 and 112-5).

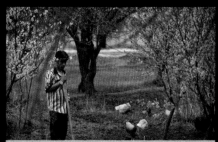

Problem...

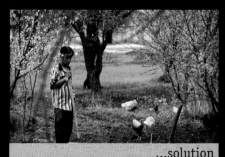

...solution

Manipulation options

The original scan (*top*) is not only dull, it is also not an accurate representation of the original scene. However, Auto Levels has generally brightened up the image (*above*). Colour saturation was increased using the Hue and Saturation control, and, finally, the USM filter was applied to help improve the definition of subject detail.

● Canon EOS-1n with 80–200 mm lens. ISO 100 film. Nikon Coolscan LS-1000 scanner.

How to avoid the problem

● In bright, contrasty lighting conditions it may help to underexpose by a small amount: set the camera override to -½ of a stop or -⅓ of a stop, depending on what the controls permit.

● Avoid taking pictures in dull and dark conditions. However, bright but partly overcast days usually

days, consider using a warm-up filter (a very light orange or pink colour) over the camera lens.

● Avoid setting the camera to very high sensitivities – for example, film-speed equivalents of ISO 800 or above. And avoid using high-speed colour film of any type in a conventional camera if colour

Levels

The Levels control shows a representation, in the form of a histogram, of the distribution of tone values of an image. Levels offers several powerful options for changing global tone distribution. The easiest thing to do is to click on the Auto Level button. This, however, works effectively in very few cases. What it does is take the darkest pixel to maximum black and the brightest pixel to maximum white, and spreads everything else evenly between them. This, however, may change the overall density of the image.

Another control that may be available is Output Level. This sets the maximum black or white points that can be produced by, say, a printer. Generally, by setting the white point to at least 5 less than the maximum (in other words, to about 250) you prevent the highlight areas in your output image appearing totally blank. Setting the black point to at least 5 more than the minimum (in other words, to about 5) you will help to avoid the shadow areas looking overly heavy in your output image.

Auto Level

An underexposed image contains dark tones with few high-value ones (*far left*), confirmed in the Levels display (*bottom far left*). The gap on the right of the histogram indicates an absence of values lighter than three-quarter tone, with peak values falling in deep shadow. Applying Auto Level (*left*) spreads all available pixel values across the whole dynamic range. The new Levels display (*bottom left*) has a characteristic comb-like structure, showing gaps in the colour data. Auto Level not only brightens colours and increases contrast, it also causes a slight overall colour shift.

● Kodak DC210.

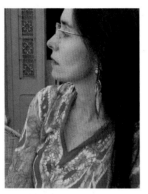

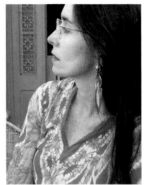

How to read Levels

The Levels histogram gives an instant check on image quality – perhaps warning of a need to rescan.

● If all values across the range are filled with gentle peaks, the image is well exposed or well scanned.

● If the histogram shows mostly low values (weighted to the left), the image is overall low-key or dark; if values are mostly high (weighted to the right), the image is high-key or bright. These results are not necessarily undesirable.

● If you have a sharp peak toward one or other extreme, with few other values, you probably have an image that is over- or underexposed.

● If the histogram has several narrow vertical bars, the image is very deficient in colour data or it is an indexed colour file. Corrections may lead to unpredictable results.

● A comb-like histogram indicates a poor image with many missing values and too many pixels of the same value. Such an image looks posterized.

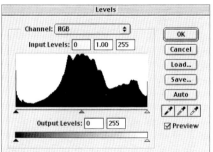

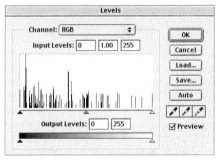

Well-distributed tones

As you can see from this Levels histogram, a bright, well-exposed image fills all the available range of pixels, with no gaps. Since the image contains many light tones, there are more pixels lighter than mid-tone, so the peak of the histogram lies to the right of centre. This image would tolerate a lot of manipulation thanks to the richness of colour data it contains.

● Kodak DCS315 with 28–70 mm lens.

Deficient colour data

An image with only a limited colour range, such as this still-life composition, can be turned into a very small file by saving it as an indexed colour file (*p.121*). In fact, just 55 colours were sufficient to represent this scene with hardly any loss of subject information. However, the comb-like Levels histogram associated with it indicates just how sparse the available colour data was. Any work on the image to alter its colours or tonality, or the application of filter effects that alter its colour data, would certainly show up artefacts and produce unpredictable results.

● Nikon Coolpix 990.

Histogram display

The histogram for this image shows mid-tones dominated by yellow and blue with large amounts of red in mid- to light tones, consistent with the strong orange colour of the shirt. This display is from the FotoStation application, which displays histograms for each RGB separation in the corresponding colour.

Burning-in and dodging

Two techniques used in film-based and digital photography for manipulating the local density of an image are known as burning-in and dodging.

Controlling density

Burning-in increases the density in the area of the image being worked on, while dodging reduces it. Both techniques have the effect of changing the tonal reproduction of the original either to correct errors in the initial exposure or to create a visual effect. For example, the highlights and shadows of both film and digital images are low in contrast, and to counteract this you can burn-in and dodge

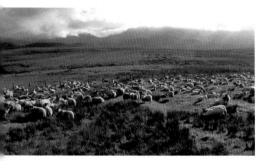

to bring out what shadow and highlight detail does exist by increasing local image contrast.

The same techniques can be used in order to reduce contrast – to darken highlight areas, for example – to bring them tonally closer to image mid-tones. An often-used application of this in conventional photography is burning-in areas of sky when printing to darken them. Increasing the sky exposure (while shading, or dodging, the rest of the print) not only helps differentiate sky and cloud tonally, it also helps match the sky tones to those of the foreground.

Digital techniques

In digital photography, burning-in and dodging are easily achieved using the tools available in all image-manipulation software. Working digitally you can be as precise as you like – down to the individual pixel, if necessary. And the area treated can be between 1 and 100 per cent of the image area, nominated by the Marquee or Lasso tool.

A drawback of working digitally, however, is that when manipulating large areas results are often patchy and uneven, while working on large area in the darkroom is easy.

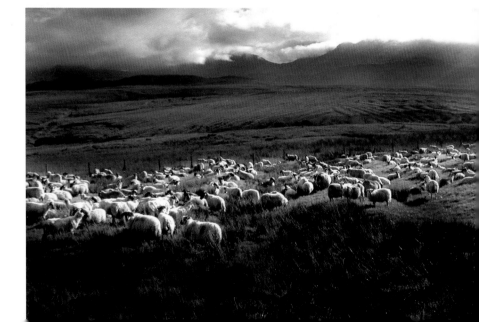

Working digitally, some applications allow you to set the tool for the shadows, mid-tones, or high-lights alone. Carefully choosing the tonal range to be manipulated helps avoid tell-tale signs of clumsy burning-in and dodging. Corresponding techniques, available in Photoshop and some other professional software packages, are known as Color Dodge and Color Burn painting modes.

Color Dodge is not only able to brighten up the image, it also pushes up image contrast as you apply the "paint". In addition, if you set a colour other than white, you simultaneously tint the areas being brightened. Color Burn has similar effects – darkening and increasing image contrast.

Correcting exposure

Taken on a bright winter's afternoon, the camera's meter was fooled by the sudden appearance of the sun within the picture area, causing it to underexpose the scene (*above left*). This situation can be rescued using the Dodging tool set to work on the high-lights areas alone. However, to produce the corrected image shown here (*above right*), the Color Dodge tool was used. This gives more rapid results and has less tendency to burn out subject details. As an optional way of working, you can paint onto a layer and simply discard it if you don't like the results.

● Nikon Coolpix 990, set to black and white mode.

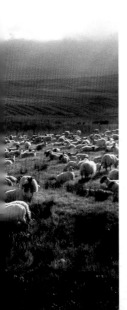

Correcting colour balance

Looking at the original image (*above left*), the temptation to burn-in the foreground and some of the background in order to "bring out" the sheep is irresistible. Brief applications of the Burn tool on the foreground (set to mid-tone at 10 per cent) and background hills, plus the Dodge tool on the sheep (set to highlight at 5 per cent) produced an image (*left*) that was very similar to the scene as it appeared at the actual time of shooting.

● Nikon Coolpix 990.

●HINTS AND TIPS

● Apply dodging and burning-in techniques with a light touch. Start off by using a light pressure or a low strength of effect – say, 10 per cent or less – and then build up to the strength the image requires.

● When burning-in image highlights or bright areas, set the tool to burn-in the shadows or mid-tones. Don't set it to burn-in the highlights.

● When burning-in mid-tones or shadows, set the tool at a very light pressure to burn-in the highlights or mid-tones. Don't set it to burn-in the shadows.

● When dodging mid-tones, set the tool at very light pressure to dodge the highlights or mid-tones. Don't set it to dodge the shadows.

● When dodging shadows, set the tool to dodge the highlights. Don't set it to dodge the shadows.

● Use soft-edged or feathered Brush tools to achieve more realistic tonal results.

Sharpening

The ease with which modern image-manipulation software can make a soft image appear sharp is almost magical. Although software cannot add to the amount of information contained in an image, it can put whatever information is there to the best possible use. Edges, for example, can be given more clarity and definition by improving local contrast.

Digitally, sharpen effects are true filters, as they hold back some components and selectively let others through. A Sharpen filter is, in reality, a "high-pass" filter – it allows high-frequency image information to pass while holding back low-frequency information.

Unsharp masking

The most versatile method of image sharpening is to use unsharp masking (USM). This takes a grid of pixels and increases edge definition without introducing too many artefacts. The difficulty with USM is knowing which values to set (*see examples on these page and those following*).

Like any manipulation effect, it is possible to overdo sharpening. In general, assess image sharpness at the actual pixel level, so that each image pixel corresponds to a pixel on the monitor. Any other view is interpolated and edges are softened, or anti-aliased, which makes sharpness impossible to assess properly.

As general guidance, for images intended for print reproduction, the screen image should look very slightly over-sharpened – so that artefacts (such as halos or bright fringes) are just visible. For on-screen use, however, sharpen images only until they look right on the screen.

Sharpening makes deep image changes that cannot easily be undone. Therefore, it is generally best to leave sharpening to last in any sequence of image manipulations, except for combining different layers. However, if you are working on a scan that has many dust specks and other similar types of fault, you should expect the final sharpening to reveal more fine defects, so be prepared for another round of dust removal using cloning .

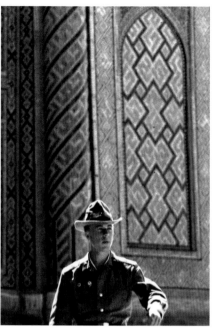

Under-sharpening

In images containing large amounts of fine detail, such as this scene taken in Uzbekistan, applying a modest strength of USM filtering (55) and a large radius (22), with a threshold set at 11 does little for the image. There is a modest uplift in sharpness, but this is due more to an overall increase in contrast rather than any other effect.

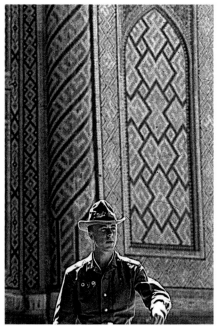

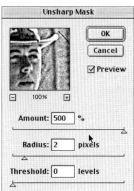

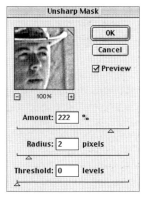

Over-sharpening

The maximum strength setting used for this version results in over-sharpening – it is still usable and is arguably a good setting if you intend to print on poor-quality paper. The same setting applied to the Kashgar image (*pp. 106-7*) would simply bring out all the film grain – a technique for increasing noise in the image.

Ideal setting

The best settings for images with fine detail is high strength with a small radius and a very low threshold: here, strength was 222, the radius was 2, and the threshold was kept at 0. Details are all well defined and if large-size prints are wanted, details are crisper than those obtained with sharpening using a larger radius setting.

Sharpening continued

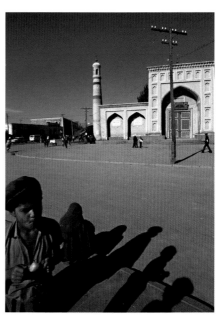

Original image

This photograph of the main town square in Kashgar, Xinjiang, China, has large areas of smooth tone with little fine detail, and it would clearly benefit from the effects of image sharpening.

● Leica R6 with 21 mm lens. ISO 50 film.

Using an advanced Photoshop technique for image sharpening, first mask off areas (such as a face) to be protected from oversharpening and any associated increase in defects. Next, produce a duplicate layer of the background and set it to Soft Light mode. This increases contrast overall. Then apply the High-Pass filter (found under the Filter menu in Other > High Pass). Increasing the radius strengthens the effect (passes higher frequencies, or more detail). You can now enter Quick Mask mode or add a layer mask to control which areas of the image will be sharpened by the High-Pass filter. This method is also effective for sharpening an image overall and can be controlled by direct settings and by opacity. However, the preview window in the dialogue box does not give an accurate view because it samples only the top layer.

Over-sharpening

If you increase the sharpening effect (222 in this version) and reduce the threshold (0), but reduce the radius to 2, virtually everything in the image increases in sharpness. The result is that film grain and fine detail are sharpened to an undesirable extent. Compare the result of these settings with that of an image that contains a mass of fine detail (*p. 104*).

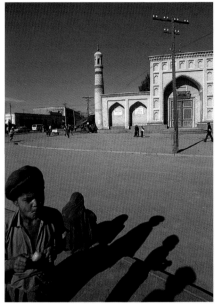

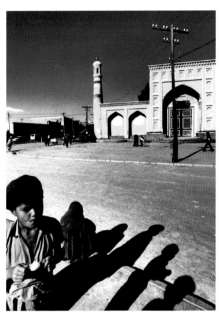

Sharpening areas of tone

A moderate amount of sharpening (55) and a relatively wide radius for the filter to act on (22) improves sharpness where there is subject detail, without bringing out film grain or unwanted information, such as in the subject's skin-tones. A threshold setting of 11 prevents the filter from breaking up smooth tonal transitions, as the sharpening effect operates only on pixels differing in brightness by more than 11 units.

Extreme settings

This version results from maximum amount and radius settings. The effect is extreme, but a threshold of 32 controls coloration. Even so, the image has highly saturated colours and brilliant contrast. In addition, film grain is emphasized. The random appearance of film grain gives more attractive results than the regular structure of a digital image, so if you want to use this effect introduce image noise first.

Quick fix Image distractions

Unless there is a fundamental problem with your image, most minor distractions can be removed, or at least be minimized, using digital techniques.

Problem

While concentrating on your subject it is easy not to notice distracting objects in the picture area. This could be something minor, such as a discarded food wrapper, but out-of-focus highlights can also be a problem.

Analysis

The small viewfinders of many cameras make it difficult to see much subject detail. Furthermore, though something is distant and looks out of focus, it may still be within the depth of field of your lens. At other times, you simply cannot avoid including, say, telephone wires in the background of a scene.

Solution

You may not need to remove a distraction completely – simply reducing the difference between it and adjacent areas may be enough. The usual way to achieve this is with cloning – duplicating part of an image and placing it into another part (*see pp. 160-5*). For example, blue sky can be easily cloned onto wires crossing it, as long as you are careful to use areas that match in brightness and

hue. If you clone from as close to the distraction as possible, this should not be too much of a problem.

You could also try desaturating the background: select the main subject and invert the selection; or select the background and lower saturation using the Color Saturation control. You could also paint over the background using the Saturation or Sponge tool set to desaturate.

Another method is to blur the background. Select the main subject and invert the selection, or select the background directly, and apply a Blur filter. Select a narrow feather edge to retain sharpness in the subject's outline. Choose carefully or, when Blur is applied, the selected region will be left with a distinct margin. Try different settings, keeping in mind the image's output size – small images need more blur than large ones.

How to avoid the problem

Check the viewfinder image carefully before shooting. This is easier with an SLR camera, which is why most professionals use them. Long focal length lenses (or zoom settings) reduce depth of field and tend to blur backgrounds. And, if appropriate to the subject, use a lower viewpoint and look upward to increase the amount of non-distracting sky.

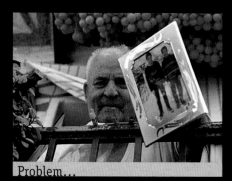

Problem...

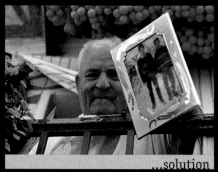

...solution

Foreground distraction

An old man photographed in Greece shows me a picture of his sons. As he leans over the balcony, the clothes pegs in front of his chin prove impossible to avoid.

● Canon EOS-1n with 28–105 mm lens. ISO 100 film. Microtek 4000t scanner.

Cloning

Luckily, in this example there was enough of the man's skin tone visible to give a convincing reconstruction. To do this, the skin part of the image was used to clone areas of colour over the adjacent distractions.

Problem... ...solution

Background distractions

In the chaos of a young child's room, it is neither possible nor desirable to remove all the distractions, but toning them down would help to emphasize the main subject.

● Bronica SQ-A with 40 mm lens. ISO 64 film. Heidelberg Saphir II scanner.

Desaturated background

Applying Desaturate to the background, turning all the colours into grey has helped separate the girl from the numerous objects surrounding her. A large, soft-edged Brush tool was chosen and the printing mode was set to desaturation at 100 per cent.

Problem... ...solution

Selective blur

Despite using a large aperture, a wide-angle lens setting still produced more depth of field than I wanted in this example (*above left*). To reduce the intrusive sharpness of the trees, I used the Gaussian Blur filter set to a radius of 9 pixels (*right*). First, I selected the figure with a feathering of 5 and then inverted this selection in order to apply the Gaussian Blur to the background alone (*above right*).

● Canon EOS-1n with 17–35 mm lens. ISO 100 film. Nikon Coolscan 4000 scanner.

Gaussian Blur

OK

Cancel

☑ Preview

□ 100% ⊞

Radius: 9 pixels

Quick fix Image framing

Don't allow your images to become unnecessarily constrained by the sides of the camera viewfinder or the regular borders of your printing paper. There are creative options available to you.

Problem

The precise and clear-cut rectangular outlines around images can not only become boring, sometimes they are simply not appropriate – for example, on a Web site page where the rest of the design is informal. What is needed is some sort of controlled way of introducing some variety to the way you frame your images.

Analysis

In the majority of situations, producing images with clean borders is the most appropriate method of presentation. But with the less-formal space of a Web page, a looser, vignetted frame might be a better option. On occasion, a picture frame can also be used to crop an image without actually losing any crucial subject matter.

Solution

Scan textures and shapes that you would like to use as frames and simply drop them onto the margins of your images. Many software applications offer simple frame types, which you can easily apply to any image and at any size. Specialist plug-ins, such as Extensis Photoframe, simplify the process of applying frames and provide you with numerous, customizable framing options.

How to avoid the problem

The need to create picture frames usually arises from the desire to improve an image that has not been ideally composed. Nobody thinks about picture frames when looking at a truly arresting photograph. Inspect your pictures carefully, checking the image right to the edges. Tilting the camera when shooting creates a different style of framing, or simply crop off image elements you don't need.

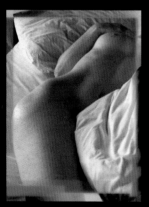

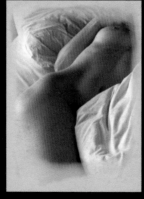

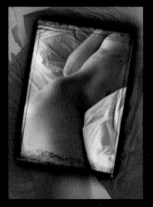

Framing option 1
The first option applies a geometric frame in which it partially reverses the underlying tones of the image. It is effective in hiding unwanted details in the top left of the image, but its outline is perhaps too hard in contrast with the soft lines of the subject's body.

Framing option 2
The simplest frame is often the best – here it is like looking through a cleared area of fogged glass. The colour of the frame should be chosen to tone in with the image. However, you should also consider the background colour: on this black page, the contrast is too high whereas against a white page or an on-screen background, the nude figure would appear to float.

Framing option 3
Here a painterly effect is combined with a frame that reverses both hue and tone (a Difference mode). By carefully adjusting the opacity of the frame, the colours were toned down to match that of the main image. Finally, the frame was rotated so that the main axis nude figure runs across the diagonal, leading the eye from the thigh to her just-revealed breast.

Quick fix Converging parallels

While the brain largely compensates for visual distortions – so, in effect, you see what you expect to see – the camera faithfully records them all.

Problem

Images showing subjects with prominent straight lines, such as the sides of a building, appear uncomfortable when printed or viewed on screen because the lines appear to converge. Regular shapes may also appear sheared or squashed (*see also p. 60*).

Analysis

The change in size of different parts of the image is due to changes of magnification – different parts of the recorded scene are being reproduced at different scales. This occurs because of changes in distance between the camera and various parts of the subject. For example, when you look through the viewfinder at a building from street level, its top is further away than its base – a fact that is emphasized by pointing the camera upward to include the whole structure. As a result, the more distant parts appear to be smaller than the closer parts.

Solution

Select the whole image and, using the Distortion or Transformation tool, pull the image into shape. If there are changes in magnification in two planes, both will converge, and so you will need to compensate for both.

How to avoid the problem

• Choose your shooting position with care and try to compose the image in order to keep any lines that are centrally positioned as vertical as possible. In addition, look to maintain symmetry either side of the middle of the picture.

• Rather than pointing the camera upward, to include the upper parts of a building or some other tall structure, look for an elevated shooting position. This way, you may be able to keep the camera parallel with the subject and so minimize differences in scale between various parts of the subject as they are recorded by the camera.

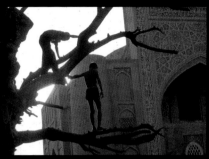

1 Verticals converge
Shooting from ground level with the camera angled upward caused the scene to appear to tilt backward.

2 Image manipulation
Stretching the lower left-hand corner of the image using the Distortion tool is the solution to this problem.

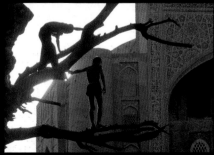

3 Verticals corrected
The corrected image looks better and corresponds more closely to the way the scene looked in reality.

Colour balancing

All image-manipulation software allows you to adjust the overall colour of an image. Most also offers Levels and Curves control. In powerful software, such as Photoshop, you have separate tools for controlling an image's hue and saturation, as well as others for replacing specified colours.

Color Balance control

This control makes global changes to the standard primary or secondary hues in an image. In some software, you can restrict the changes to shadows, highlights, or mid-tones. This control is useful for making quick changes to an image that has, for example, been affected by an overall colour cast.

Levels control

This can be used to alter colour balance of an image by adjusting separately the Level in each colour channel. It is similar to the Color Balance facility, but it provides you with greater control over brightness. The great advantage of Levels is that, in most software, settings can be saved and reapplied to other images.

Curves control

This controls the tonal reproduction of image brightness values, represented by a curve running from the lightest to darkest values. It can do everything the Levels control can, but with more precise location of where changes in tonal value occur. By carefully manipulating the curves in separate colour channels you can change the colour balance to counteract irregularities in colour reproduction in both film-based and digital originals. For example, you can decrease the blue content of shadows, to remove cold-looking tones, while leaving the rest of the image's colour balance untouched (*for more details, see pp. 116–120*).

Warm white point
The original picture of a simple still-life (*above left*) has reproduced with the strong orange cast that is characteristic of images lit by domestic incandescent lamps. The corrected image (*above right*), was produced using using Color Balance. It is still warm in tone because a fully corrected image would look cold and unnatural.
● Nikon Coolpix 990.

White point

A quick method of working when you wish to colour-correct an image is by deciding which part of the picture you want to be the white point – that part you want to be seen as pure white. You then use the Highlight Dropper tool, which is commonly available in image-manipulation software as well as part of scanner drivers, to select that area. If the white point needs to be corrected, the whole image will change in tonality (it is said to be mapped to the new white point) to reflect the fact that your selected area is now the "official" pure white point. This, like all colour-correction methods, works only if the image has no strong colour cast. If it has, then more drastic measures may be needed.

Colour adjustments

With some types of software you can control the hue and saturation levels of a picture file globally and by waveband. In Photoshop, for example, the Hue control shifts all colours or a band of colours (for example, reds or cyans) around the colour wheel (*see p. 63*). You can also select colours directly from the image. The Saturation control increases colour purity by decreasing its grey/white content.

The Lightness control is useful for improving poor scans and digital pictures (*see also see pp. 80–1 and 125*).

Replace Color control

This replaces one hue, within a "fuzziness" setting or waveband, with another. Select the colours in the image you wish to change by sampling the image with the Dropper tool, and then transform that part via the Hue and Saturation dialogue box (*see p. 115*). By setting a small fuzziness factor – the top slider in the dialogue box – you select only those pixels very similar in colour to the original; a large fuzziness setting selects relatively dissimilar pixels. It is best to accumulate small changes by repeatedly applying this control. Replace Color is good for strengthening colours printers have trouble with (yellows and purples), or toning down colours they overdo (reds, for example). Film, monitors, or prints reproduce less than a third of the colours perceived by our eyes. But although we can distinguish very slight errors in reproduction when comparing samples side by

Original image
This original image has not been corrected in any way, and it accurately reproduces the flat illumination of a solidly cloudy sky.
○ Nikon Coolpix 990.

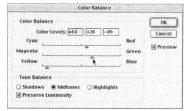

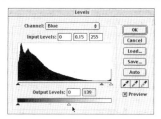

Color Balance control
Strong changes brought about via the Color Balance control, mainly by increasing yellow in the mid-tones –

which is the lowest slider in the dialogue box here – make the scene look as if it has been lit by an early evening sun.

Levels control
A golden tone has been introduced to the image here by forcefully lowering the blue channel in the Levels control – the middle slider beneath

the histogram – thus allowing red and green to figure more strongly. Red and green additively produce yellow, and this colour now dominates the highlights of the image.

Colour adjustments continued

side, we cannot remember colours with anything like the same degree of precision. In addition, we remember some colours better than others.

Colour balancing in photography is, therefore, usually not about achieving perfect reproduction but about controlling the process so that the output is not only accurate, given the limitations and characteristics of the medium used, but that it is also pleasing to the eye.

What is colour balance?
In the context of colour, "balance" does not refer to harmony or equality, but neutrality. A scene that is colour balanced is one in which the illuminating light offers all hues in equal proportion: in other words, the illumination is white and not tinted with colour. Thus, a scene can be full of blues or greens yet still be colour balanced, while another scene with a well-judged combination of secondary colours may look harmonious, but may not be colour balanced at all.

The aim of colour balancing is to produce an image that appears as if it were illuminated by white light, achieved by adjusting the white point

(*see p. 112*). However, there are different standards for white light, and so there are different white points. For example, it would not look natural to correct an indoor scene lit by domestic lamps in order to make it look like daylight; rather, a warm-toned white point is called for instead. However, in a scene containing brilliant colours, a cool-toned white point is more acceptable (giving colours like that from a bright Mediterranean sky). A colour balance that is slightly warmer than neutral is generally preferred by most viewers.

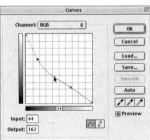

Colour temperature
The colour temperature of light has, in fact, nothing to do with temperature as we traditionally think of it; rather, colour temperature is measured by correlating it to the colour changes undergone by an object as it is heated. Experience tells us that cooler objects, such as candles or domestic lights, produce a reddish light, whereas hotter objects, such as tungsten lamps, produce more of a blue/white light.

The colour temperature of light is measured in degrees Kelvin, and a white that is relatively yellow in colouration might be around 6,000 K, while a white that is more blue in content might be, say, 9,500 K.

While colour slide film must be balanced to a specific white point, digital cameras can vary their white point dynamically, according to changing needs of the situation.

Curves control
A simple inversion of colour and tone leaves dark shadows looking empty and blank. Manipulating tonal reproduction via the Curves dialogue box, however, gives you more control, allowing you to put colour into these otherwise empty deep shadows (the bright areas after inversion). In the

dialogue box here you can see how the curve runs top left to bottom right – the reverse of usual – and the other adjustments that were made to improve density in the image's mid-tones.

Working in RGB

The most intuitive colour mode to work in is RGB. It is easy to understand that any colour is a mixture of different amounts of red, green, or blue, and that areas of an image where full amounts of all three colours are present give you white. The other modes, such as LAB and CMYK, have their uses, but it is best to avoid using them unless you have a specific effect in mind you want to achieve. When you are producing

image files to be printed out onto paper, you may think you should supply your images as CMYK, since this is how they will be printed. However, unless you have the specific data or separation tables supplied by the processors, it is preferable to allow the printers to make the conversions themselves. In addition, CMYK files are larger than their RGB equivalents and so are far less convenient to handle.

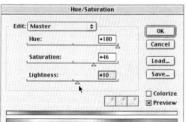

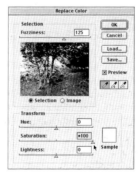

Hue and Saturation control

Here, in this dialogue box you can see that image hue has been changed to an extreme value, and this change has been supported by improvements in saturation and lightness in order to produce good tonal balance. Smaller changes in image hue may be

effective for adjusting colour balance. Bear in mind that colours such as purples look brighter and deeper on a monitor than in print because of limitations in the printer's colour gamut (*pp. 65 and 174-7*).

Replace Color control

Four passes of the Replace Color control were made to create an image that is now very different from that originally captured (*p. 113*). The dialogue box here shows the location of the colours selected in the small preview window, and the controls are

the same as those found in the Hue and Saturation dialogue box (*above left*), which allow you to bring about powerful changes of colour. However, for Hue and Saturation to have an effect, the selected values must indeed have colour. If they are grey, then only the lightness control makes any difference.

Curves

The Curves control found in image-manipulation software may remind some photographers of the characteristic curves published for films. This is a graph that shows the density of sensitized material that will result from being exposed to specific intensities of light. In fact, there are similarities, but equally important are the differences. Both are effectively transfer functions: they describe how one variable (the input either of colour value or of the amount of light) produces another variable (the output or density of silver in the image).

The principal difference is that when it comes to image-manipulation software the curve is always a 45° line at the beginning. This shows that the output is exactly the same as the input. However, unlike the film curve, you can manipulate this directly by clicking on and dragging the curve or by redrawing the curve yourself. In this way, you force light tones to become dark, mid-tones to become light, and with all the other variations in between. In addition, you may change the curve of each colour channel separately.

Original image and curve

Since the original negative was slightly underexposed, the image from the scan is tonally rather lifeless. You cannot tell anything about exposure by looking at the curve in the screen shot (*above*) because it describes how one tone is output as another. As nothing has been changed, when it first appears the line is a straight 45°, mapping black to black, mid-tone to mid-tone, and white to white. It is not like a film characteristic curve, which actually describes how film is responding to light and its processing.

● Mamiya 645 with 80 mm lens. ISO 400 film. Heidelberg Saphir II scanner.

Boosting the mid-tones

The bow-shaped curve displayed here subtly boosts the mid-tone range of the image, as you can see in the resulting image (*top*). But the price paid is evident in the quarter-tones, where details in the shadows and the details in the highlights are both slightly darkened. The result is an image with, overall, more tonal liveliness – note, too, that the outline of the subject's face has been clarified. With some image-manipulation software, you have the option of nudging the position of the curve by clicking on the section you want to move and then pressing the arrow keys up or down to alter its shape.

What the Curves control does

The Curves control is a very powerful tool indeed and can produce visual results that are impossible to achieve in any other way. By employing less extreme curves you can improve tones in, for example, the shadow areas while leaving the midtones and highlights as they were originally recorded. And by altering curves separately by colour channel, you have unprecedented control over an image's colour balance. More importantly, the colour changes brought about via the Curves control can be so smooth that the new colours blend seamlessly with those of the original.

In general, the subjects that react best to the application of extreme Curve settings are those with simple outlines and large, obvious features. You can try endless experiments with Curves, particularly if you start using different curve shapes in each channel. The following examples (*see pp. 118–120*) show the scope of applying simpler modifications to the master curve , thereby changing all channels at the same time.

Emphasizing the highlights

The scan's flat, dynamic range suggests that it could make an effective high-key image by changing the curve to remove the black tones (the left-hand end of the curve in the screen shot is not on black but is raised to dark grey) and mapping many highlight tones to white (the top of the curve is level with the maximum for nearly a third of the tonal range). The result is that the input midtone is set to give highlights with detail. Very small changes to the curve can have a large effect on the image, so if you want to adjust overall brightness, it is easier to commit to the curve and then use Levels to adjust brightness (*pp. 100-1*).

Emphasizing the shadows

The versatility of the original image is evident here, as now it can be seen working as an effective low-key picture. The mood of the picture is heavier and a little brooding, and it has lost its fashion-conscious atmosphere in favour of more filmic overtones. The curve shown in the screen shot has been adjusted not simply to darken the image overall (the right-hand end has been lowered to the mid-tone so that the brightest part of the picture is no brighter than normal mid-tone). In addition, the slight increase in the slope of the curve improves contrast at the lower midtone level to preserve some shadow detail. This is crucial, as too many blank areas would look unattractive.

Curves continued

Original image

The image you select for manipulating Curves does not have to be of the highest quality, but it should offer a simple shape or outline, such as this church. In addition, the range of colours can be limited – as you can see below, dramatic colours will be created when you apply Curves with unusual or extreme shapes.

- Sanyo VPC-3000.

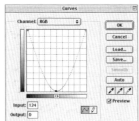

Reversing dark tones

A U-shaped curve reverses all tones darker than mid-tone and forces rapid changes to occur – an increase in image contrast, for example. The deep shadows in the church become light areas, giving a negative type of effect, but the clouds have darkened and greatly increased in colour content. The effect of using this shape curve is similar to the darkroom Sabattier effect, when exposed film or paper is briefly re-exposed to white light during development.

Reversing light tones

An arc-shaped curve reverses the original's lighter tones, giving the effect shown here. Although it looks unusual, it is not as strange as reversing dark tones (*left*). Note that the curve's peak does not reach the top of the range – the height of the arc was reduced to avoid creating overbright white areas. The colour of the building changes as the red-green colour in the normal image was removed by the reversal, allowing the blue range to make its mark.

Tone/colour reversal

Applying an M-shaped curve plays havoc with our normal understanding of what a colour image should look like. Not only are the tones reversed as a result, but areas with dominant colour whose tones have been reversed will also take on a colour that is complementary to their own. And since parts of the tonal range are reversed and others are not, the result is a variegated spread of colours.

Using small files

When working on smaller image files, the results on the image of applying extreme curves become increasingly unpredictable due to gaps in the colour data the software has to work with. When a W-shaped curve is applied, the picture becomes rather garish – an effect emphasized by the theatricality of the black sky. You can also see how some picture areas have sharply defined colours while others have smooth transitions, due to variations in the pixel structure of JPEGs (*pp. 82–3*).

Curves continued

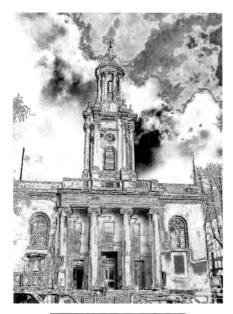

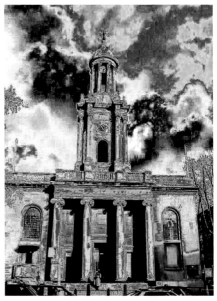

Posterized effects

By applying a shape of curve that exhibits more peaks, such as that here, less of the image is reversed to dark tones. Although, as you can see in the resulting image, this produces a much brighter image overall, the many steep parts of the curve cause an effect something like that of posterization – the poster-like separation of colours into clearly segregated bands without the usual colour transitions. This in large part contributes to the broken-up texture of the picture. If you wished to refine this style of image to a greater degree, then it might be best, after applying the Curve control, to bring the Dodge, Burn, and Saturation tools to bear in order to tidy up small areas of the picture. Such an area in the example shown here might be the distracting appearance of the black cloud looming ominously behind the church tower.

Keyboard shortcut

When you are experimenting with the Curves control to discover the range of possible effects offered by your particular software, you may not have to start from scratch each time. In many image-manipulation applications, including Photoshop, if you press a key, such as Alt or Options, while accessing the tool, it will open with the last used settings in place. With extreme Curves invoked, very small changes can have a marked effect on the image. Experiments such as these are all part of the fun.

Bit-depth and colour

The bit-depth of a colour file tells you how finely a piece of equipment can recognize or reproduce colours. It is a measure of resolution. Modern film scanners work to 24-bit RGB depth, or better (8 bits x 3 channels gives 24 bits). This means, in theory, that each channel is divided up into 256 equally spaced steps, which is the minimum requirement for good-quality reproduction. The total number of colours, if all combinations could be realized, is in the region of 16.8 million.

Higher resolution

Increasingly, we are finding that 24-bit does not measure up to our expectations – tones are not smooth enough and there is insufficient data to allow for dramatic changes in tones or colours. This is why, when applying curves with very steep slopes, the image breaks up into separate blocks of colour. Better-quality scanners can work in 36-bit depth or more – even when images are down-sampled back to 24-bit, results are better than if the scanner had worked in 24-bit. Some scanners even provide 48-bit RGB files, but there are very few image-manipulation software packages that can use them. Even the professional application Photoshop is limited in its ability to manipulate 48-bit files. But results are worth the extra effort, as images exhibit far smoother tones and fewer problems when Levels or Curves tools are used.

File size

Once the image is ready for use, you may find that very few colours are needed to reproduce it. A picture of a lion among sun-dried grass stems on a dusty plain will have very few colours, for example. Because of this, you may be able to use a small palette of colours and greatly reduce file size.

Some software allows images to be stored as "index color". This enables image colours to be mapped onto a limited palette of colours – the advantage being that the change from full 24-bit RGB to an index reduces the file size by two-thirds. Reducing the colour palette or bit-depth should be the last change to the image as the information you lose is irrecoverable.

Colour bit-depth and image quality
When seen in full colour (*top*), this image of coloured pens is vibrant and rich, but is the next image (*middle*), which contains a mere 100 colours, significantly poorer in quality? Yet this index colour image is only a third of the size of the full-colour original. As the colour palette is reduced still further, to just 20 colours (*above*), the image is dramatically inferior. However, since this change does not reduce file size any further, there is no point in limiting the colour palette beyond what is necessary.

⊛ Nikon F-80 with 70–180 mm lens. Nikon LS-2000 scanner.

Colour into black and white

Creating a black and white picture from a colour original allows you to change the shot's emphasis. For example, a portrait may be marred by strongly coloured objects in view, or your subjects may be wearing clashing coloured clothing. Seen in black and white, the emphasis in these pictures is skewed more toward shape and form.

The translation process

A black and white image is not a direct translation of colours into greyscale (a range of neutral tones ranging from white to black) in which all colours are accurately represented – many films favour blues, for example, and record them as being lighter than greens.

When a digital camera or image-manipulation software translates a colour image, it refers to a built-in table for the conversion. Professional software assumes you want to print the result and so makes the conversion according to a regime appropriate for certain types of printing press and paper. Other software simply turns the three colour channels into grey values before combining them – in the main giving dull, murky results.

There are, however, better ways of converting to black and white, depending on the software you

have. But before you start experimenting, make sure you make a copy of your file and work on that rather than the original. Bear in mind that conversions to black and white loses colour data that is impossible to reconstruct.

Before you print

After you have desaturated the image (*see box below*), and despite its grey appearance, it is still a colour picture. So, unless it is to be printed on a four-colour press, you should now convert it to greyscale to reduce its file size. If, however, the image is to be printed in a magazine or book, remember to reconvert it to colour – either RGB or CMYK. Otherwise it will be printed solely with black ink, giving very poor reproduction.

Four-colour black

In colour reproduction, if all four inks (cyan, magenta, yellow, and black) are used, the result is a rich, deep black. It is not necessary to lay down full amounts of each ink to achieve this, but a mixture of all four inks (called four-colour black) gives excellent results when reproducing photographs on the printed page. Varying the ratio of colours enables subtle shifts of image tone.

Desaturation

All image-manipulation software has a command that increases or decreases colour saturation, or intensity. If you completely desaturate a colour image, you remove the colour data to give just a greyscale. However, despite appearances, it is still a colour image and looks grey only because every pixel has its red, green, and blue information in balance. Because of this, the information is self-cancelling and the colour disappears. If, though, you select different colours to desaturate, you can change the balance of tones. Converting the image to greyscale at this point gives you a different result from a straight conversion, since the colours that you first desaturate become lighter than they otherwise would have been.

Saturation screen shot

With the colour image open you can access the Saturation control and drag the slider to minimum colour. This gives a grey image with full colour information. In some software you can desaturate the image using keystrokes instead (such as Shift+Option+U in Photoshop, for example).

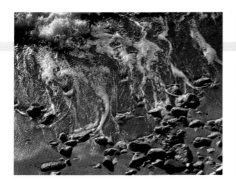

Colour saturation

While the original colour image is full of light and life, the colours could be seen as detracting from the core of the image – the contrasts of the textures of the water, sand, and stones. This is purely a subjective interpretation, as is often the case when making judgements about images.

● Leica M6 with 90 mm f/2 lens. ISO 64 film. Microtek 4000t scanner.

Colour desaturation

By removing all the colours using the Saturation control to give an image composed of greys, the essentials of the image emerge. The Burn and Dodge tools (*pp. 102-3*) were used to bring out tonal contrasts – darkening the lower portion of the picture with the Burn tool, while bringing out the sparkling water with the Dodge tool.

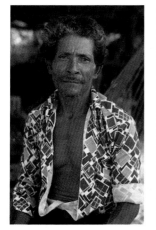

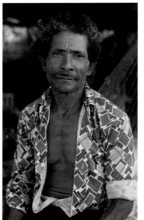

Overcoming distracting colour

The colour of the shirt in the original image (*above left*) detracts from the calm and quiet dignity of the subject. However, a straight desaturation of the image (*above middle*) leaves the whites and pattern contrast too apparent, so the shirt still represents a distraction.

However, by reducing the white point (*above right and below*), the pure white areas have been eliminated. This has the effect of softening image contrast overall and so toning down the impact of the shirt. As a result, however, some light was lost from the subject's face, but this was returned with a few touches of the Dodge tool to bring out the catchlights in his eyes and the light areas on his face.

● Nikon F2 with 50 mm f/l.4 lens. ISO 64 film. Nikon LS-1000 scanner.

Levels screen shot

With the desaturated image open, move the white point slider in the Levels dialogue box to force the brightest pixels to be about a fifth less bright: in other words, to have a value no greater than 200.

Colour into black and white continued

Channel extraction

Since a colour image consists of three greyscale channels, the easiest way to convert the colour to greyscale is to choose, or extract, one of these and abandon the others. This process is known as "channel extraction", but it is available only as part of more professional software packages.

When you view the image on the monitor normally, all three colour channels are superimposed on each other. However, if you look at them one channel at a time, your software may display the image as being all one colour – perhaps as reds of different brightnesses, for example, or as a range of grey tones, according to the software preferences you have set. If your software gives you the option, choose to view the channels as grey (by selecting this from the preferences or options menu). Then, simply by viewing each channel,

you can choose the one you like best. Now when you convert to greyscale, the software should act on the selected channel alone, converting it to grey.

Some software may allow you to select two channels to convert to grey, thus allowing you a great deal of experimentation with the image's appearance. In general, the channels that convert best are the green, especially from digital cameras, because the green channel is effectively the luminance channel, and the red, which often gives bright, eye-catching results.

Another method, available in the popular Photoshop program, is to use Split Channels to produce three separate images. With this, you save the image you like and abandon the others. Note, however, that this operation cannot be undone – the extracted file is a true greyscale, and is just a third the size of the original file.

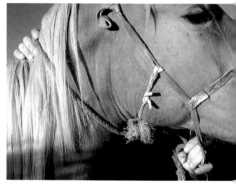

Red-channel extraction

While the colours of the original image are sumptuous (*above left*), black and white seemed to offer more promise (*above right*). It is clear that the sky should be dark against the mane and cradling hand, so the green and blue channels (*right*) offered no promise. Neither did the

lightness channel (*opposite*), as it distributes tonal information too evenly. The red channel, however, presented the blues as dark and the brown of the horse as light. So, with the red channel extracted, no extra work was needed.

● Canon F-1n with 135 mm f/2 lens. ISO 100 film. Microtek 4000t scanner.

Channels screen shot

If your software allows, select colour channels one at a time to preview the effects of extraction. Turn off the colour if the software shows channels in their corresponding colours.

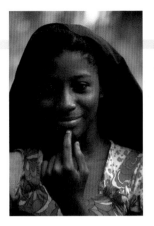

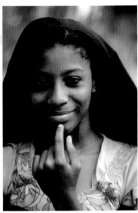

Blue channel

Red channel

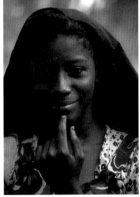

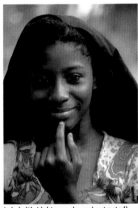

Green channel

Lab (with Lightness channel extracted)

Comparing channels

The three greyscale images that make up the original colour image (*top left*), photographed in Kenya, can be seen in the Channels screen shot (*above*). An image from the blue channel alone is very dark because there is little blue in the image. In contrast, the red channel is too light and seems to make the girl's face look insubstantial, while the dress is nearly white because of its high red content. The green channel is, overall, the best balanced since it carries much of the detail information. As a final experiment, the colour image was converted from RGB to Lab mode and the Lightness channel extracted (*right*) – the other two carry hardly any detail information. The advantage of this approach is that, given a well-balanced original, it needs no further manipulation.

● Canon F-1n with 135 mm f/2 lens. ISO 100 film. Microtek 4000t scanner.

Lab mode

When you convert a colour image image to LAB, or Lab mode, the L channel carries the lightness information, which contains the main tonal details about the image. Using software such as Photoshop, you can select the L channel and manipulate it with Levels or Curves. With the L channel selected, you can now convert to greyscale and the software will use only the data in that channel. If your software gives you this option, you will come to appreciate the control you have over an image's final appearance, and results are also likely to be sharper than if you had extracted another of the channels to work on. The extracted file is a true greyscale, and so is only a third the size of the original colour file.

Colour into black and white continued

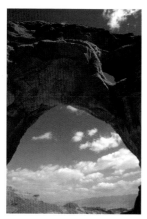

Original image
A simple conversion of this image could make colours look lifeless – a problem avoided by using the Channel Mixer control (*below*).

⦿ Canon F-1n with 20 mm lens. ISO 100 film. Microtek 4000t scanner.

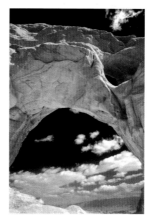

Working in RGB mode
In RGB, the blue channel was reduced, making the sky dark, and the red was increased to compensate. Results of using these settings are contrasty and dramatic, but the foreground is too bright.

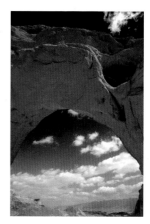

Working in CMYK mode
With the original image translated into CMYK mode, results are noticeably softer than those achieved via the Channel Mixer in RGB mode.

Channel Mixer control

A coloured filter used in black and white photography looks a certain colour because it transmits only its own colour waveband of light. Thus, a yellow filter looks yellow because it blocks non-yellow light. If you then use this filter to take a picture (making the appropriate exposure compensation), yellows in the resulting image are white and the other colours look relatively dark.

Lens filters are limited by the waveband transmissions built into each piece of glass, irrespective of the needs of the subject. But using the Channel Mixer tool you can choose from, in effect, an infinite range of filters until you find the ideal one for each subject.

Using this tool, you can now decide how to convert a colour image to greyscale – making greens brighter in preference to reds, for example, or making blues dark relative to greens. Depending on your image software, you may also be able to work in RGB or CMYK (*see above*), the two methods producing different results.

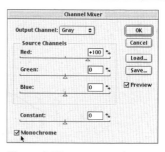

Channel Mixer screen shot
With the control set to monochrome, the result is grey. If one channel is set to 100 per cent, and the others at 0, you are effectively extracting that channel. This is more powerful than channel extraction (*pp. 124–5*).

If you set the control to Preview you can see the image change as you alter the settings. For landscapes, increase the green channel by a large margin and correct overall density by decreasing the red and blue channels. Channel mixing is useful for ensuring that reds, which are dominant in colour images, are rendered brighter than greens.

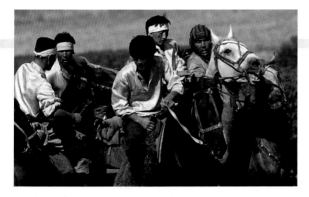

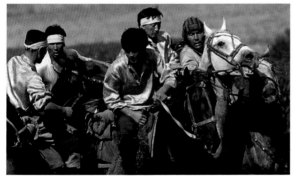

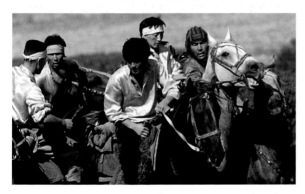

Separating tones

Starting with this colour image (*top left*), a standard greyscale conversion gives acceptable results (*middle left*), but channel mixing separates out the tones more effectively, particular in shadow areas (*bottom left*). The settings required were complicated, and arrived at by trial and error (*screen shot above*). The work done reduces the need for further processing of the image, but if you wish to refine the results further, a channel-mixed image makes such techniques as burning-in and dodging (*pp. 102-3*) easier to apply, since, as you can see, the shadows on the shirts are far more open and susceptible to local density control.

● Canon EOS-1n with 300 mm lens. ISO 100 film. Microtek 4000t scanner.

Duotones

Much of the art of traditional black and white printing lies in making the most of the limited tonal range inherent in the printing paper. A common tactic is to imply a wider tonal range than really exists by making the print contrasty. This suggests that shadows are really deep while highlights are truly bright. The success of this depends on the subtleties of tonal gradation between these extremes. A further technique is to tone the print, adding colour to the neutral grey image areas.

Modern digital printers have opened up the possibilities for toning well beyond that possible in the darkroom. The range of hues is virtually unlimited as you can simulate all those that can be created with the four-colour (or more) process.

Creating a duotone

Starting with an image, even a colour one, first turn the file into a greyscale (*see pp. 122–7*) using, in Photoshop, the Image > Mode menu. This permanently deletes colour information, so you need to work on a copy file. Similar results can be obtained in the Sepia Tone effect, a menu option in almost all image-manipulation applications.

Now that you have a greyscale image you can enter the Duotone mode, where you have a choice of going it alone or loading one of the preset duotones. If you are not familiar with the process, use the Duotone Presets (usually found in the "Goodies" folder of Photoshop). Double-click on any one to see the result.

Simple duotones
This view of Prague (*left*) has been rendered in tones reminiscent of a by-gone era. After turning the image to greyscale, two inks were used for the duotone, neither of them black. This gave a light, low-contrast image characteristic of an old postcard.
● Canon F-1n with 135 mm lens. ISO 64 film. Nikon Coolscan 4000 scanner.

Duotone Options screen shot
The curve for the blue ink (*above*) was lifted in the highlights in order to put a light bluish tone into the bright parts of the image and also to help increase the density of the shadow areas.

Clicking on the coloured square in the dialogue box (*see opposite*) changes the colour of the second "ink". Bright red could give an effect of gold toning; dark brown, a sepia-toned effect. This is a powerful feature – in an instant you can vary the toning effects on any image without any of the mess and expense of mixing chemicals associated with the darkroom equivalent.

If you click on the lower of the graph symbols, a curve appears that tells you how the second ink is being used, and by manipulating the curve you can change its effect. You could, for example, choose to place a lot of second ink in the high-lights, in which case all the upper tones will be tinted. Or you may decide to create a wavy curve,

in which case the result will be an image that looks somewhat posterized.

In version 5 and later editions of Photoshop, you can choose Previews. This updates the image without changing the file, allowing you to see and evaluate the effects in advance.

You need to bear in mind that a duotone is likely to be saved in the native file format (the software's own format). This means that to print it you may first have to convert it into a standard RGB or CMYK TIFF file, so that the combination of black and coloured inks you specified for the duotone can be simulated by the coloured inks of the printer. This is the case whether you output on an ink-jet printer or a four-colour press.

Retaining subject detail

In this original image (*above*), there was so much atmos-phere it was a pity to lose the colour. But the resulting duotone, with a green second ink, has its own charms (*above right*). To reduce

overall contrast and allow the green ink to come through, it was necessary to reduce the black ink considerably – as shown by the Duotone Curve dialogue box (*right*).
● Nikon FG with 70–210 mm lens. ISO 64 film. Nikon Coolscan 4000 scanner.

Duotone Curve and Color Picker screen shots

The low position of the end of the curve in the dialogue box (*above*) indicates a low density of black, but the kinks in the curve were introduced to increase shadow contrast and

retain subject detail. The lifted end of the curve shows that there are no real whites: the lightest part still retains nearly 14 per cent of ink, as shown in the top box labelled "0:" in the Duotone Curve dialogue box.

Tritones and quadtones

The addition of one or more inks to a duotone (*see pp. 128-9*) adds extra layers of subtlety to an image. Using most image-manipulation software, you will have tritone or quadtone boxes offering additional inks and curves for you to apply.

Bear in mind that with the extra inks on offer you can produce tinted highlights or you can hint at colours in the shadows that are not present in the mid-tones, and in this way create more tonal separation. But there is no substitute for experimenting by applying different curves and colours, as this is the best way to learn how to use this powerful control. As a starting point, try using colour contrasts by applying third and fourth inks in small amounts. Or, if you want a graphic-art type of effect, try curves that have sharp peaks.

One technical reason for using a quadtone is to help ensure accurate colour reproduction. While not guaranteeing results, the chances of an accurate four-colour black are greatly increased by specifying a quadtone in which the colours used are the standard cyan, magenta, yellow, and black of the printing process.

You can save curves and sets of colours and apply them to other greyscale images. When you find a combination that appeals to you, save it for future use in a library of your favourite settings.

Original image
Starting with this view of the city of Granada, in southern Spain (*above*), I first made a copy file of the original to work on. Then, using the copy file, I removed all the colour information to make a greyscale, before deciding on which inks to apply.
● Nikon Coolpix 990.

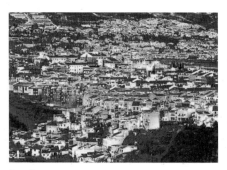

Quadtone
For this image, black has been assigned to the dark featureless shadows, green to those shadows that still retain details, and blue to the lower and mid-tones. This is shown by the peaks in the graphs next to each colour ink in the Duotone Options dialogue box (*above right*). Adjusting the heights of the peaks changes the strength of the colours.

Tritone
Assigning different-coloured inks to specific tonal densities in the image produces visual effects that are very difficult to achieve in any other way. In this tritone version of the scene, the fourth (blue) colour has been switched off, and the result is a brighter, lighter image compared with the quadtone (*above left*).

Sepia tones

With digital technology you can bring about image changes with more control than is possible in a darkroom. A prime example of this is the digital equivalent of sepia toning – the low-contrast, nineteenth-century technique that gives warm, brown image tone with no blacks or whites.

Old prints lack contrast due to the film's recording properties and the make-up of the print's emulsion. The softness is likely due to the lens, while the brown tone is down to the print being treated with a thiocarbamide compound.

Some digital cameras produce "sepia-toning", if correctly set, and various image-manipulation applications will also give these effects with just a single command, though with little control.

For controlled results, first convert your greyscale image to RGB colour mode. Once in RGB, desaturate the image. Invoke the Levels command (*see pp. 100-1*) and make the image lighter and greyer and then remove the blacks and whites.

Now you can add colour. The easiest way to do this is by using Color Balance (*see p. 112*) to increase the red and yellow. Or use the Variations command (if available) to add red, yellow, and possibly a little blue to produce a brown that you find suits the content of your image.

Another option is to work with a greyscale image in Duotone mode to add a brown or dark orange as the second ink. Using Photoshop, this provides the most subtle effects.

Using Variations
There are several ways to add overall colour to the type of interior view shown here. Although subject content is strong, the black and white version (*top left*) lacks atmosphere. The multi-image Variations dialogue box (*right*), an option available in most image-manipulation software packages, presents several versions of the toned original from which to choose. By clicking on one (*shown outlined in the dialogue box above*), you turn it into the image of choice, and you can then compare it against the original. To arrive at the final sepia-toned image (*bottom far left*), the Levels control was used to reduce shadow density and so produce a flatter contrast.

● Rolleiflex SL66 with 50 mm lens. ISO 125 film. Heidelberg Saphir II scanner.

Split toning

Toning is a traditional darkroom technique – or workroom technique, as darkness is not essential for the process. Here, the image-forming silver in the processed print is replaced by other metals or compounds to produce a new image tone.

The exact tone resulting from this process depends, in part, on the chemical or metal used and, in part, on the size of the particles produced

by the process. Some so-called toners simply divide up the silver particles into tinier fragments in order to produce their effect. Where there is variation in the size of particles, the image takes on variations in tone – from red to brown, for example, or from black to silvery grey. This variation in tone is known as split toning and is caused by the toning process proceeding at different

Using the Color Balance control
Images with well-separated tones, such as this misty mountain view, respond best to split toning. To add blue to the blank, white highlights of the mist, an adjustment layer for Color Balance was created. The Highlight Ratio button was clicked and a lot of blue then added. Another adjustment layer was then created, but this time the tone balance was limited to the shadows.

The Preserve Luminosity tickbox was left unchecked in order to weaken the strong corrections given: the screen shot (*above*) shows that maximum yellow and red were set. While this gives a satisfactory result, it can be refined further in some software packages (*right*).

● Canon F-1n with 80–200 mm lens. ISO 100 film. Nikon Coolscan 4000 scanner.

Blending Options
This is part of the Blending Options box from Photoshop. The colour bars show which pixels from the lower and which from the upper layer will show in the final image. With the sliders set as here, there is partial show-through – enabling a smooth transi-

tion between the blended and unblended image areas. For this layer, the underlying area shows through the dark blue pixels. In addition, a wide partial blend was indicated for all channels, allowing much of the light blue to show over the dark, reddish tones.

rates. These rates are dependent on the density of silver in the original image.

This, perhaps, gives you a clue about how the effect can be simulated digitally in the computer – by manipulating duotone or tritone curves (*see pp. 128–30*) you can lay two or more colours on the image, the effects of which will be taken up according to image density.

Another method is to use Color Balance (*see p. 112*), a command that is available in all image-manipulation software. This is easiest to effect in software that allows you to adjust the Color Balance control independently for highlights, mid-tones, and shadows. If your software does not allow this, you will have to use Curves, working in each colour channel separately (*see pp. 116–20*).

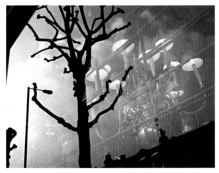

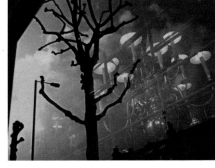

Using Tritone

The Tritone part of the Options dialogue box for the final image shows a normal curve for the first, orange-brown, colour. The second, blue, colour is boosted to darken the mid-tones, while the third colour, another blue,

supports the first blue. Without the addition of this third colour, the mid-tones would look a little too weak and lack visual impact.

● Leica M6 with 35 mm lens. ISO 400 film. Nikon Coolscan 4000 scanner.

Using Color Blance

Highlighting the similarity in shape between the tree reflected in the shop window and the lamps within in the original image (*top left*) was the aim here. At first, two colours – brown and blue – were used, but it was hard to create sufficient contrast between the dark and light areas. To help overcome this problem, another blue was added to boost the dark

areas, as shown in the Duotone Options dialogue box (*above left*) – the blue plus brown giving deep purple. Color Balance (*above right*) was shifted to help shadow saturation, and the lamps were also dodged a little. to prevent them being rendered too dark.

Hand tinting

Ever since the early days of photography, the hand colouring of black and white prints has been considered an art form, with its own palette of "permitted" tones. And because of the undeniable skill required by practitioners, the process tends not to be for the faint-hearted – the slightest mishap could cost you the entire print.

Working digitally

However, hand colouring in the digital domain is very different. It allows you risk-free experimentation, no commitment to interim results, and, of course, it is an entirely mess-free process.

This said, there are still some points you need to consider. Many photographers make the mistake of painting directly onto their image with the Brush tool set to Normal. This never works well because you are switching the pixel values of your image directly into the Brush colour. You may then try painting into a layer, but this does not help much either. Even if you change the opacity percentage in an attempt to make the effect more subtle, it still appears as if the colour has replaced the image. What you need to do instead is add the colour values, still using the Brush tool but to the greyscale values of the image, without changing

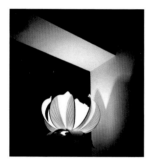

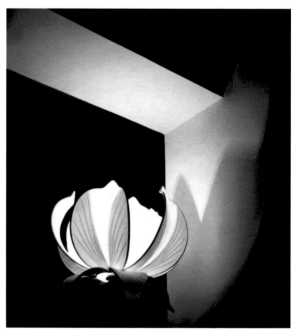

Colour combinations

To suit the strong shapes of the original (*top*), equally strong colours were called for. You can work with any combination of colours and it is worth experimenting – not only will some combinations look better, some will print more effectively than others. Bear in mind that a blank

area will not accept colour if the Color or Blending mode is set to Colorize. To give white areas density, go to the Levels control and drag the white pointer to eliminate pure white pixels. Once the pixels have some density, they have the ability to pick up colour. To give black areas colour, reduce the amount of black,

again via Levels control. Although the "paint" is applied liberally (*above left*), note in the finished print (*above*) that colour does not show up in the totally black areas.

● Rolleiflex SL66 with 80 mm lens. ISO 125 film. Heidelberg Saphir II scanner.

the luminance value of the pixels. That is the job of the Color or Colorize mode.

There are two ways of proceeding. The way most like painting is to set the Brush to Color and then paint away. The second is to create a new layer set to Color above the image, and paint into it. This makes it possible to erase errors without damaging the underlying image. If you find it easier, add strong colours to see what you are doing and then reduce the opacity afterward.

Pastel shades are often out-of-gamut with colour printers and monitors, so you may need to work with barely visible subtleties for the printed result to look soft enough. As yet, the porcelain-like textured finish of a good-quality, hand-coloured print is beyond the ability of ink-jets. The careful use of papers with tinted bases can help the effect, as the paper's tints will then narrow the dynamic range and soften contrast.

Painted layer

When tinting an image, you can apply the paint quite freely – as you can see in this image of the painted layer that lies above the base image. However, for a realistic final effect you need to use a range of colours to give variety. Unlike using real paints on a print, you can easily erase any unwanted mistakes and repaint the layer as often as you wish.

Reduced opacity

The spring-time foliage deep within an old wood (*above*) was emphasized by a great deal of detailed dodging (*pp. 102-3*) to lighten individual leaves. In order to introduce some colour into the scene, a new layer was created and its Blending mode was set to Color – this means that only areas with density are able to pick up colour (*above right*). The paint was then applied to this layer. Finally, the opacity of the layer was reduced to 40 per cent for the final image (*right*) to allow the quality of the foliage to show through the colour overlay.

● Nikon 601 with 20–35 mm lens. ISO 400 film. Nikon LS-2000 scanner.

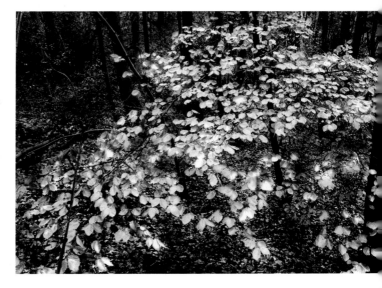

Cross-processing

Of the numerous unorthodox ways to process colour film, perhaps the most popular is developing transparencies in chemicals designed for colour negatives. Second is processing colour negatives in chemicals designed for colour transparency film.

Cross-processing techniques make fundamental and irreversible changes to the film, so there is much to be said for simulating the effects using digital image-manipulation techniques. There is a further advantage to working digitally. Colour negative film is overlaid with an orange-coloured mask whose job it is to correct inherent deficiencies in the colour separation or filtering process during exposure. Before the final print can be made, this mask has to be replaced or neutralized.

Colour negative film to transparencies

Results from this type of cross-processing have flat tones and muted colours due to the fact that colour negative film is low in contrast and transparency processing chemicals compress highlights. Colour is also unpredictable, resulting in colour balance in the highlights being different from that in the lower mid-tones and shadows.

Digitally, the Curves control is the best way to simulate this effect, though don't be alarmed if

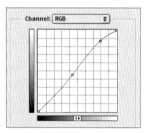

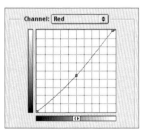

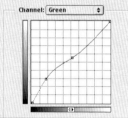

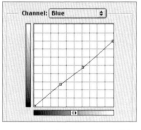

Processing negatives as transparencies

The flattening out of image contrast and the semblance of colour toning that results from processing colour negative film in chemicals intended for transparencies can become an interesting portraiture effect. By applying different curves to each colour channel (*above*), the colour balance was shifted away from the red (*above left*) toward the yellow-green colouration that is typical of this form of cross-processing (*left*). Note the posterization beginning to become

apparent in the shadow areas around the subject's eyes. This is due to the original image being shot on high-speed film. The curves that are given here are for your guidance only: you can start with these but you are likely to want to adjust them, particularly the master RGB curve, to suit the particular images you are working on.

● Canon F-1n with 135 mm lens. ISO 1000 film. Nikon LS-4000 scanner.

your image goes too dark or light – you can adjust overall brightness later. Another possible image outcome is posterization. If you find this effect unattractive, then the scan may be of insufficient quality. If so, your only option is to rescan the original image, possibly to a higher bit-depth (*see p. 121*).

From transparencies to colour negatives

Results from processing transparencies as colour negatives are often contrasty, with colour shifts toward cyan. They also have an open tonality, often with highlights reproducing as featureless white. This occurs because of the need to print inherently high-contrast transparencies on paper meant for the lower contrast of colour negatives.

The best way to create this digitally is to manipulate the separate channels in the Curves control. When you have a set of curves that work, you can save and reapply them to any image.

If you find it hard to concentrate on the overall lightness of the image while juggling with different channels, leave overall density to the end and work just on the colours and contrast. Once you are satisfied with these, call up the Levels control (*see pp. 100–1*) to adjust overall brightness.

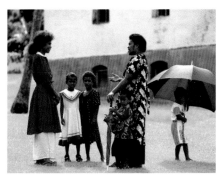

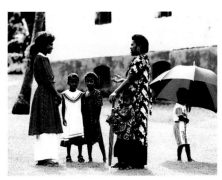

Processing transparencies as negatives

The high-contrast effect that results from cross-processing colour transparency film in colour negative chemicals works with subjects that have strong outlines and punchy colours (*above left*). By applying the set of curves shown here (*right*), the result is brilliant colour and the type of washed-out highlights typical of this form of cross-processing (*above right*). As the highlight areas are tonally balanced by the full shadows and strong colours, they are more acceptable than in an image with a normal tonal range. The curves are given here are for your guidance only: you can start with these but you are likely to want to adjust them, particularly the master RGB curve, to suit your particular images.

● Canon EOS-1n with 80–200 mm lens. ISO 100 film. Nikon Coolscan 4000 scanner.

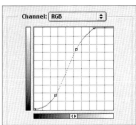

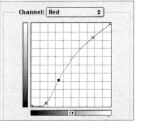

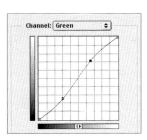

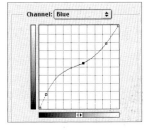

Filter effects

One of the alluring features of working digitally is being able to create, at the touch of a button, fantastic visual effects. These range from the dazzling to the ridiculous. However, while filter effects can impress, they are often solutions looking for visual problems. Experienced digital workers use filters only when they have a definite objective in mind.

Special filter effects are most useful when judiciously used with standard operations, where they lift an image into the extraordinary. However, not all filters are obvious or give strange results: some, such as Unsharp Masking, are essential tools.

The variety of different filter effects can be bewildering at first glance, so it may be helpful to classify them into broad categories.

Sharpness and Blur filters These affect the image, or selected areas, uniformly (*see pp. 104–7*). They work at the edges of image detail to increase differences at these boundaries (sharpening) or decrease differences (softening or blurring).

Distortion filters These change the shape of the image – either overall or small portions of it. These can be very tricky to control and need to be used with care (*see pp. 52 and 140*).

Art Materials and Brushstroke filters These filters aim to simulate such effects as charcoal drawing or painting brushstrokes by using image information and combining it with effects based on mimicking real artists' materials. With these may be grouped filters that are designed to break

Distortion filters
This extreme shape distortion was created using the Liquify filter in Photoshop. The effects can be extreme and cartoon-like in appearance. However, delicate distortions are also possible – such as putting a smile on a person's face, for example.
● Canon D30 with 28–135 mm lens.

Art Materials filter
Filters designed to imitate artists' techniques are readily available, and can be effective when applied to appropriate imagery. Adjustments to tone, colour, and sharpness after application of the filter often determine whether the effect is a success or failure.
● Canon EOS-1n with 28–80 mm lens. ISO 100 film. Nikon LS-1000 scanner.

up the image into blocks or which add "noise" (*see p. 143*).

Stylizing filters These use geometric shapes to build up the image, or else they base the new image on features, such as edges, of the original (*see p. 145*).

Texturizing filters These filters (*see p. 147*) are similar to Rendering filters in three-dimensional modelling programs. For example, lighting effects simulate a light shining on the image, and by altering the "surface" of the image, the light appears to give the image a texture. These filters make heavy demands on the computer and you may find large files cannot be processed if the machine does not have enough RAM.

Using filters

● Practise on small files when experimenting with filter effects.

● Try the same filter on different styles of image to discover which filters work best on particular types of imagery.

● Filters often work best if applied to selected areas.

● Repeated applications of a filter can lead to unpredictable results.

● You usually need to adjust contrast and brightness after applying a filter.

● Reduce the image to its final size on screen to check the effect of filters.

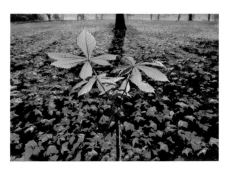

Stylizing filters
These filters take their cue from geometric shapes, applying them to images to create mosaic-like effects. Dramatic, three-dimensional effects, such as Extrude, are also possible.

They usually need to work on images that feature clear shapes and strong colours.

● Canon F-1n with 20 mm lens. ISO 100 film. Nikon LS-1000 scanner.

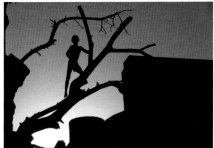

Texturizing filters
Texturizing filters, or the very similar Rendering filters, provide a range of challenging effects for digital photographers. The computer, too, is likely to be challenged

by them, since they all soak up a great deal of computing power.

● Canon F-1n with 80–200 mm lens. ISO 100 film. Nikon LS-1000 scanner.

Filter effects continued

Distortion filters

In essence, Distortion filters work by changing the position of a pixel in an image by moving its value onto another pixel while leaving the original colour and brightness information intact. The key point here is that the distance the pixel value is moved depends on its original position.

The effects of the filters can be applied over small, repeated grids, such as in the Glass Distortion, or globally, as in the Pinch filter effect. These filters change the inherent shape of objects in ways that are simply impossible to imitate using any type of conventional treatments, such as the special effects filters used on the camera lens or in a traditional darkroom.

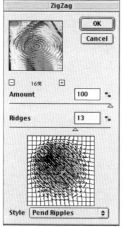

ZigZag (ripples)

This Distortion filter makes an image look as if it is a reflection in a pond. With any Distortion filter, it is vital to be able to control the degree of the effect (*above*). For an animation, you can increase the effect progressively, adding more ridges and saving separate images (later to be the animation "frames") for each step.

Pinch

This filter acts as if the image is on a rubber mat being squeezed or stretched. It compresses the "mat" toward the centre with most effect away from the diagonals. When lightly applied to a limited area, the filter is useful for subtle shape changes of small features. You can also experiment with rotating the whole canvas before applying the filter. Try rotating the image a little and applying the filter; then repeat with another small rotation. If any distortion is not enough, reapply the effect to strengthen it.

RAM problems

Rendering and Distortion filters use large amounts of RAM. If you run low, try distorting the image one channel at a time. However, if the image is not full of information, or suffers from noise, the effects of this method may not be the same as a single, simultaneous application. If you run out of RAM with other operations, try reducing the image file size a little at a time until you can perform the operation. Rendered images seldom need the resolution of an unblemished one, so you can resize images without worrying about loss of detail.

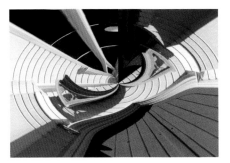

Polar Coordinates

This filter performs some very complicated mathematics in order to show how an image might look if it were projected onto a globe. Notice how the vertical lines in the church have been mapped into circular lines, as if the original image (p. 138) had been a map in two-dimensions of a three-dimensional globe, and the filter has returned the image to what would have been its original appearance. However, since the original image was not corrected for projection distortions, the filtered image appears to be strongly distorted.

Glass

Looking at an object through a refracting medium, such as glass, causes distortion. This filter imitates different types of glass, which you can nominate, as well as the size and strength of the effect. One way of using this filter is to duplicate the image on another layer, apply the effect, and then merge it with the original.

Filter effects continued

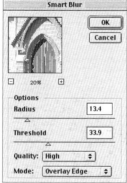

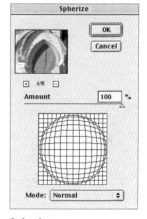

Smart Blur

With this filter you can specify a radius that sets how far the filter searches for dissimilar pixels to blur. In addition, you can set a threshold that determines how different the pixels' values should be before they are blended. In short, the filter can be set to leave the edges but blur lower-contrast detail. You can also set a mode for the entire selection or for the edges of colour transitions. Where there is significant contrast, Edge Only gives black and white edges; Overlay Edge gives white.

Spherize

This filter produces a simple distortion, making the image look as if seen through a water droplet. With high settings (*above*) the effect is not obviously useful, but when applied with a light touch it can be used for correcting lens distortions, such as those introduced by lens attachments. Try applying the filter to small sections of the image at a time – the effects on images that have clear lines can be visually very intriguing.

● TRY THIS

The best way to learn about digital filters is to work systematically through them, using a variety of images each time. Start by selecting three different colour images. One should have a single, strong shape, such as a leaf or a silhouette of a church. Another should have masses of detail – perhaps a landscape full of trees. The third test image should feature strong colours arranged in a pattern, which could be abstract. Resize the images to about 1 MB and save them with a new file name. Now try the different filters you have available on each one and make notes of which types of filter work best with each type of image.

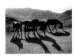

Art Materials filters

Filters that imitate the effects of artists' materials can be very rewarding. Different software packages approach this class of filter with varying degrees of success – ultimately, a filter that applies its effects in an indiscriminate manner across an image is not as versatile as building up effects by hand. However, they do provide quick solutions: the trick is in selecting the right type of image to work on. Choose those with simple outlines and clear shapes that do not rely on intricate details.

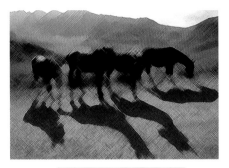

Crosshatch

This filter is often more effective when it is applied to black and white images, as it mimics the strokes used by artists to cover an area in tone. You need to experiment with different settings for length of stroke and other features (*above*). You have a choice of applying another filter to improve the Art Materials filter's appearance or to change the image to a black and white. Another option with an image such as the one here, is to print it onto highly textured paper. If you select the right paper stock, the interaction of the crosshatched strokes and the texture of the paper can create a very real impression of an artist's work.

Plastic Wrap

Filters can produce a metallic effect by creating neutral highlight areas accompanied by shadow regions. This is called Plastic Wrap in Photoshop, and by varying (in particular) Highlight Strength (*above*) with Detail set to follow the image outlines, the resulting image looks as if it has been printed and embossed onto a metal plate. If the shininess is too hard, however, image noise can increase as a result.

Filter effects continued

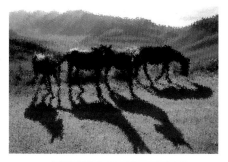

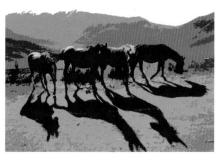

Spatter

The Spatter filter imitates an oil painting in which colour has been applied with a broad-bristle brush. Starting with an image that has very clear outlines is essential. To improve the simulation of the work of a real artist, you can increase the saturation of colours, as well as add a little unexpected colour to uniform areas. As an artist is unlikely to leave any canvas bare, you may need to clone some strokes into any white, empty areas.

Cutout

This filter uses areas of flat colour to produce an effect similar to a wood-cut. It reduces an image to its bare essentials and is useful when quick, graphics-like effects are called for. "No. of Levels" in the dialogue box refers to the number of different greyscale steps per channel. If you choose a high figure, there are more colours, and this reduces the effect of the graphic simplification of detail.

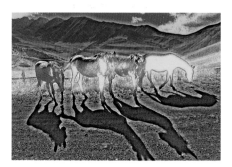

High Pass

This filter, in the Corel Painter application, produces a very surprising result when it is applied. The original image was too dark and it also lacked colour saturation, but with a little extra work the final result (*left*) has certain attractive, painterly qualities. The lesson to be learned here is that even if you know, or think you know, what a filter will do to an image, it is still worth taking the time to experiment – sometimes you will be surprised. "High Pass" is a technical term describing a filter that passes subject detail, or high-frequency information.

Stylizing filters

This class of filter uses image colour data from the original to build up blocks of colour, or the location of image edges, as the basis for producing graphics-like effects. It is always best to check the appearance of the image at the final size it will be viewed – some effects may look eyecatching when they are seen at large screen magnifications but they are subsequently lost when printed out at their final size. Beware of options such as Find Edges. These have alluring effects that seem to improve any image to which they are applied, but are popular to the point of being a cliché.

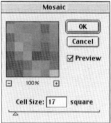

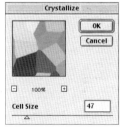

Mosaic

The filter produces pixellated-like images. It creates a representation of what an image would look like if you were to reduce its resolution considerably, and then enlarge it back up to the required size. In fact, it makes a lot of sense to work in just this way, as the resulting image will then be just a tiny fraction of its original file size. However, when using the filter, you can preview the results more easily. To improve further the effect of a low-quality image, you can posterize the colours, thus reducing the number of colours used in the image.

Crystallize

This simple filter averages out the colour under irregular, polygonal areas and gives each polygon a uniform hue. The size of polygons can be varied to match the output size (*above*). Some applications may call this filter effect Mosaic or Tessellation: the idea is that there are no gaps between the blocks of colour, which fully cover the image. With filters of this type, you may need to reduce the density of black areas of the image if they predominate. Not only can you work with very low-resolution images, you may, indeed, achieve better results if you do. One experiment worth trying is to compare the effects of the filter on the same image at both high and low resolutions.

Filter effects continued

Emboss

This filter emphasizes image outlines while leaving all other details a neutral grey. The outlines are then shown as if they are an embossed surface lit from the side. If you wish to obtain the best from this filter, experiment with the controls offered, which adjust not only the strength of the effect but also the direction from which the light appears to come.

Glowing Edges

The Glowing Edges filter builds on the Find Edges filter by adding a solarization effect. This partially reverses image tones and produces a neon-like glow around image borders. As a result, images are always dark and benefit from being lightened after the filter has been applied. "Edge Width" in the dialogue box (*above*) preserves the original image outlines if it is kept to low figures.

Working with filters

● When trying filters, use small files. Those 1 MB or smaller speed up all operations. Larger files of the same image, however, may give slightly different results.

● Make a careful note of any filter settings you try that produce effects you like.

● Avoid running other applications or performing tasks such as printing or Internet operations while using filters, as these slow down your machine.

● A filter once used is likely to run faster the next time (on modern computers it will have been stored in the RAM cache), so it may be easier to keep a few small images open and apply the same filter to each to try it out, rather than try a different filter each time.

● Incorporate the figures of settings you like to use by including them in the file name ("tree glow 2 6 5", for example).

Texturizing or plug-in filters

Filters that work on original image data and change both its colour values and pixel position can sometimes have weird and wonderful effects. These can be said to be Rendering filters as they apply a combination of surface texture and lighting properties – rather like the rendering processes in three-dimensional modelling programs used to create backgrounds for computer games.

Many filters designed to work within software applications, such as Photoshop or Painter, fall into the same category. They plug into these existing, larger applications, and it can take many hours of trial and error to learn how to use them effectively. Plug-in effects are readily available as Web downloads; in addition, they are frequently offered on a free trial basis with digital photography and computing magazines (*see also pp. 212–3 and 216–7 for further information*).

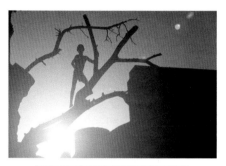

Lens Flare

This filter imitates the effect of a bright light source flaring into the camera lens. Plug-in collections that give a full range of effects are available, though software such as Photoshop has only basic controls. The dialogue box here shows just three types of effect, corresponding to different lenses, and a flare-strength control. You can also change the position of the "light source". Although it appears to be a simple filter, it makes considerable demands on the computer, so you need ample RAM.

Stained Glass

This filter combines the effects of an Art Materials filter with Texture and Lighting filters. You need to choose the colour of the borders with care: an inappropriate one will ruin the effect of the changes. As this and similar filters, such as Mosaic, greatly simplify colour data as well as reduce detail, you can save images as very small JPEG files without worrying about loss of quality.

Filter effects continued

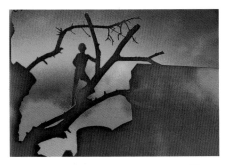

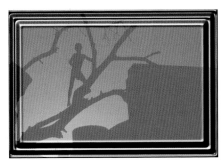

Clouds (via Levels)

The Clouds filter reverses colour values in a non-uniform way. The result of applying this filter is difficult to predict, but on images with plain, clear outlines it can be dramatic. If you apply the filter, then reduce its opacity over the original image, you can produce a very passable imitation of a badly faded colour print. As well, you can apply the filter twice (*top*) and darken with Levels (*top and above*) to elaborate the effect – or even more times to explore stranger and stranger effects (*below*).

PhotoGroove

The PhotoGroove is a plug-in filter from the Extensis Phototools set, and it is useful for giving images a highly customizable border – as if they were wrapped over a box cover. Not only can you vary the width and height of the border, the profile of the border's shape can also be precisely drawn (*above*). The border design here suggests a metallic box on which the image has been printed (*top*).

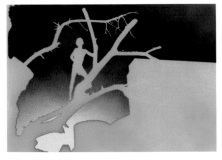

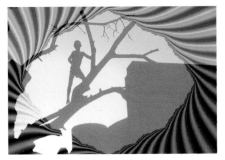

Multiple clouds

Applying filters more than once can give rise to unpredictable results. Here, the colours are far removed from those of the original, while the sharpening effect on image contours was unexpected.

Fractal explorer

This filter, part of the range of KPT plug-in filters, delivers a bewildering array of options that operate together to produce millions of visually challenging combinations.

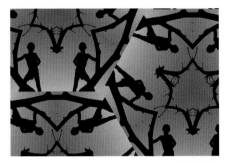

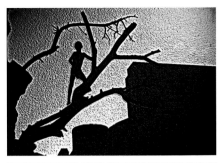

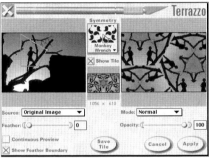

Terrazzo

The Terrazzo plug-in filter from Xaos Tools is a very efficient short-cut to some striking graphics effects. Quick and easy to use, it is able to turn the most mundane of images into stunning patterns. It works rather like a kaleidoscope, in which you can control, to a fine degree, the number and placement of the mirrors. The filter acts on a nominated part of the image – here the boy in the tree – and the resulting render, or tile, is repeated until the whole image area is filled.

Lighting Effects

The dialogue box for this filter looks complicated (*above*), but it is worth persevering with. The filter allows you to apply different shapes and qualities of light, varying its colour and position, and applying simple textures. The filter takes some time to work, due to the calculations needed, but the preview image is accurate and you can try different settings before you commit to one. It is easy to get lost, so make notes of setting combinations you like before moving on to a new one. For this effect (*top*), the settings have increased contrast and made the image look as if it is printed on a textured, metallic surface with a strong light from the lower left.

Behind the scenes

Image filters are groups of repeated mathematical operations. Some work by operating on small parts of an image at a time; others need to "see" the entire image at once. For example, the USM filter looks at blocks of up to 200 pixels square at a time, while Rendering loads the entire image into memory. A simple filter effect to understand is Mosaic. The filter takes a group of pixels, according to the size you set, and calculates their average value by adding them all and dividing by the number of pixels. It then gives all the pixels in the group the same value, so the pixels appear greatly enlarged. The filter then moves to the next set of pixels and repeats the operation. Most Mosaic filters can work on small image segments at a time, but some need to operate on the entire image for each calculation. These latter types require a great deal of computer memory and calculating power. Add all of these operations together and you obtain the pixelated effect of the Mosaic filter.

Selecting pixels

There are two ways of limiting the action of an image-manipulation effect: using a tool that applies the effect locally (a Dodge tool or Brush, for example); or selecting an image area and applying the effect just to those pixels.

Making a selection

One method is to select every pixel contained within an area defined using, say, the Lasso or Marquee tool: these pixels can be of any value or colour. In this case, the pixels are said to be contiguous. Or you can select pixels from across the image that are the same as or similar to a colour you specify, using a tool often called the Magic Wand. As there may be gaps between these areas, this selection is said to be non-contiguous.

A crucial aspect of selection is that you can partially select a pixel near the edge of a selection in order to "feather" the effect. This creates a gradual transition across the boundary from pixels that are fully selected through those that are partially selected to those that are unselected, thus smoothing out the image-manipulation changes.

The effect of selecting a local, defined set of pixels for the changes to work on has an effect similar to that of masking (see pp. 154–5). But there are important differences. First, a selection is a temporary mask – it disappears as soon as you click outside a selected area. Second, in software with Layers, the selection applies only to the layer that is active or chosen. Third, with some software, you can copy and move selected pixels – something that cannot be done with a mask.

Some advanced software provides two different types of image data – bitmap and vector. If so, you need to use different tools to make selections. When you select pixels, you can also create selections using the Pen or Shape tools to give precise outlines called paths. A path is a vector shape that contains no pixels.

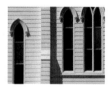

Original image
This cropped view of a church in New Zealand shows the original, unmanipulated image. The change I wanted to make here was to the windows, which looked too dark in contrast to the colour of the boarded exterior.
● Canon D30 with 28–135 mm lens.

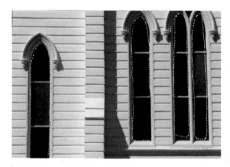

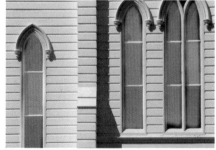

Making a selection
Using Photoshop's Lasso, with a feathering width set to 11 pixels, I selected the dark glass within the window frames. To start a new area to be selected, hold down the Command key (for Macs) or the Control key (for PCs) – the selected area is defined by moving dashes, known as "marching ants". When the Levels command is invoked, settings are applied only to the selections.

Final effect
In some circumstances, the somewhat uneven result of using the Lasso selection can produce more realism than a perfectly clean selection would give. The dark areas remaining toward the bottom of the right-hand windows correspond to the area omitted from the selection in the previous image (above left).

●HINTS AND TIPS

● Learn about the different ways of making a selection – some are obvious, such as the Lasso or Marquee tool, but your software may have other less-obvious methods, such as Color Range in Photoshop, which selects a band of colours according to the sample you choose.

● Use feathered selections unless you are confident you don't need to blur the boundaries. A moderate width of around 10 pixels is a good start for most images. But adjust the feathering to suit the task – for a vignetted effect, use very wide feathering, but if you are trying to separate an object from its background, then very little feathering produces the cleanest results. Set the feathering before making a selection.

● Note that the feathering of a selection tends to smooth out the outline: sudden changes in the direction of the boundary are rounded off. For example, a wide feathering setting to a rectangular selection will give it radiused corners.

● The selected area is marked by a graphic device called "marching ants" – a broken line that looks like a column of ants trekking across your monitor screen: it can be very distracting. On many applications you can turn this off or hide it without losing the selection: it is worth learning how to hide the "ants".

● In most software, after you have made an initial selection you can add to or subtract from it by using the selection tool and holding down an appropriate key. Learning the method provided by your software will save you the time and effort of having to start the selection process all over again every time you want to make a change.

● Examine your selection at high magnification for any fragments left with unnatural-looking edges. Clean these up using an Eraser tool or Blur tool.

● Making selections is easier to control with a graphics tablet (*see p. 32*) rather than using a mouse.

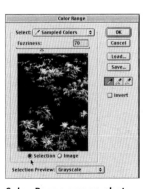

Original image
The brilliant red leaves of this Japanese maple seem to invite being separated out from their background. However, any selection methods based on outlining with a tool would obviously demand a maddening amount of painstaking effort. You could use the Magic Wand tool but a control such as the Color Range control (*right*) is far more powerful and adaptable.

Color Range screen shot
In its implementation in Photoshop, you can add to the colours selected via the Eye-dropper tool by using the plus sign; or by clicking the eye-dropper tool with a minus sign (beneath the "Save" button), however, you can refine the colours selected. The Fuzziness slider also controls the range of colours selected: a medium-high setting, such as that shown, ensures that you take in pixels at the edge of the leaves, which will not be fully red.

Manipulated image
Having set the parameters in the Color Range dialogue box (*above left*), clicking "OK" selects the colours – in this case, just the red leaves. By inverting the selection, you then erase all but the red leaves, leaving you with a result like that shown here. Such an image can be stored in your library to be composited into another image or used as a lively background in another composition.

Quick fix Removing backgrounds

One of the commonest image-manipulation tasks is to eliminate a background. There are two main methods: one is to remove the background directly by erasing it (time-consuming); the other is to hide it under a mask.

Problem

The main problem is how to separate a foreground object from its background while retaining fine edge detail, such as hair, or maintain the transparency of a wine glass and retain shadows and blurred edges.

Analysis

Almost all edges in images are slightly soft or fuzzy – it is more the transitions in colour and brightness that define edges. If a transition is more sudden and more obvious than other transitions in the locality, it is seen as an edge. If you select the foreground in such a way as to make all its edges sharp and well defined, it will appear artificial and "cut-out". However, much depends on the final size of the foreground: if it is to be used small and hidden by a lot of other detail, you can afford a little inaccuracy in the selection. If not, you must work more carefully.

Solution

Make selections with edge transitions that are appropriate to the subject being extracted. The usual selection methods – Lasso or Magic Wand – are sufficient most of the time, but complicated subjects will need specialist tools, such as Corel KnockOut, Extensis Mask Professional, or the Extract Image command in Photoshop.

How to avoid the problem

With objects you expect to separate out, it is best to work with a plain backdrop. However, while a white or black background is preferable to a varied one, even better is a coloured ground. The aim is to choose a colour that does not appear anywhere on the subject – if your subject is blond, has tanned skin, and is wearing yellow, a blue backdrop is perfect. As well, avoid using rimlighting, as this imparts a light-coloured fringe to the subject. In addition, avoid subject-movement blur and try to keep an extended depth of field so that any detail, such as hair behind the subject's head, is not soft or fuzzy.

Low tolerance

With simple tasks, such as removing the sky from this image, the Magic Wand or similar tool, which selects pixels according to their colour and is available in almost all image-manipulation software, is quick to use. It has just one control – the tolerance – which allows you to set the range of colours to be selected. If you set too low a tolerance (here the setting was 22) you obtain a result in which only a part of the sky is selected, seen by the marching ants occupying just the right-hand portion of the sky and small, isolated groups.

● Nikon Coolpix 990.

Removing the sky

Adjusting the tolerance setting in small, incremental steps allows you to see when you have captured just the right area to be removed. Then, pressing "OK" removes your selection. The edges of the selection may be hard to see in a small image, but are clearly visible on a large monitor screen.

High tolerance

If you set too high a tolerance, you will capture parts of the building where it meets the sky. Here, notice the result of setting a large feathering (111 pixels) to the selection – pixels a long way either side of a target pixel are chosen. As a result, the selection is smoothed out and the boundary is very fuzzy.

1 Original image

This original image of a young Afghan girl, who is also an expert carpet weaver, shows her taking to the floor to dance. Unfortunately, the distracting background does not add to the image as a whole.

● Canon EOS-1n with 80–200 mm lens. Microtek 4000t scanner.

2 Defining fore- and background

Using Corel KnockOut, I first drew inside the girl's outline to define the foreground and then outside her outline to define the background. The region between the two outlines comprises the transition area that allows soft boundaries to be smoothly masked.

3 Making the mask

Using the information from the previous step, a mask is created. The mask outlines the foreground while hiding the background: the black shows the hidden area and the white where the image will be allowed to show through.

4 Knocking out the background

Now, while the mask hides part of the image on its own layer, it does not affect images on another layer (*below left*). Therefore, if you place an image behind the mask, you will see that image appear.

5 Layers screen shot

The Layers dialogue box shows the little girl and the associated mask lying over the introduced image. Because the mask was produced by extracting the girl, the original background is gone, awaiting a new background image to be introduced.

6 Masked combination

The background was lightened to tone in with the colours of the girl. The mask has preserved the softness of the girl's outline, and now she appears to be dancing in front of the wall-hanging. An extra refinement may be to soften the background so that it appears less sharp.

Masks

Masks allow you to isolate areas of an image from colour changes or filter effects applied to the rest of the image. Unlike real-life masks, digital types are very versatile: you can, for example, alter a mask's opacity so that its effects taper off allowing you to see more or less clearly through it. Using image-manipulation software you can alter a mask until you are satisfied with it and then save it for reuse. When you do so, you create what are known as "alpha channels", which can be converted back to selections. Technically, masks are 8-bit greyscale channels – just like the channels representing the colours – so you can edit them using the usual array of painting and editing tools.

If your software does not offer masks, don't worry – it is possible to carry out a good deal of work by the use of selections. But remember that selections are inclusive – they show what will be included in a change; masks work the opposite way, by excluding pixels from an applied effect.

Software takes two approaches to creating masks. First is Photoshop's Quick-mask, which gives direct control and allows you to see the effect of any transitional zones. Or, you can create a selection that is turned into a mask. This is quick, but transitional zones cannot be assessed.

Quick-mask

In Photoshop and Photoshop Elements you hit the Q key to enter Quick-mask mode. You then paint on the layer and hit Q again to exit, but in the process, you turn the painted area into a selection. You can also invert your selection (select the pixels you did not first select) – sometimes it is easier to select an area such as bright sky behind a silhouette by selecting the silhouette and then inverting the selection. You then turn the selection into a mask by adding a layer mask.

The layer mask makes all the underlying pixels disappear, unless you tell it to leave some alone. When applying a layer mask, you can choose to mask the selected area or mask all but the selected area. The advantage of Quick-mask is that it is often easier to judge the effect of the painted area than it is to make many selections. It also means that an accidental click of the mouse outside a selection does not cancel your work – it simply adds to the mask. Use Quick-masking when you have many elements to mask out at once.

Turning selections into masks

Some methods of selecting pixels have already been discussed (*see pp. 150–1*). If you need a

Using Quick-mask

1 Bottom layer
Quick-mask, or any method where you "paint" the mask, is best when you are not attempting to enclose a clearly defined shape, such as a person's silhouette. It is best first to place the image that will be revealed under the mask – in this example, it is an Islamic painting.

2 Creating the mask
Next, the mask is applied to the main leaves in this negative image. The red colour shows where the free-hand masking will be created. When it is turned into a mask, this is the area that will allow the base image to show through.

sharp-edged selection whose scale you can change without losing crispness of line, then you need to create a clipping path.

Although almost anything you can do with masks you can do with selections, it is convenient to turn a selection into a mask as it is then easier to store and reuse – even for other images. It is good practice to turn any selection you make into a mask (just in case you wish to reuse it), particularly if it took a long time to create.

Alpha channels

Alpha channels are selections stored as masks in the form of greyscale images. The convention is that fully selected areas appear white, non-selected areas are shown black, while partially selected areas appear as proportionate shades of grey. In effect, an alpha channel is just like a colour channel, but instead of providing colour it hides some pixels and allows others to be visible. An alpha channel can be turned into a selection by "loading" the selection for that channel. The term "alpha" refers to a variable in an equation defining the blending of one layer with another.

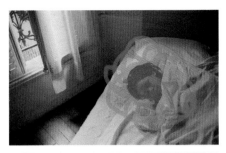

Limiting filter effects
Here (*top*), the mask has been applied to "protect" the child's face from the effect of the Stylize/Extrude filter. Note that when you turn the painted area into the selection, the mask would be applied only to that selection, so you have to invert the selection to take in everything but the face. When the filter was applied (*above*), it worked only on the pixels that were not protected.

Quick-mask Layers screen shot
This dialogue box shows that the painting forms the bottom layer (but not the background, as masks cannot be applied to the background). The top layer consists of the grass and, to the right, the mask is also shown.

Final effect
You can move the underlying image around until you are happy with the results – in other words, when the most effective areas are showing through within the areas defined by the masking.

Greyscale and colour

The usual way to obtain greyscale images – those with no colour information – is by making a scan of existing artwork. Even if the artwork contains colour, you can still scan into greyscale, which, incidentally, will usually speed up scanning. Or you can scan in full colour and then drop the colour data to make a greyscale (*see pp. 122–7*).

If the artwork consists of sharp black and white lines then you will need to take extra care with the scanning if you hope to maintain the crispness of the contours, and you will also need a high resolution setting on your scanner. Should you wish to scan into bit-map (an image in only black or white), then you should set the highest possible resolution. This is because you lose the anti-aliasing effect provided by the intermediate tones and, therefore, need the highest possible resolution to avoid stair-stepping or jagged-edged ("jaggies") artefacts. This applies particularly to originals with subtleties of shape and form. Unfortunately, when you use the highest resolution required to capture the fine details, you will also pick up all the defects in the paper which we normally ignore. Do not be tempted to remove them by raising the contrast of the image as you will destroy detail in the writing. Instead, use cloning tools to remove the defects (*see pp. 160-5*).

● Remove dust specks and other defects carefully before combining a greyscale with other images. These defects can be hard to spot but they can become very evident in certain layer blend modes.

● You can control the effect of certain blends by changing the opacity of either top (blending) or bottom (source) layers – not just the uppermost layer.

● For best results, avoid increasing the size of a component image by a large amount once it is layered with another image. Rescan if necessary – otherwise the mix of sharp and unsharp images that results will look unprofessional.

Output densities
If your image has large, completely black areas, you need to take special care when printing or the paper may become saturated with ink. Reduce the output levels in the Levels control, or equivalent, in your software.

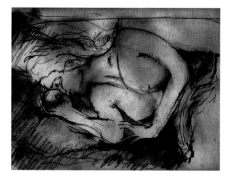

Choosing the colour component
When I was considering which colour picture to combine with the greyscale image (*above right*) I looked for a subject that was soft in contrast and contained lots of texture. In order to combine the two images, the greyscale component must be turned to full-colour.

The greyscale component
I scanned the original graphite drawing as a greyscale image with the background kept grey rather than white. This was essential as I intended to add colour to the whole image, and pure white would not be coloured.

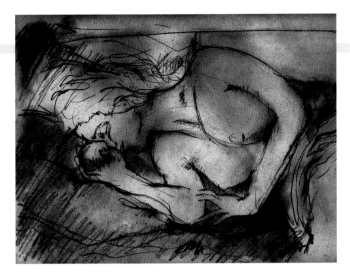

A change of mood
Simply by using a different image to add colour to the greyscale, as done here, you can very quickly achieve a totally different feel and atmosphere. As the donor image was pastel in tone, it was placed at 100 per cent.

Coloured drawing
By laying the coloured image over the greyscale and setting the Layer mode to Color, you effectively add colour to the drawing without overriding the underlying tones. You will need to adjust both the opacity of the top layer as well as the tonal quality of both layers to obtain exactly the right effect. If the receiving (lower) layer is darker, it takes on more colour; if the donor (top) layer is of higher opacity, it places more colour into the lower layer. Here the opacity was reduced to 85 per cent in order to soften the colours.

Difference mode
For a totally different type of toning effect for greyscale images, try applying the top layer in Difference mode. This mode, as always, produces dramatic effects. By reducing the opacity, or strength, of the mode in the Layers dialogue box to just 35 per cent (*above right*), an intriguingly rich texture has been added to the drawing (*above left*). The image in the colour layer was moved sideways to ensure that any distracting details were not located on the face.

Text effects

Typefaces, also known as letter-forms or fonts, can be treated in many unique ways using image-manipulation software. Letters can be made to flame up, for example, dissolve into clouds, recede and blur into the distance, or appear transparent over another image – the possibilities are truly unlimited. All image-manipulation applications offer at least a basic range of effects, but if they also accept Photoshop-compliant plug-ins, you can greatly extend your repertoire.

Note, however, that text can sit uncomfortably with image pixels. The reason is that type is best

digitally encoded as "vector graphics", whereas photographic images are best encoded as "bitmap graphics" (*see below*). Nearly always, the text would have to be turned from vector into a set of bit-mapped pixels, resulting in a loss of clarity and sharpness. As a consequence, as you increase the size of an image that incorporates text, the letter-forms quickly start to look ragged, with poorly defined outlines. More than anywhere else in image manipulation, if you work with text always work at the full output size; and avoid altering the image size after applying text to the image.

Bitmap and vector graphics

There are two classes of graphic image. Digital cameras all produce a bitmap type of image, also called a raster image, which is based on a grid of data (the coloured pixels). Each pixel is placed in a specific location and given a colour value. Image manipulation is all about altering pixels, and so such images are resolution-dependent – that is, they start with a fixed number of pixels and thus a change in image size alters the amount of detail that is available.

Vector graphics, also known as object-oriented images, are described according to their geometrical basics – lines, circles, and so on – with their location, together with operations such as stroke (to draw a line) or fill (to cover an enclosed area with colour). Vector graphics are said to be resolution-independent – that is, they can be scaled to any size and printed at any resolution without losing sharpness, and so can always use the output device's highest resolution.

Vectors are best for describing text as well as graphics such as company logos, and are created by graphics software such as Macromedia FreeHand, Corel Draw, or Adobe Illustrator. You may discover that the more complicated letter-forms, such as those with scrolls or long loops, may not print properly in your printer: if so, you may need to install special software to interpret the vector information, called a PostScript RIP (Raster Image Processor).

Display type
If you wish to add type effects to a face it is advisable to start with a chunky display type such as Postino Italic shown here, with its vertical scale increased to stretch its height. With a colour chosen to contrast with the rest of the image, the effect is unattractive and garish, but it is easy to read at any size.

Drop shadow
By asking the image-manipulation software to create a drop shadow, you make the letters appear as if they are floating above the image. The overall effect is of a poster. The colour of the type was toned down to that of a tint of white: any light tint of white is likely to be an effective and safe choice of colour for type.

It is always best to check the typeface at full size by printing it out. Check again if you change the face: even at the same point size, different typefaces vary considerably in legibility. Consider, too, the following points:

● Use typefaces with narrow lines where they contrast well with the background; faces with broad shapes should be used where the contrast is less obvious.

● You can use typefaces with narrow outlines if you create effects that separate the text from the underlying image, such as with drop shadows.

● Use typefaces with broad lines if you want to use them for masking or to allow images to show through.

● Avoid faces with narrow serifs – the little extensions to the end of a stroke in a letter – as these are easily lost into the underlying image. In addition, avoid letterforms with hollow strokes or those made up of double strokes for the same reason.

● Use only small amounts of text when combining it with images – at best a heading and at most a short block of text; but avoid using more than 50 words.

Inner shadow
Here, an inner shadow in pink has been applied with a high level of noise, so creating the appearance of rough texture. Drop shadows have been retained, but note that the "light" can be made to come from different directions.

Text warp
Distortion of text can be effective for drawing the viewer's attention. Here, the text has been warped as if it is a waving flag. In addition, various stroke and inner glow effects were applied to make the type look metallic.

Graduated overlay
Another way of making the type lively is to make the colour appear graduated. Here, colours move between yellow and orange. The gradient chosen was sloped so that it runs across the type at an angle. With these effects you can produce comic-book effects that used to have to be laboriously hand-painted.

Eye Candy's Fire
Plug-in software can bring very powerful effects to type. Here, with the type area of the image selected, Eye Candy's Fire filter was applied to make the words look as if they are going up in flames. You can adjust all the important parameters of the effect – such as the size of the flames, their angle, and their colours.

Cloning techniques

Cloning is the process of copying, repeating, or duplicating pixels from one part of an image, or taking pixels from another image, and placing them on another part of the image. First, you sample, or select, an area that is to be the source of the clone and then, second, apply that selected area where it is needed. This is a basic tool in image manipulation, and you will find yourself constantly turning to it whenever you need, say, to

replace a dust speck in the sky of an image with an adjacent bit of sky, or remove stray hairs from a face by cloning nearby skin texture over them.

This is only the start, however. Such cloning makes an exact copy of the pixels, but you can go much further. Some applications, such as Corel Painter, allow you to invert, distort, and otherwise transform the cloned image compared with the source you took it from.

Original image
An unsightly tarred area of road left by repairs marred this street scene in Prague. All it will take is a few moments to bring about a transformation.

History palette
The screen shot of the History palette shows the many individual cloning steps that were necessary to bring about the required transformation.

Manipulated image
The result is not perfect as it has none of the careful radial pattern of the original, but it is far preferable to the original image. It was finished off by applying an Unsharp Masking filter plus a few tonal adjustments.

● HINTS AND TIPS

The following points may help you avoid some of the more obvious cloning pitfalls:

● Clone with the tool set to maximum (100 per cent). Less than this will produce a soft-looking clone.

● In areas with even tones, use a soft-edged, or feathered Brush as the cloning tool; in areas of fine detail, use a sharp-edged Brush.

● Work systematically, perhaps from left to right, from a cleaned area into areas with specks – or else you may be cloning dust specks themselves.

● If your cloning produces an unnaturally smooth-looking area, you may need to introduce some noise to

make it look more natural: select the area to be worked on and then apply the Noise filter.

● You can reduce the tendency of cloning to produce smooth areas by reducing the spacing setting. Most digital Brushes are set so that they apply "paint" in overlapping dabs – typically, each dab is separated by a quarter of the diameter of the brush. Your software may allow you to change settings to that of zero spacing.

● If you expect to apply extreme tonal changes to an image using, say, Curves settings, apply the Curves before cloning. Extreme tonalities can reveal cloning by showing boundaries between cloned and uncloned areas.

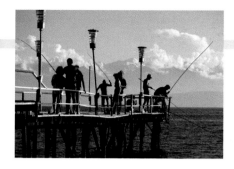

Original image

Suppose you wished to remove the lamp on the far left of this image to show an uninterrupted area of sky. You could use the cloning tool to do this, but it would be a lot of work and there would be a danger of leaving the sky's tones unnaturally smoothed-out in appearance.

1 Marquee tool

The Marquee tool was set to a feather of 10 pixels (to blur its border) and placed near the lamp to be removed to ensure a smooth transition in sky tones.

2 Removing the lamp

By applying the Marquee tool, you can see here in this image how the cloned area of sky is replacing the lamp. Further cloning of sky was needed in order to smooth out differences in tone and make the new sky area look completely natural.

3 Looking at details

The final removal of the lamp was done with a smaller Marquee area, with its feather set to zero (as sharp as possible). Finally, the lamp behind the one removed was restored by carefully cloning from visible parts of the lamp

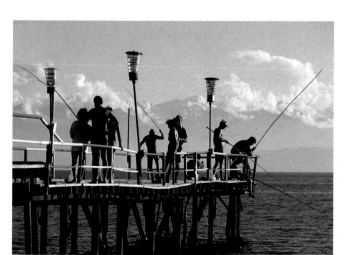

4 Cleaned-up result

As a finishing touch, a small area of cloud was cloned over the top of the lamp and its lid was darkened to match the others left on the pier.

Cloning techniques continued

Special cloning

In most software, there are two main ways of applying a clone. The basic method is what is now known as non-aligned, or normal: the first area you sample is inserted to each new spot the Brush tool is applied to. The other cloning method keeps a constant spatial relationship between the point sampled and the first place the sample is applied to – in other words, an offset is maintained so that the clone is aligned to the source point.

However, software such as Corel Painter offers as many as nine other ways of aligning the clone to the source. You can distort, shear, rotate, mirror, scale up or down, and so on. The procedure is more complicated than with normal cloning because you need to define the original scale and position prior to applying the clone. You first set the reference points in the source image, then set the transformation points – this can be either in the original image or in a new document. It is this latter feature that gives Painter's cloning tools tremendous power.

One interesting feature is that as the cloned image is being built up, it can become itself the source of the cloning process. Even after long acquaintance with these features, it has the power to surprise and delight.

As with all cloning experiments, you should work only on a copy of the original image. And since some transformations require huge computing power, you need to allocate maximum RAM to the software.

Original images
Both of these originals (*left*) were taken in New Zealand. Note that images do not have to be the same size or shape for cloning to take place, but look for originals with strong, simple shapes. Sharpness and colour were improved prior to the cloning: increasing sharpness after cloning can exaggerate the patches of cloned material.

Manipulated images
The originals were first cloned into a new file, but with added textures and overlaid with different layers. The first image (*below*) is intended to give a modern feel to the Chinese character "good fortune"; the other (right) has been given a crackle texture.

Original image

Any original image can be cloned onto itself to make complexes of line and form. Starting with an image with clear-cut lines and simple colours, such as this, special cloning techniques can make images that are difficult to produce in any other way.

Original image

Very interesting results can be achieved by cloning an ordinary, everyday object, such as this brightly coloured shirt (*above*), into a new document.

Rotation and scale

Cloning with rotation and scale calls for two points to be set to define the source and a corresponding two points to determine the clone. By experimenting with different positions of the source and clone points, you can create a wide range of effects: here the boy appears to be spinning into an abyss.

Bilinear transformation

Here, bilinear transformation was used to bring about this dramatic transformation. This technique warps the image according to the relative positions of the reference points set. By experimenting with the positions of the clone points, a totally unexpected shape was produced from a simple original image of a shirt.

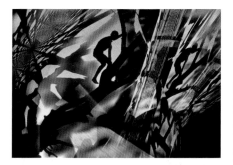

Perspective tiling

Here, the boy was cloned with perspective tiling applied twice to different parts of the image. This requires four points to be set as the source, and four for the clone. By switching around the positions of the reference points, wild perspective distortions are produced, which could have come from a sci-fi comic.

Dust removal

PenDuster is a component of the PenTools software, which comes bundled with the Wacom graphics tablet. It is an excellent tool for neatly and effectively removing dust and hairs, and it employs a special type of cloning technique that replaces the dust with pixels from immediately adjacent areas. So useful is this feature for the digital photographer that it alone is worth the purchase price of a small Wacom tablet.

Cloning techniques continued

Natural media cloning

Many of the filter effects for image manipulation (*see pp. 138–49*) take photographs into the realm of painting and the textures of fine art materials. Filters operate on the whole image simultaneously with overall control possible only over the strength of effect, and no local control at all. Very different effects result, however, if you lay down the strokes yourself.

Don't be afraid if you think you are not artistic: the beauty of working digitally is that if you are not happy with the results, you can step backward to undo the work and start again. You can experiment for as long as you like until the result is to your satisfaction. And don't think you are being "amateurish" if it takes hours: some professionals will confess that it can take them days before they achieve results they are content with.

All digital image-manipulation software offers art material effects as special "paints" with which Brushes may be loaded. The difference is that instead of simply loading a Brush with colour, it is loaded with instructions – to vary colour or intensity as the stroke progresses, to add texture to it or "dilute" the colour as if you were mixing water in, and so on. The Brush colour can be based on the colours of an underlying or source image, so offering you a short-cut to a radical modification of the original. You can turn a sharp digital image into a soft watercolour, a colourful abstraction

Jerusalem 1
Once I had settled on an image I wanted to use, I started to experiment with the Curves setting to see what would happen if I set a very distorted value (*pp. 116–20*). The result that seemed to hold out the best potential turned the image into a metallic rendering, something like a weathered painting. The trick in this mode of working is knowing when to stop: you can work endlessly trying out different effects. Remember to save promising-looking images as you go so that you can assess them in the cold light of day.

Jerusalem 2
Only those images that have clear outlines and distinct features will survive the detail-destroying aspects caused by applying brush-strokes. Here, impressionist-like strokes were applied – taking their colour from the original picture, the strokes build up a new image by cloning, or copying, from one image into another. At the same time, the strokes were set to respond to the underlying texture of the paper. You can experiment with different settings and directions of "painting" as often as you like.

into a vibrant "oil painting" with strong strokes of colour and the texture of a bristly brush.

The reason for working with a low-resolution file is that it is smaller and the effects you apply will, therefore, appear on screen much faster than with a large file. It makes the whole system much more responsive to your Brush. As you will be obliterating any fine detail anyway, it is not necessary to keep all the image data. Reduce the source file resolution to at least half that normal for the output you envisage. But when you are happy with your work, change resolution back to normal, in order to avoid pixelation *(see pp. 178-9)*.

Many people prefer using a graphics tablet rather than a mouse for this way of working. The graphics tablet and pen responds to many levels of pressure, speed of stroke, and even to the angle of the pen, thus making for livelier, more natural-looking and varied strokes *(see p. 32)*.

●HINTS AND TIPS

For the most effective results you will find it easiest to work when:
- The source offers clear outlines and strong shapes: fine detail, such as that of grass or hair or facial features, are generally lost.
- The source image has areas of strong colour.
- The source image does not have extensive areas of black or of white.
- The source image is relatively low resolution.

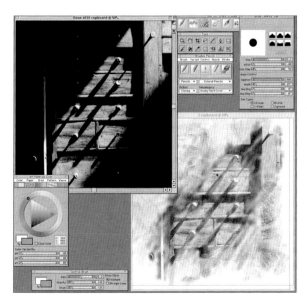

Applying art effects
Powerful software, such as Painter, offers a bewildering choice of effects to experiment with, but you will probably find that you regularly use only a fraction of the range available. The transformation from the original image of a chest of drawers seen in the screen shot panel *(upper left)* to that rendered in Natural Media *(lower right)* took less than an hour to achieve, yet suggested many other treatments on the way.

Image before and after
The shadows in the original *(top)* were replaced by textures from a drawing on rough-textured paper, which were applied using a Brush tool. Parts of the image were cloned into other areas and tonally adjusted to balance.

Photomosaics

Since digital pictures are composed of an array of individual pixels, it is only a short step to making up an image from an array of individual pictures. This is the principle behind photomosaics: you can replace an image's pixels with tiny individual images, like the tiles of a traditional mosaic.

Preparation

As with an image hose you need to prepare images with which to create the mosaic. The small "mosaic pieces" may be tiny versions of the larger one or be different images. Photomosaic software treats individual pictures as if they are pixels, looking for best matches between the density and colour of the small images to the pixel of the larger image that is to be replaced.

Photomosaic software usually provides libraries of mosaic pieces for you to work with, but it is more fun to create your own. However, the large numbers of images needed mean that this can be a long-winded process. Advanced users can create batch processing sets to automate the process of rendering files into the specific pixel dimensions needed for the mosaic pieces. Other sources are the thumbnails (small files) found in some collections of royalty-free CDs.

Composite photomosaic

The original image was relatively complicated, but its clear lines and shapes, as well as the repeated elements it contained, made it a suitable candidate for photomosaic techniques. By selecting a small size for the mosaic "tiles" the resulting image still, overall, retains many details, but with an added richness of texture that invites closer inspection. The close-up view of the photomosaic (*below*) shows an intriguing mixture of images. Varying the component images is one way to produce an entirely different feeling to the image, while still retaining the outlines of the originals.

If you are thinking of producing a photomosaic, bear the following points in mind:

- Provide a wide range of images from which to make up the mosaic pieces.
- Remember that smaller mosaic pieces produce finer, more detailed photomosaics.
- Use subjects with very clear or recognizable out-

lines; avoid complicated subjects lacking clear outlines as the process destroys all but the largest details.

- Bear in mind that if you create images in which a high level of detail is replaced with large mosaics, the resulting files will be very large.
- The rendering process that creates the photomosaic can take some time for your machine to handle.

High-key photomosaic

The large, even spread of tones presents a challenge to photomosaic software, as identical images next to each other must be avoided, or else false patterns are created. However, the photomosaic has superimposed an attractive texture over this image. The close-up view (*below*) is richly rewarding.

Image stitching

Panoramic views can be created by "stitching", or overlaying, images side-by-side. Essentially, a sequence of images is taken from one side of the scene to the other (or from the top to the bottom). The individual images are then overlapped to create a seamless composite.

You do not need specialist software to achieve panoramas if the original shots are taken with care. You simply create a long canvas and drop the images in, overlapping them. However, small errors in framing can make this a slow process due to the need to blend the overlaps to hide the joins.

Appropriate software

Specialist panoramic software makes joining up component shots far easier, especially if they were inexpertly taken. The available software packages take different approaches. Some try to match overlaps automatically and blend shots together by blurring the overlaps. Results look crude but are effective for low-resolution use. Other software recognizes if the overlaps are not matching (which results from a camera not being mounted on a tripod) and tries to accommodate the problem – some by distorting the image, others by trying to correct perspective. Many digital cameras are supplied with panorama-creation software.

For more unusual effects, experiment with placing incongruous images together, or deliberately distort the perspective or overlaps so that the components clash instead of blend. There is a great deal of interesting new work still to be done.

Photographs © Louise Ang

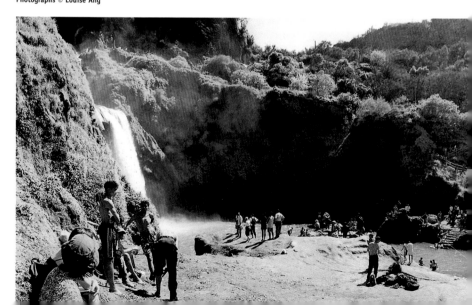

Assembly

To start the assembly (*left*), move the component images into a single folder where the software can access them. With some software, you will be able to move images around to change their order, while in others you will have to open the images in the correct order. To merge the images, the software may need extra instructions, such as the equivalent focal length of the lens used.

● Nikon Coolpix 990.

Final version

The component images show very generous overlaps, which make it easier for the software to create smooth blends. Once the component images are all combined on the same canvas you can use the facilities offered by the particular software to blend and disguise the overlaps to create a seamless, single image (*below*). Once you are happy with your work, save the file as a TIFF, not as a JPEG, for best-quality results.

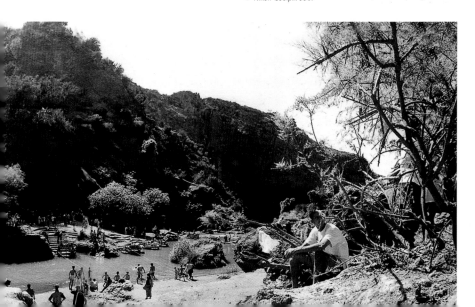

5
The output adventure

Publishing your results

With enough information to help you attain professional-quality output, but only with as much technical detail as you really need, this is your guide to high-quality and satisfying output, time after time. Image software, proofing and printing, and placing pictures on the Web, are all explained.

Help on hand

Quick-fix sections help you to diagnose and fix printer problems as well as anticipate and avoid potential Web-related problems.

How to take your hobby further

A unique coverage of subjects such as training courses in digital photography, mounting an exhibition, guidance for disabled photographers, as well as copyright matters.

Useful information

A highly accessible and authoritative glossary, and numerous hardware- and software-related resources.

Image software

All software consists of thousands, sometimes millions, of instructions, which tell the computer what do when it receives commands from you, from software such as scanner drivers, or from attached equipment, such as a modem. Image-manipulation software is a specialized set of instructions for working on images and, as such, numbers among the most complicated and powerful software generally available. In practice, what matters is not exactly how the software works, but how to make it work effectively and efficiently for you. Here are some hints and suggestions:

• Keep referring to the instruction manual: it makes little sense when you first read it, but after you have used the software for a while, you will start to see the light. A good software manual is worth reading even if you think you know the program, as the more subtle tricks it can teach you will be easier to understand once you are familiar with the main features of the software.
• Use the keyboard shortcuts: all good software, particularly those programs for Windows, offer commands from the keyboard. Use as many of these as possible – it saves time and effort and is healthier, as it puts less strain on your wrist controlling the mouse. One of the reasons for Photoshop's popularity is that it is easy to set up time-saving shortcuts. At the very least you should never need to use the mouse to initiate a save or to print, or to close a file.
• Quit from other applications you do not need: image-manipulation software is highly processor-intensive (it takes up all the time and attention of the central processor unit). So, to have other software – such as a word processor or an internet browser – running at the same time can seriously slow down image manipulation operations.
• Use the highest resolution available on your monitor: this forces the palettes and associated labels to be as small as possible, reducing clutter on the screen and thereby gives you more room to work with images. A screen resolution setting of 1,024 should be the very minimum: most monitor screens can be set to 1,280, some to as high as

1,600. The symbols may appear too small initially, but you will get used to them – and the bonus is that the image-manipulation software will be much easier to use.

Some of the questions frequently asked about software are considered next:

When is software worth up-dating?

If you can do all you want to with your current software, it is not worth up-dating. Even if you think you need the new features, consider carefully: the new version may need more memory, run more slowly, behave slightly differently, and be unstable – in addition to costing you for the upgrade. You may also have to invest time in learning the new features. The best applications in their respective fields are mature products that are difficult to improve – usually simply to bloat the application with extra features.

Why is some software so expensive?

The cost of software is made up not only of the obvious, such as the cost of the CD, instruction book, packaging, marketing, and development, but professional software may need proprietary technologies to implement some features – for which licences have to be paid. Nonetheless, the market-leading applications can charge a premium safe in the knowledge that they cannot be neglected for long. The advantage of using your own copy of an application, apart from the legalities involved, is that you can then obtain upgrades and technical support direct from the manufacturer, without trying to pretend to be someone else.

Should I wait before buying the newest software?

Yes: all new software has errors, or bugs, in it, which are usually fixed by up-dates – for example, version 6.0.1 repairs bugs found in version 6.0 – which often appear within weeks of the initial introduction. Wait for these to settle down before purchasing your software and you will save yourself a good deal of time and trauma.

Is it worth getting the best software?

The best software is that which has the features you need (but no more) and which is easy to use. Photoshop has by far the fullest feature-set but is expensive and takes a long time to learn. Photo-Paint, Picture Publisher, Photoshop Elements, and Paint Shop Pro are relatively full-featured applications, much cheaper than Photoshop, and easier to learn. Simpler applications, such as PhotoImpact, PhotoSuite, and PhotoDeluxe, have basic feature sets and are correspondingly easy to use (*see pp. 216–7 for software Web sites*).

Why should I reinstall software?

After some use, your application may become unstable and crash frequently or give rise to error messages. Software components may become corrupted or, if they are in a faulty portion of a hard disk, they give rise to errors when read. The easiest solution is to reinstall the whole application. Advanced users may run a disk-repair utility before reinstallation; other users may omit this. It is worth moving preferences and settings files that you have evolved over time to prevent them being overwritten by default settings – see your software manual for the names of folders where these are kept within your system. When the application is reinstalled, you can move your personal settings back to their correct folders.

Is Mac and Windows software different?

There are few practical differences when standard applications, such as Photoshop and Quark XPress, are written for either the Mac OS or Windows operating systems. Most keyboard commands are the same, except that Control in Windows is usually Command in the Mac, and of course the interface looks a little different. However, some applications are available only for Windows or for Mac OS: you should confirm availability. Furthermore, you should check whether the software you want will run with the operating system you have – for example, if you are still using Mac OS 8.5 you would not be able to run many modern applications.

What are viruses?

Viruses, worms, Trojan horses, and the like are all small applications written in the same language as full applications. What distinguishes these applications is that they are designed to be destructive – to erase files or change settings, which confuse the computer – or they may be harmless but generate unusual behaviour, such as making all the text on a page appear to fall into a heap at the bottom of the screen. Viruses are distinguished by being able to make copies of themselves onto, for example, a disk introduced into the computer, so they will install themselves on another computer. Computers running Windows are far more vulnerable than Apple Mac computers – with tens of thousands known to infect Windows, but only a few hundred for Macs. If you have any information of value on your computer, you should install virus-protection software and regularly up-date it, especially if you are a Windows user.

Norton AntiVirus

Are downloads from the Internet safe?

Software downloads from commercial sites should be perfectly safe from viruses and other destructive software. If, however, you download from sites specializing in cheap, pirated software, then you are running a risk because you do not know exactly what you are copying onto your computer until it arrives and installs itself – then it is too late to resist any infection. Bear in mind that you may have to turn off virus-protection software before installing an application.

Proofing and printing

It is an exciting moment. You have worked for hours at your computer, using all your know-how to create an image that looks just the way you want it, and now you are ready to print. You take a deep breath and press the button to send the file to the printer. If, then, the printer produces satisfactory results for most images, without any intervention on your part or setting up, you are lucky (make sure you note the settings in the printer driver for future reference). Unfortunately, the experience for many digital photographers is that the results of printing will be disappointing.

An important point is that mismatch between the monitor image and the printer is not, in the first instance, caused by any malfunctioning of your printer or monitor. The basic problem is that the monitor produces colours by emitting a mix of red, green, and blue light, while a print reflects a mix of light to produce the colours you perceive. These fundamentally different ways of producing colour lead to a difference in gamut, which is the range of colours which can be produced by a device (*see p. 65*).

There are two main approaches open to you. You can adjust the image to compensate for the differences between what you see on screen and the resulting print, then print again and again, repeating the process until the print is satisfactory. This is not only unscientific, but the adjustments apply only to one image. The best way is to use software, such as Photoshop, that offers colour-management facilities.

Printing with colour management

To use colour management for printing, you must first calibrate your monitor (*see pp. 88–91*). Note, too, that for the highest reliability, settings will apply only for the paper and inks with which you make the test. The basic idea is that you will first specify the source colour space containing the colours you want to send to your printer – those that typically relate to your monitor. Second, you specify the colour space of the printer, usually tied

to the material being used. This gives the software the information it needs in order to make the necessary conversions.

A typical task is to proof an image currently in the monitor RGB space as it will appear on an offset printer (a commercial machine). The source colour space uses the soft-proof profile while your printer profile is the printer space. The following description details the steps for Photoshop.

First choose File > Print Options and select "Show More Options", then "Color Management". For Source Space, select "Document" to reproduce colours as interpreted by the profile currently assigned to the image. Select "Proof" to reproduce document colours as interpreted by the current proof profile. Under Print Space, choose the profile that matches the colour space of your printer

Color Settings

Settings: **Custom**

☑ Advanced Mode

Working Spaces

RGB: Colorperfexion RGB
CMYK: Euroscale Coated v2
Gray: ColorSync Gray – Generic Gray Profile
Spot: Dot Gain 20%

Color Management Policies

RGB: Convert to Working RGB
CMYK: Convert to Working CMYK
Gray: Convert to Working Gray

Profile Mismatches: ☐ Ask When Opening ☐ Ask When Pasting
Missing Profiles: ☐ Ask When Opening

Conversion Options

Engine: Adobe (ACE)
Intent: Perceptual
☑ Use Black Point Compensation ☑ Use Dither (8-bit/channel images)

Advanced Controls

☐ Desaturate Monitor Colors By: 20 %
☐ Blend RGB Colors Using Gamma: 1.00

Colour settings

The dialogue box controlling colour settings looks complex, and careful attention is needed to make full sense of it. However, there are many guides – such as those provided in printer and software manuals – which should help you master it. The crucial point to keep in mind is that, unless you are producing work to be printed by a commercial press for a mass market, you need not worry about these settings. You can get by without touching them: however, if you can control them, it will be far easier to obtain reliably good prints from your desktop printer.

Printer settings

A driver that complies with the ColorSync protocol for colour management will offer a dialogue such as that shown here. The Source Space is the colour space or profile for the image: here I have specified a commercially defined standard, which defines an RGB space in a way that is optimized for print. The Print Space is not only that of the printer but of the paper and print quality being set. "Perceptual" has been chosen for the Intent, or preference for colour conversions of colours that fall out of gamut, as that is most likely to give a photo-graphically acceptable print.

What is PostScript?

This is the most important of a range of programming languages that describe text and graphics on a page. PostScript breaks the most complex text and graphics into elementary components, such as lines or dots, and into basic operations, such as "stroke" (to draw a line) or "translate" (to turn a component). When a printer receives a PostScript file it has to interpret it in order to turn these commands into the correct output on the page. This can be done with software in the computer's operating system or through specialist PostScript RIPs (Raster Image Processors). Using a PostScript RIP is the best way of making sure that complicated graphics and text are properly printed out on the page.

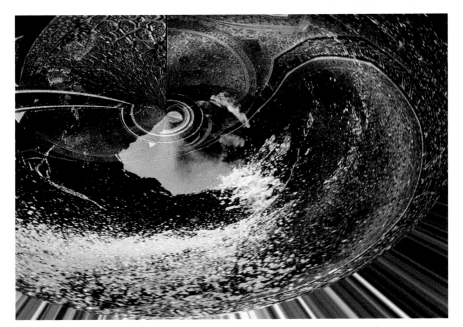

Fantasy colours

When you produce highly manipulated images, even a large error in colour accuracy is unlikely to damage the effectiveness of the image, since most viewers will not ever know what the right colours were supposed to be. Of course, for the sake of artistic integrity, you will strive to produce the exact colour you have in your mind's eye, but the impact of images such as that shown here, with its artificial colours and fantasy content, does not depend on precise colour reproduction.

Proofing and printing continued

to print using that printer space or else select "Same As Source" to print using the original source profile.

If you have an ink-jet printer, select "Printer Colour Management" to send all the colour data that is needed for the printer's driver to manage the colours. (Those using a PostScript printer should follow the instructions that are supplied with their PostScript RIP software.) Finally, under "Print Space", choose a suitable "rendering intent" (*see below*).

You are now ready to print, but before proceeding any further check that:
• You are using the same type of paper as that intended for the final output.
• You are using the correct side of the paper.
• There is a good supply of ink (check the level using the printer's controls).
• Your image has been sized to the correct output dimensions.

Previewing

The key to efficient printing practice is to employ soft-proofing as much as possible – that is, checking and confirming everything you can on the

Textile colour
For accurate records of valuable artefacts, such as this piece of textile (*above*), precise colour control is essential. Reds are visually very important but deep reds can vary considerably between monitor image and paper output. The subtle variations in deep tone are easily lost if a print-out is too dark.

What are rendering intents?

Converting from one colour space to another involves an adjustment to accommodate the gamut of the destination colour space. The rendering intent determines the rules for adjusting source colours to destination gamut: those that fall outside the gamut may be ignored or they may be adjusted to preserve the original range of visual relationships. Printers that are ColorSync-compliant will offer a choice of rendering intents that determine the way in which the colour is reproduced.

• Perceptual (or image or photo-realistic) aims to preserve the visual relationship between colours in a way that appears natural to the human eye, although value (in other words, brightness) may change. It is most suitable for photographic images.
• Saturation (or graphics or vivid) aims to create vivid

colour at the expense of colour accuracy. It preserves relative saturation so hues may shift. This is suitable for business graphics, where the presence of bright, saturated colours may be important.
• Absolute Colorimetric leaves colours that fall inside the destination gamut unchanged. This intent aims to maintain colour accuracy at the expense of preserving relationships between colours (as two colours different in the source space – usually out-of-gamut – may be mapped to the same colour in the destination space).
• Relative Colorimetric is similar to Absolute Colorimetric but it compares the white or black point of the source colour space to that of the destination colour space in order to shift all colours in proportion. It is suitable for photographic images provided that you first select "Use Black Point Compensation".

monitor screen before committing the image to print. If you have implemented the colour management suggested in this book (*see pp. 112-5*), the on-screen image should be very similar to the print you obtain. If, though, images are to be

Original image

All digital images are virtual and thus have no dimensions until they are sized for output, with a suitable output resolution. Usually, there are sufficient pixels in the image for the combination of output resolution and output size.

printed on a four-colour (CMYK) press, set the destination printer or printer profile to that of a standard to which it conforms.

The first check is the output size: most image applications and print drivers will show a preview of the size and/or position of the image on the page before printing it out. If you are not sure of what you are doing, it is best always to invoke print preview to check – the print preview here (*see below*), from Photoshop, shows an image that is too large, while the screen shot (*see bottom*), from an Epson driver, shows an image enlarged 300 per cent to make better use of the page. Printer drivers should warn you if the image size is too great to be printed without cropping.

Photoshop print preview

Some software provides a quick way to check the print size in relation to the paper size set for the printer. Here (*right*) is Photoshop's way of displaying it. The corners of the image fall outside the paper as can be seen by the diagonals not meeting the corners of the white rectangle, which pops up when you click on a bar at the bottom of the frame: the image is clearly far too large for the paper.

Print Options preview

This screen shot (*left*), taken from a printer driver, shows how a printer expects to produce a given file. The image has been enlarged by 300 per cent to make better use of the paper and has been centred (ensure your image has sufficient data to print at this enlargement). Note how the preview shows the image on paper and that it provides you with handy functions, such as being able to position the image as well as a choice of units of measurement. Modern printers can place an image with great and repeatable precision.

Output to paper

One great advantage of ink-jet printers is that they can print on a wide variety of surfaces. In fact, some desktop models will print on anything from fine paper to thin cardboard.

For the digital photographer, there are three main types of paper available. Most papers are a bright white or a near-white base tint, but some art materials may be closer to cream.

Paper types

Office stationery is suitable for letters, notes, or drafts of designs. Quality is low by photographic standards and printed images cannot be high in resolution or colour saturation. Ink-jet paper described as 360 dpi or 720 dpi is a good compromise between quality and cost for many purposes.

Near-photographic quality is suitable for final print-outs or proofs for mass printing. These papers range from ultra-glossy or smooth to the slightly textured surface of glossy photographic paper. Paper thickness varies from very thin (suitable for pasting in a presentation album) to the thickness of good-quality photographic paper. Image quality can be the best a printer can deliver

with excellent sharpness and colour saturation. However, paper and ink costs may be high.

Art papers are suitable for presentation prints or for special effects and include materials such as hand-made papers, watercolour papers, or papers with hessian or canvas-like surfaces. With these papers, it is not necessary to use high-resolution images or large files that are full of detail.

Paper qualities

If you want to experiment with different papers just ensure that the paper does not easily shred and damage your machine and clog the nozzles of the ink-jet cartridge. If using flimsy papers, it is a good idea to support them on thin card or a more rigid piece of paper of the same size or slightly larger. The main problem with paper not designed for ink-jets is that the ink either spreads too much on contact or else it pools and fails to dry.

Dye-sublimation printers will print only on specially designed paper – indeed some printers will even refuse to print at all when offered the wrong type of paper. Laser printers are designed only for office stationery and so there is little point in using other types of paper.

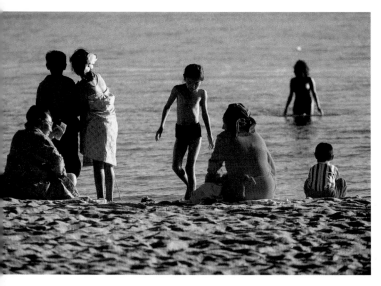

Crucial colour

Not only does the blue of this scene test the evenness of printing, it also tests colour accuracy. Very slight shifts away from blue will make the image look unbalanced in colour and distract the viewer's attention from the relaxed, sun-filled scene. In fact, blue ranks with skin tones as the most important of colours that must be correctly printed, or else the foundation of an image will be seen as unsound.

● Canon EOS-1n with 80–200 mm lens. ISO 100 film. Nikon LS-2000 scanner.

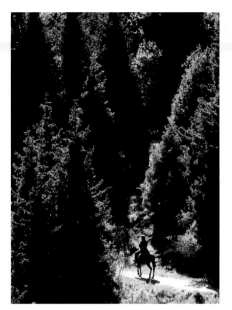

Dark subjects

The blacker a colour image, the more ink will be needed to print it. If your subject is full of very dark areas, such as this scene, the paper could easily be overloaded with ink. The ink may then pool if it is not absorbed and the paper could buckle or become corrugated. To minimize this problem, use the best quality paper and tone down the maximum of black as much as possible by reducing the black output level in the Levels control.

● Canon EOS-1n with 80–200 mm lens. ISO 100 film. Nikon LS-2000 scanner.

●**TRY THIS**

To determine the minimum resolution that gives acceptable results on your printer, you need to make a series of test prints with the same image printed to the same size but saved to different resolutions. Start by printing out a good-quality image of about 25 x 20 cm (10 x 8 in) or A4 size at a resolution of 300 dpi – its file size is about 18 MB. Now reduce resolution to 200 dpi (the file size will get smaller but the output size should be the same) and print the file, using the same paper as for the first print. Repeat with resolutions at 100 dpi and 50 dpi. Compare your results and you might be pleasantly surprised: depending on the paper and printer, files with low output resolution can print to virtually the same quality as much higher-resolution files. With low-quality or art materials, you can set very low resolutions and obtain results that are indistinguishable from high-resolution files. In fact, low resolutions can sometimes give better results, especially if you want brighter colours.

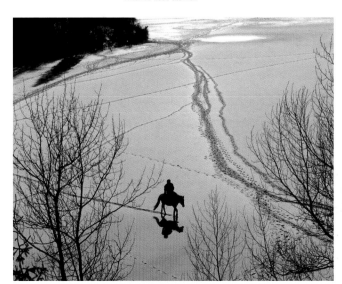

Even tones

Subjects with large expanses of even and subtly shifting tone present a challenge to ink-jet printers in terms of preventing gaps and uneven-ness in coverage. However, in this image of a frozen lake in a Kazakh winter, the challenge is not so great as the colour is nearly grey, which means that the printer will print from all its ink reservoirs. If there is only one colour, most often the blues of skies, you are more likely to see uneven ink coverage.

● Canon EOS-1n with 80–200 mm lens. ISO 100 film. Nikon LS-2000 scanner.

Quick fix Printer problems

A great deal of computation is needed before your printer can translate the image on screen or captured in a digital camera into a print. Not only must the pixel data be translated to individual dots or sets of dots of colour, that translation must ensure the final print is sized correctly for the page and is the right way around. The real surprise is that people do not experience more printer problems than they do. But it is true that everybody reports having some problems with printers. This table may help you solve the more commonly encountered glitches.

Troubleshooting

The commonest causes of problems with the printer are often the easiest to deal with. As a routine response to problems, check that the power lead and printer cable are securely inserted at both ends, check that your printer has not run out of ink, and make sure that the paper is properly inserted, with nothing jammed inside.

Problem	Cause and solution
Prints show poor quality – dull colours or unsharp results.	If you run the self-check or diagnostic test for the printer and nothing appears to be mechanically at fault, then the cause is a user setting. You may have set an economy or high-speed printing mode. If so, set a high-quality mode. You may be using a low-quality paper or one unsuitable for the printer, or you could be using the wrong side of the paper: change the paper and see what happens. You may be using an uncertified ink cartridge instead of the manufacturer's: use the manufacturer's own brand.
Prints do not match the image seen on the monitor.	Your printer and monitor are not calibrated. Go through the calibration steps (*see pp. 88-91*). Your image may contain very little colour data: check the image using Levels – rescanning may be necessary.
A large file was printed really small.	File size does not alone determine printed size. Change the output dimensions using the Image Size dialogue box.
An image does not fully print, with one or more edges missing.	Output size is larger than the printable area of the printer – most printers cannot print to the edge of the paper. Reduce the output or print size of the image in the Image Size dialogue box and try again.
The printer works very slowly when it is printing images.	You may have asked the printer to do something complicated, such as printing a complex graphic, text overlaying an image, or a picture in landscape format. If your graphic has paths, simplify them. If your image has many layers, flatten the image prior to printing. To print landscape-format pictures, turn the picture to one side using your image-manipulation software prior to printing. If you set the factor or magnification to any figure other than 100 per cent, the printer is burdened with resizing the entire image. Change the image size using image-manipulation software before printing.

Out of memory
This close up of a print-out shows the printer making a start, then suddenly printing lines instead of the image. The cause was a shortage of memory available to the printer driver: when that was increased, the problem disappeared.

Unsuitable paper
An attempt to print on normal photographic paper produced this result: the ink has not been absorbed into the paper and individual droplets have pooled together taking many hours, if not days, to dry.

Garbled print
It is easy to send the wrong message down the wrong port. This was the result of trying to send a facsimile message to the printer – it does its best to interpret the signals.

Streaky prints
The result of a very poor-quality printer working on low-quality paper is an output image that is streaky, uneven, and wholly unacceptable. Cleaning the nozzles may improve matters to a degree.

Problem	Cause and solution
The printer works slowly even when printing text.	You have set the printer to a high-quality setting, such as high resolution or fine, or the high-speed or economy mode has been turned off, or you have set the printer to uni-directional or to print on high-quality (photorealistic) paper. Check and reset the printer to high-speed, bi-directional, and reduce the resolution or choose a normal or standard paper.
The computer crashes or slows to a crawl during printing.	You do not have sufficient RAM to do more than one thing at a time. For Mac OS, turn off background printing. For Windows, wait until printing is over. For both platforms: obtain and install more RAM into the computer.
The printer cannot be found or nothing happens when "OK" is pressed at the printer dialogue box.	You may have a conflict – this is probably the case if this problem occurs just after you install a new scanner, mouse, or similar. Reinstall the printer driver software. Ensure you have the latest drivers for the USB ports: download them from the manufacturer's Web site. Owners of early iMac computers should ensure they have the latest iMac Update (find Mac OS ROM and check the version).
Prints appear smudged, with colours bleeding into each other.	The paper is damp, you have made settings for the wrong paper type, or there may be ink on the printer's rollers. Store paper in dry conditions inside its original wrappings. Check the settings against the paper type. Clean the rolls using a cloth and run the printer cleaner sheets, which are supplied by the manufacturer, through the printer.
The printer produces random lines or crashes the computer.	The system is lacking memory. With Mac OS, turn off background printing and restart the printer; with Windows, don't try to do anything on the machine while the printer is working.

Quick fix printer problems continued

Problem	Cause and solution
The print is missing lines or there are gaps.	The printer head nozzles have almost certainly become blocked with ink or the printer head may need to be recalibrated. Clean the nozzles using the driver utilities supplied with the printer and try to print again. You may need to repeat the cleaning cycle three or more times to solve the problem. Run the calibration utility in order to realign the print heads. Blocked printer nozzles are less likely to occur if you use the manufacturer's own brand of ink cartridges.
The print suddenly changes colour part of the way through.	Either one of the colours in the ink cartridge has run out or it has become blocked during printing. Clean the nozzles using the driver utilities and try to print again. You may need to repeat the cleaning cycle three or four times to solve the problem.
The printer produces garbled text.	You may have connected the printer to the wrong computer port or you may have tried to use the printer port to send a file, fax, or similar. This problem can also occur if you have aborted a print operation some time earlier. If so, turn the printer off, wait for a few seconds, turn the printer back on, and try the operation again. With Windows machines, check that the spool or print manager has no jobs waiting to be processed. If there are any, delete them and start again.
The printer fails to print text accurately – for example, it misses off the tail, or descender, of letters such as "p", "q", or "g", or misses out overlapping items in images.	The printer driver has been unable to rasterize complicated shapes or multiple image layers. Simplify the image by flattening it – in other words, combining all the layers into one – before trying to print the job again. If this does not work, you will need to install a software PostScript RIP (Raster Image Processor), but note that not all printers will print to a PostScript RIP (see p. 158).
Printer produces banded lines in areas of even tone.	The paper transport is not properly synchronized with the print head. This could be a fundamental fault of the printer. If this is not the case, try changing the weight of paper being used or the thickness setting (usually achieved by adjusting a lever on the printer). You could also try adding noise to the image, using image-manipulation software, to disguise the unevenness of tone.
Details in prints appear soft and blurred and colours are dull – all despite printing at high resolution and on good-quality paper.	You may be using the wrong side of the paper. Most ink-jet papers have a good, receiving side and a support side: it may be difficult to feel the difference in texture if the paper is not highly glossy or to see the difference in whiteness under household lighting if the paper is textured. Manufacturers often pack their paper with the receiving side facing the back of the pack or there may be a mark faintly printed on the support side.

Quick fix Web page problems

It is rare to come across a Web page that does precisely what is expected of it by the designer or the client, and shows users everything where it is meant to be on the screen and when it is meant to appear. In the available space, the list below is by no means comprehensive, but it does at least cover some of the more major problems that are frequently encountered.

Problem	Cause and solution
The browser cannot find your Web page.	The most likely cause is that you have placed the Web page in the wrong folder or directory on the server – check with your ISP (Internet Service Provider) or WPP (Web Presence Provider). Another possible cause is that your home page is incorrectly identified – the convention varies, so check with your Provider – the home page is usually called index.html.
Your Web page appears incorrectly.	If you produced the Web page by writing HTML code directly, it is likely you made a small typing error. Check the spelling of every tag and attribute. If a section of a page is missing you may have failed to close quotation marks (" – and – ") or angle brackets (< – and – >) and these must always occur in pairs. If a single element is missing, then you probably gave the wrong path or location for that element or else gave the incorrect suffix or extension to the item. An incorrect extension is one that is not recognized at all or which is wrongly associated with the file – for example, .jpg used with a GIF file. If formatting is applied to a large mass of text, you probably forgot to provide the closing tag.
The browser displays your HTML code.	The browser has not recognized your document as containing HTML code. If some of your pages did not carry the .htm or .html suffix or carried an incorrect suffix, such as .doc or .txt (as easily occurs if you used a word-processor program to create the code), then the browser may display the raw code. All HTML documents should start with the tag <HTML> and close with the end tag </HTML>; if not, a browser may not recognize it as HTML, even if the file carries the correct suffix.
Pictures are missing.	The browser cannot find the images where it was told to look. Check that file names in the HTML document match exactly with the file names of the images and that the names carry the correct suffix. If any images are in PNG format, earlier browsers may not recognize the format. If the images are very large or high-resolution, the browser may have insufficient memory to display them.
Pictures take too long to download.	The pictures may be too large. Reduce the file size with compression and by reducing the number of colours. The phone or other connection may be slow or when traffic is heavy (when many people are logged on), data transfer rates are reduced. Try logging on at quieter times of the day.

Permanence: Ink and paper

The two main factors governing the permanence of photographic images are the characteristics of the materials used and the storage conditions. Both of the main components of the materials – the ink that makes up the image and the substrate, or supporting layer – are important.

For the ink to be stable, its colours must be fast and not fade in light or when exposed to the normal range of chemicals in the atmosphere. For the paper to be stable: it should be neutral and "buffered" (able to remain neutral when attacked with a small amount of acidic chemicals); it should not depend on volatile chemicals for its colour or physical state; and it should not discolour with exposure to light.

When colours fade, one is likely to fade more rapidly than others, which quickly becomes obvious as a colour shift. Black and white materials do not suffer from colour shift, so appear more stable. Inks based on pigments (materials that are themselves coloured) are more permanent than dyes (dissolved pigments that give colour to materials).

The substrate may be a source of impermanence: papers fade or become brittle; the layer of plastic used to cover paper may crack and peel apart, taking the image with it; or the plastics itself may discolour.

The careful design of storage conditions can ensure that even highly unstable images are preserved, but these may not be practical. Ideally, images should be stored in chilled conditions –

nearly at freezing point – with low humidity and in total darkness. To ensure the best colour stability, exposure to light and chemicals should be kept to a minimum, and storage temperatures and humidity should also be as low as is practicable. In normal room conditions, most materials will last several years but if you keep pictures in a kitchen or bathroom, you can expect the life expectancy of your prints to be much reduced.

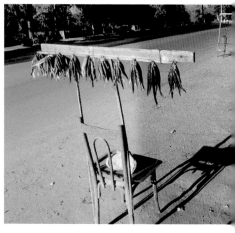

Faded print
With half the print shielded, the exposed half faded after only one week's constant exposure to bright sunlight.

Since some colours are more fast, or resistant to fading, than others, there will be a colour shift in addition to an overall loss of density.

Archival storage

Digital photographers have two strategies for the archival storage of images. The first is to store images in the form of prints in the best possible conditions – specifically, in total darkness, low humidity, chilled (to temperatures close to freezing point) with slow air circulation in archivally safe containers. These containers – boxes made from museum board – should emit no chemicals or radiation, are pH neutral (are neither acidic nor alkaline), and, preferably, incorporate a buffer (a substance that helps maintain

chemical neutrality). These conditions are ideal for any silver-based or gelatin-based film or print.

The alternative strategy is to store images as computer files in archivally safe media. The current preferred option is the MO (magneto-optical) disk, but nobody really knows how long they will last. Next down are media such as CDs or DVDs, which are, in turn, more durable than magnetic media such as tapes or hard-disks. But you can never be sure: a fungus found in hot, humid conditions has developed a taste for CDs, rendering them useless.

Poster-sized printing

It can be a thrill to see your images enlarged to poster size. The subject of the poster does not have to be unusual – sometimes the simplest image is the most effective – and the digital file from which it is output may not even need to be of the highest resolution. This is because large prints tend to be viewed from a distance, in which case finely rendered detail is not necessarily an issue.

Preparing a print

There are two main approaches to outputting prints larger than A3, the maximum that can be comfortably printed on a desktop printer. The first is the simplest: you use an over-sized ink-jet printer. These range from self-standing machines somewhat larger than desktop printers to monsters capable of printing on the entire side of a bus. These are far too expensive for the average digital photographer to own, so you need to take your file to a bureau. Before you prepare your file, ask the bureau for its preferred format (usually RGB TIFF uncompressed) and which type of media it accepts – all will take a CD-ROM and most will accept Zips as well as MO (magneto-optical) disks. You also need to check the resolution the bureau prefers and you should adjust the file to the output size you require (although some bureaus do that for you).

There are different printers that produce prints appropriate to different markets. The Iris printer, for example, produces the very highest quality on a variety of papers for art and fine-art exhibition purposes. Ink-jet printers, manufactured by, for example, Hewlett-Packard or Epson, generally produce good-quality prints intended for commercial display and trade exhibitions.

The other approach is a hybrid one, based on the digital manipulation of true photographic materials. Your file is used to control a laser that exposes a roll of photographic paper. This is then processed in normal colour-processing chemicals to produce a photographic print. Many off-line printing services use the same method to produce small photographic prints from digital image files. The results can be extremely effective and look very much as if they are traditional photographic images from start to finish. Another advantage to this method is that relatively small image files can produce excellent results – 20 MB of detail may be sufficient for a print of A2 size. A variant of the hybrid approach is to use the digital file to create a colour negative, which is then processed and used to make large colour prints. This method is the preferred route if you wish to make many copies of the same image.

Tiling a print-out

One way to make prints larger than your printer can print is to output the image in sections, or tiles, which you then join up. This is straightforward in a desktop publishing application such as Quark XPress: you simply create a large document size, set-up the page for the available paper dimensions, and tell the software to print out each section on the paper supplied. You can then trim the prints to remove the overlaps and butt the joins together to produce a seamless, large-size image. For those occasions when economy is important and critical image quality is not required, tiling is worth considering.

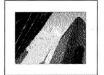
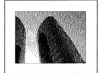
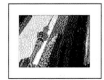
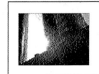

Tiling option
Modern printers work with great precision and consistency, so it is possible to combine tiles almost seamlessly. Use heavier-weight papers, plastic, or film-like material to help retain shape. Then the overlaps need be only sufficient to allow you to trim off the excess and butt up the images together before fixing.

Pictures on the Web

As a producer of pages for the Web, your goal should be to create lively, dynamic, and interesting material as the means of engaging a wider audience. To do this, everything reaching the screen should do so quickly and smoothly. When working with images, the main problem is how small you can make image files, to minimize download times, while ensuring image quality is up to scratch.

Fortunately, the practice is to cater for people with small monitors and less capable computers. The assumption is a screen size of not larger than 38 cm (15 in) – usually measured on the diagonal – which, allowing for the browser, means that full-size images are at best not larger than about 640 x 480 pixels in size. The other control that reduces the size of the image is file compression – a way of coding the information so that it takes up less room than it would otherwise. You can do this in two ways: you can sacrifice some information in the search for the tiniest file (lossy compression, which gives the highest compression); or you sacrifice no information and put up instead with a somewhat larger file (lossless compression).

For Internet use, the two most widely used formats are JPEG and GIF. Both formats use lossy compression (*see pp. 82–3*). JPEG is generally best for photographic images in which there is a good deal of fine detail, gradual tonal transitions with few areas of even colour, and a rich variety of colour. GIF, as its name, Graphic Interchange Format, suggests, is designed for graphics: large

areas of even tone and colour with few fine details and a limited palette of colours. The PNG formats can be also used but are not supported by all Web browsers: PNG is better than GIF for the same, graphic, images.

Preparation

There are three main steps in preparing images for use on Web pages or sending via the Internet: evaluation, resizing, and conversion.

Evaluation Assess the image quality and content. If it is photographic, you can convert it to JPEG; if it is a graphic, with few subtle colour gradations, you can convert to GIF. Also check brightness and colour – adjust both so that the image will be an acceptable compromise when viewed on both Apple Mac and Windows monitors: the higher monitor gamma (2.2) of Windows and domestic television screens delivers a significantly darker image than Apple monitors (gamma of 1.8).

Resizing Change the size of copies (not original files) of the images to the viewing size intended, so that the size of files is no larger than is needed for the screen layout. Images may be tiny, perhaps 10 x 10 pixels (for use as buttons), or large, perhaps 360 x 240 pixels (to show off your work). Images to be used as backgrounds do not have to be large, as the browser will repeat a small tile until it fills the screen. In assessing how large the

Optimizing your pictures on the Internet

You will want Internet surfers who access your site to receive your images quickly on their screens and to have the best experience of your images the system permits. Here are some hints for optimizing your images on the Internet:

● Use Progressive JPEG if you can. This presents a low-resolution image first and gradually improves it as the file is downloaded. The idea is that it gives the viewer something to watch while waiting for the full-resolution image to appear.

● Use the WIDTH and HEIGHT attributes to force a small image to be shown on screen at a larger size than the actual image size.

● Use lower resolution colour – for example, indexed-colour files are much smaller than full-colour equivalents. An indexed-colour file uses only a limited palette of colours (typically 256 colours or fewer), and you would be surprised at how acceptable many images look when they are reproduced even with only 60 or so colours (*see p. 121*).

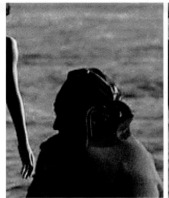

Original

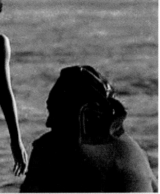

JPEG compression

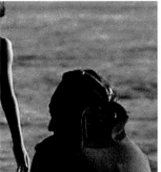

Original

Minimum quality

Original

Medium quality

JPEG compression

With minimum JPEG compression you get maximum quality. In fact, at the highest magnification it is very hard to see any loss in detail but at the magnification shown here you can make out, with careful examination, a very slight smoothing of detail in the right-hand image compared with the original on the left. The cost, of course, is that the file is compressed from nearly 7 MB to about half the size, 3.7 MB.

Quality setting

At the minimum quality setting, the file size is pared down to an impressive 100 K from 7 MB – to just 2 per cent of the original size – a reduction of nearly 50 times and the download time has dropped to an acceptable 16 seconds. The loss of image quality is more evident: notice how the grain in the original (*far left*) has been smoothed out and the girl's arm is altered, with slightly exaggerated borders. But when it is used at its normal size on screen, it is a perfectly acceptable image.

Medium quality

With a medium-quality setting, here showing a different part of the same image, there is a substantial and useful reduction in file size – from nearly 7 MB to just 265 K – some 20 times smaller, or 5 per cent of the original file size. The download time is accordingly reduced from over 15 minutes to 50 seconds. This latter figure is still uncomfortably long and the image quality is arguable better than needed for viewing on screen, while being just adequate for printing at postcard size.

Pictures on the Web continued

image should be, keep in mind that the larger the image, the longer it takes to download.

Conversion Convert images to the correct Web format: image files should be JPEG or GIF, possibly PNG, but not TIFF. In the process, you will be faced with the choice of image compression ratios. For most purposes, it is best to set a compression slightly greater than you would like (the image is degraded just a little more than you would wish). Chances are that visitors to your site will not know your images and will tolerate a slight loss of detail. But they will appreciate not having to wait long for your images to appear. Part of image conversion is to ensure that image files are correctly named, with their appropriate suffix.

On-line printing

If you have only the occasional need to print or to make a poster-sized print (see p. 185), you can always consider using an on-line printing facility. To take advantage of this, you simply send your image file or post your film to an Internet-based service, together with your credit-card details to cover the processing and handling costs. Most of these services allow you to set up your own album or folder in which to keep your images, so saving you having to resend images if you need a repeat printing. Since new services are always being added, and some others may cease trading, it is probably best to use a service that is based in your own country.

Original

GIF 256 colours

GIF 256 colours
This image shows that even when you restrict what looks like a scene with many colours to just 256 colours, you can obtain a very passable reproduction (p. 121). The view shows an enlarged portion of the image – very little quality loss is visible. The file size is about a quarter smaller than the original (far left) – 840 K instead of 3.4 MB.

GIF colour table
The colours used to reproduce the image are displayed in this table (left) – also known as a colour look-up table. Here, colours are displayed in order of popularity – the colour most used is a near-black followed by four pale blues, and so on.

PNG colour table
The colour look-up table for PNG (right) shows all the colours that can be reliably reproduced across the Web. Only 136 of the 256 colours available were actually used for the image.

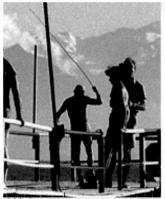

Original

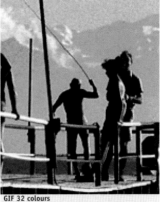

GIF 32 colours

GIF 32 colours

Even when using a mere 32 colours to create the image (*near left*), quality loss is not that apparent, apart from an increase in graininess in the sky. Note that the file size is some 10 per cent smaller than the original (*far left*)– a level of compression not equal to that of a JPEG file at the medium-quality setting, yet giving inferior image quality.

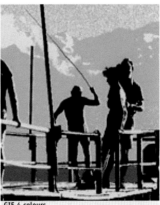

Original

GIF 4 colours

GIF 4 colours

By setting the GIF to use only four colours, a graphic image results (*near left*). This is a useful way of creating posterized effects – an effect in which the colours used to reproduce an image are drastically reduced in number.

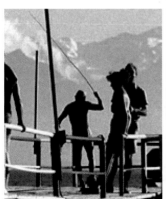

Original

PNG version

PNG version

The PNG format set to use Web-safe colours – those that can be reliably reproduced, irrespective of browser software – produces inferior results (*near left*). The sky is mottled yet the file size is only reduced to a quarter of the original (*far left*).

Getting started

With the vast quantity of information available it is relatively easy to find out all you need to know about the many aspects of digital photography: there are videos that guide you step-by-step; CD-ROMs with interactive lessons; and, of course, there are numerous books on the subject. There are also many sources of information on the Internet – although these may vary in both quality and depth, most of them should at least be up-to-date. The best way to learn from these sources is usually to have a specific task to complete: having a clear direction in mind often greatly speeds up your learning, rather than just picking up on unrelated snippets of information.

Another option to help you get started is to attend a course of some description. Many are available, but the best types for most people are those offering intensive or residential tuition. These are often run as summer schools in which you immerse yourself in a completely "digital" environment. Such courses will enable you to concentrate on problem-solving, and being able to ask for help from experts at the immediate time that you need clarification can greatly accelerate the learning process. However, if you do not have the equipment to continue at the same level once you return home, you may quickly forget all you

have learned. To make the most of immersion teaching, you need to continue using your newly acquired skills. To check if an intensive or residential course is suitable for you, ask these questions when you speak to the administrator or when you read through the prospectus:
● Do the fees include all materials, such as ink-jet paper and removable media?
● Will there be printed information to take home and keep?
● Which software will be taught?
● Which computer platform will be used?
● Do students have individual computers to work on or will you have to share?
● What standard is expected at the start; what standard is to be attained by the end?
● What are the qualifications of tutors?
You will gain most from any course if you first thoroughly prepare yourself. Having a project or two in mind to work on prevents your mind going blank when you are asked what you would like to achieve. And take along some image files or a scrapbook of pictures to use or to scan in. The best way to learn how to use computer software is to have a real task to complete – this might be a poster for a community event you are involved in, making a greetings card, or producing a brochure for a company.

Getting on a course

To help ensure that you get onto the course of your choice, consider the following points:
● Plan ahead: most courses recruit and interview only at certain times of the year.
● Prepare a portfolio – this does not have to comprise professional-quality work. Show the work that you most like, not necessarily the most technically perfect. Be prepared to talk about your work, but don't feel offended if you aren't asked. Ink-jet prints are perfectly acceptable. Do not spend a fortune on a large portfolio. Keep it neat and a manageable size – no larger than A3.
● Read up: if the course contains elements you are not familiar with, such as art history or media theory,

check that you are interested in them before applying. Further, if you know what the course objectives are, you will then know that what you want to do is in line with what the institution wants to achieve. This is important for you – and it is likely to impress the interviewer.
● Check on any formal requirements, such as minimum educational qualifications. You may need to attend an access or refresher course before entering college.
● Plan your finances: attending a course affects your ability to earn and can itself be a financial drain. Calculate the course fees, then add the materials, equipment, and travel costs to your living expenses to work out how much you need to put aside.

Mounting an exhibition

After spending some time taking photographs and accumulating images, the urge to show your work to people beyond your immediate circle of family and friends may start to grow and gnaw at you. The first thing you must do is banish from your mind any doubts that your work is not good enough to show to the wider public. An exhibition is exactly that: you make an exhibit of yourself. People will not laugh, but they may admire. If you have the drive and the ambition, then you should start planning now – you cannot start this process too early.

Turning a dream into reality

You may feel that you are not ready to mount an exhibition just yet. If so, then perhaps you had better get on with the task of building up a library of suitable images. At some point in the future you will know you have the right material and that the time is right.

Now try to imagine in your mind's eye what the show will look like: visualize how you would light it, how you will position your images for maximum impact, how to sequence photographs to create a particular atmosphere, and create a flow of meaning or narrative. Picture to yourself the size of the prints, how they will glow in the light.

Selling prints

Remember that silver-based prints will continue, for a long time yet, to sell for higher prices than any digital-produced print. Here are some hints for ensuring good, continuing relations with your buyers:

- Don't make unsubstantiated claims about the permanence of printed images.
- Give people advice about how to care for the prints, such as not storing them in humid conditions or where they will be exposed to bright sunlight.
- Never exceed the run when you offer limited-edition prints – produce the specific, guaranteed number, and not one more.
- Print on the best-quality paper you can afford or that recommended by the printer manufacturer.

This will help to focus your mind and guide your energies as well as act as a spur to your picture- or print-making. Here are some other pointers you might want to consider:

- Choose your venue well in advance, as most of the better-known galleries are under a lot of pressure and have to plan their schedules at least a year ahead. Other galleries may call quarterly or half-yearly committee meetings to decide what to show in the proceeding period. At the other end of the scale, venues such as a local library or a neighbourhood community hall may be prepared to show work at very short notice. In any event, you will want to give yourself the time necessary for your plans to mature and to give the venue the opportunity to tie something in to the exhibition, such as a concert or lecture (depending on the subject matter of your imagery).

- Choose your venue creatively. Any public space could be a potential exhibition venue – indeed, some seemingly improbable spaces may be more suitable for some types of work than a "proper" gallery. Bear in mind that the very presence of your work will transform the space into a "gallery", whether it is on the top deck of a bus, a shopping mall, or a pedestrian walkway.

- Budget with your brains, not your heart. Put on the best show you can afford, not one that costs more than you can afford. The point of an exhibition is to win a wider audience for your work, not to bankrupt you or to force you to call in financial favours that you might need at some time in the future to further your photographic endeavours.

- Once you have decided on the space you want to use and have received all necessary permissions, produce drawings of the layout of the entire venue. This will also involve you in making little thumbnail sketches of your prints in their correct hanging order: it is easier to visualize the effectiveness of picture order this way.

Timing

Mounting an exhibition requires very careful planning on many different levels if you want your show to look professional, so don't leave any

Drawing up a budget

When budgeting for the costs of an exhibition, take into account not only your direct photographic expenses but also the range of support services. These include the costs of electricians to light your work, picture-framing, public-liability insurance, the building (or hiring) of "flats" to break up the exhibition space and provide extra surfaces on which to hang your work. Here are some cost categories to consider:

● Direct photographic costs – including making prints or slide duplication if projected images form part of your show.

● Indirect photographic costs – including retouching, mounting, frame-making, and the hire of equipment, such as projectors.

● Gallery costs – including venue hire, deposits against damage or breakages, and the hiring of flats or similar.

● Publicity – including the cost of producing and mailing out invitations, advertising in trade or local journals or newspapers, as well as the production of an exhibition catalogue.

● Insurance – budget for the costs of insuring your work, public liability, and damage to the venue.

● And don't forget – no matter what your final budget figure is, there will always be out-of pocket expenses you cannot identify beforehand. At the last minute, for example, you might decide you want flowers for the opening night. So, as a precaution, add a 15 per cent contingency to the final budget figure.

important carpentry, electrical, picture-framing or similar work to, say, a long weekend or holiday period when you might not be able to gain access to key personnel should something go critically wrong. And you should always count on the fact that something will go wrong.

Looking at sponsorship

One way to offset some of the costs of mounting an exhibition is by sponsorship. The key to success is persuading a potential sponsor that the likely benefits from the relationship will flow both ways. It is obvious that you will benefit from the deal by being offered free film, the use of equipment you might not otherwise be able to afford perhaps, or complementary or discounted print-making, but what do the other parties get?

The best approach to sponsorship involves you persuading potential benefactors that by making equipment or services available to you they will receive some boost to their business or that their public profile will be somehow enhanced by the association. It could be that, for example, sponsoring individuals, companies, or organizations will receive coverage in trade newspapers or journals as a result of their help.

As a rule, it is always easier to obtain services or products than it is cash. Printing materials, exhibition space, scanning, processing, even food and drinks for the opening night are all possible, but cash is unlikely. And remember to make your approach in good time – organizations have budgets to maintain and once sponsorship allocations have been made, often there may be nothing left until the next financial year.

Finally, even if the answer from a potential sponsor is "no", you can still ask for something that may be even more valuable – information. So ask for suggestions about which other companies or organizations might be interested in helping.

An exhibition is your chance to get your work known by a wider audience, so make full use of the opportunity if it arises by telling everybody you know about it, and encouraging them to spread the word to their contacts.

Finally, mounting a photographic exhibition brings together many different people and skills. They are your sponsors just as much as any commercial contributor, so always take the trouble to acknowledge their invaluable help and contributions, for without them your show might never have got off the drawing board.

Copyright concerns

Copyright is a fascinating subject, and it is one that, due to the rise of digital media and information technology in particular, is becoming even more pertinent. Different traditions of copyright law in different countries lead to varieties not only in the detail but also in the entire approach to this subject. This renders the area of copyright a potential minefield for the unwary, especially since it is so dependent on national boundaries and international relations.

Rather than attempt to produce the impossible – a brief summary of copyright law and traditions that would be accurate in most places in the world – following are some frequently asked questions and their answers, which have a wide applicability. However, you should always seek professional advice if you are not sure what your rights are or how you should proceed. But you probably will not need to hire a lawyer, as many professional organizations and legal advice centres are willing to provide basic copyright law advice to members of the public who come to them for help. Another source of help is the Internet.

Do I have to register in order to receive copyright protection?

No, you do not. Copyright in works of art – which includes writing, photographs, and digital images – arises as the work is created. In more than 140 countries in the world, no formal registration is needed to receive basic legal protection.

Can I protect copyright of my images once they are on the Web?

Not directly. This is because you cannot control who has access to your Web site. Make sure you read the small print if you are using free Web space. You may be asked to assign copyright to the Web server or service provider. Do not proceed if you are not happy with this condition.

Can I be prosecuted for any images I place on the Web?

Yes, you can. If your pictures breach local laws – for example, those to do with decency, pornography, or the incitement of religious or racial hatred, or if they feature illegal organizations – and if you live within the jurisdiction of those laws, you may be liable to prosecution. Alternatively, your Internet Service Provider (ISP) may be ordered to remove them.

Do I have to declare that I own copyright by stamping a print or signing a form?

In most countries, no. Copyright protection is not usually subject to any formality, such as registration, deposit, or notice. It helps, however, to assert your ownership of copyright clearly – at least placing "© YOUR NAME" – on the back of a print or discreetly within an image on the Web, such as in the lower-right-hand corner.

Is it wrong to scan images from books and magazines?

Technically, yes you are in the wrong. Copying copyright material (images or text) by scanning

Can I prevent my ideas from being stolen?

There is no copyright protection covering ideas to do with picture essays, for example, or magazine features or books. The easiest way to protect your concept is by offering your ideas in strict confidence. That is, your ideas are given to publishers or editors only on the condition that they will not reveal your ideas to any third party without your authorization. Your idea must have the necessary quality of confidentiality – that is, you have not shared the information with more than a few confidants – and the idea is not something that is widely known. The most unambiguous approach to this issue is to require your publisher or the commissioning editor to sign a non-disclosure agreement – a written guarantee. However, this may be an unduly commercial-strength approach. You may preface your discussions with a "this is confidential" statement. If the person does not accept the burden of confidentiality, you should not proceed.

from published sources does place you in breach of copyright law in most countries. However, in many countries you are allowed certain exceptions – for example, if you do it for the purposes of study or research, for the purposes of criticism or review, or to provide copy for the visually impaired. Bear in mind, though, that these exceptions vary greatly from country to country.

What is a "watermark"?

It is information, such as a copyright notice or your name and address, that is incorporated deep in the data of an image file. The "watermark" is usually visible but it may be designed to be invisible. In either case, watermarks are designed so that they cannot be removed without destroying the image itself.

If I sell a print, is the buyer allowed to reproduce the image?

No – you have sold only the physical item, which is the print itself. By selling a print, you grant no rights apart from the basic property right of ownership of the piece of paper – and an implied right to display it for the buyer's personal, private enjoyment. The buyer should not copy, alter, publish, exhibit, broadcast, or otherwise make use of that image without your permission.

What are "royalty-free" images?

These are images that you pay a fee to obtain in the first instance, but then you do not have to pay any extra if you use them – even for commercial purposes. With some companies, however, certain categories of commercial use, such as advertising or packaging, may attract further payments. Royalty-free images usually come on CDs but they may also be downloaded from a Web site.

How is it possible for images to be issued completely free?

Free images found on the Internet can be an inexpensive way for companies to attract you to visit their site. You can then download these images for your own use, but if you wish to make money from them, you are expected and trusted to make a payment. This fee is usually relatively small, however, so you are encouraged to behave honestly and not exploit the system.

Does somebody own the copyright of an image if that person pays for the film or the hire of the equipment?

In most countries, the answer is no. In some countries, if you are employed as a photographer then it is your employer who retains copyright in any material you produce; in others, however, it is the photographer who retains the copyright. In any circumstance, the basic position can be overridden by a local contract made between the photographer and the other party prior to the work being carried out.

If I manipulate someone else's image, so that it is completely changed and is all my own work, do I then own the copyright in the new image?

No. You need to bear in mind that you were infringing copyright in the first place by making the copy. And then, altering the image is a further breach of copyright. Besides, the new image is not fully all your work: arguably, it is derived from the copy. If you then claim authorship, you could be guilty of yet another breach – this time, of a moral right to ownership.

Surely it is all right to copy just a small part of an image – say, part of the sky area or some other minor detail?

The copyright laws in most countries allow for "incidental" or "accidental" copying. If you take an insignificant part of an image, perhaps nobody will object, but it is arguable that your action in choosing that particular part of an image renders it significant. If this is accepted, then it could be argued that you are in breach. If it makes no real difference where you obtain a bit of sky, then try to take it from a free source (*see p. 214*).

Shopping for equipment

Purchasing all the equipment needed for digital photography can be either bewilderingly off-putting or delightfully full of new things to learn. There is undoubtedly a lot to consider, but if you are not lucky enough to have a knowledgeable friend to help, don't worry. There is a great amount of information available out there – much of it free and not all of it dependent on Internet access.

Where to look for help

Large retailers are a good starting place in the search for information, as many produce catalogues with basic definitions and helpful advice, in addition to equipment specifications and prices. There are also several magazines on digital photography and, if you have Internet access, there is much up-to-date information, technical details, and more-or-less objective reviews. Note, however, that information on the Internet may be as biased or as objective as advice given by a friend. And can you rely on the reviewer having sufficient depth and breadth of knowledge and experience of the equipment under review?

Similar issues apply to specialist magazines: some journalists may be only a little further ahead of you on the learning curve. Added to this, magazines can also come under pressure to find good features in products and to play down evidence of poor performance. Be especially wary of reviewers who never find anything to criticize and give high ratings to all equipment tested.

Buying on-line

Contrary to much of the bad press associated with Internet shopping, buying on-line can be a more secure route than ordering by telephone mail-order. It can also be cheaper due to the discounts offered by many retailers to Web-based customers. However, there are some sensible precautions you should take:
- Ensure the site promises secure transactions.
- Buy only low-cost items on-line when dealing with an unknown company, or simply to start with, until you are more confident in the system.
- If possible, use a credit card that guarantees against the fraudulent use of your details when shopping on the Internet.
- Make sure you take a note of the transaction references or print out a copy of any orders you make on-line.
- Don't leave ordering to the last moment before you need an item – stocking problems or postal delays are always possible.

Buying second-hand

With the rapid turn-over of equipment, buying second-hand can be a sound way to save money. It is safest to keep to the well-known brands offering high build standards. For cameras, makers such as Canon, Nikon, Leica, and Hasselblad produce consistently sound models. However, this equipment is often used by professionals, so it may have seen heavy-duty use. Makes such as Pentax, Minolta, and Olympus take excellent images, but may not be as popular with professionals.

Hiring equipment

Do you ever need expensive equipment but cannot really afford it or would use it only occasionally? You may, for example, need a super-long telephoto lens for a safari trip, a data projector for a talk, a superior-quality scanner, or a replacement computer while yours is under repair. One answer is to hire items you need – you will save on the purchase price, pay only when the item is really needed, and the hire cost should be fully tax deductible if you are in business. Note the following points:
- Research possible equipment sources and set up account facilities. Some companies will send items if you live far from their warehouse or depot if you are a known customer, while new customers may need to provide a full-value cash deposit.
- Contact the supplier to reserve the item as soon as you think you might need it.
- Try to pick up the item a day or two early so that you can familiarize yourself with it and fully test it.
- Ensure your insurance covers any hired items.

With computers, the soundest purchase is undoubtedly Apple Macintosh machines, which are made by a single manufacturer well-known for consistently high build and component quality (though this is not to say that all "Macs" were great designs). Safe choices for second-hand PC computers would be from the main players, such as IBM, Hewlett-Packard, Dell, and the like.

Shopping for specific interests

The key to shopping for a camera for some specific photographic task is to ensure that the features needed for that particular job are available or well implemented in the camera.

Challenging conditions Camera should be sealed against dust and damp, and have a rugged construction, such as the Kodak DC5000 or DCS series. Any digital camera with an underwater housing may also be suitable.

Collecting Good close-up facilities provided by the like of the Nikon Coolpix 990, or an SLR design with a macro lens. For small objects, such as coins, stamps, or medals, a flat-bed scanner may be preferable – and much, much cheaper.

Interiors Distortion-free, wide-angle lens: if high quality is needed, use a Kodak 600 series camera or scanning backs providing full-size coverage, such as the Phase One StudioKit.

Nature Very long lens and quiet operation: consider SLR digitals, such as the Canon D30, Fuji S1, Nikon D1, or Olympus E-10.

Low light Fast lens, such as on the Olympus E-10, or an SLR type with a large maximum-aperture lens. Consider models able to correct for the increased "noise" associated with long exposures – Canon D30, Nikon D1X, and Kodak DCS 320.

Portraiture Digital camera with rapid response, such as Olympus 2010 or SLR types such as Kodak DCS series and Nikon D1H. A large-aperture medium telephoto is most useful – 50 mm f/1.4 for 35 mm format is a very useful equivalent focal length of 75 mm and f/1.4 on some SLR digitals.

Sports Rapid response and a long lens: consider an Olympus E-10 or an SLR digital such as a Nikon, Fuji, or Canon. For difficult conditions, an

Shopping checklist

- Shop with somebody knowledgeable, if you are lucky enough to know one.
- Write down the details of your computer model, operating system, and the details of other equipment that needs to work with the item you need.
- If it is second-hand, check that the equipment appears to have been well treated.
- If it is second-hand, enquire about the history of the equipment – what type of person used it, for what purpose, and for how long.
- Check that there is a guarantee period and that it is long enough for any likely faults to appear.
- When buying computer peripherals, make sure they will work with your exact computer model and operating system. You may, nonetheless, still need to test equipment at home with your computer, so if any compatibility problems arise, make sure the store will provide you with free technical support. If these problems prove to be insurmountable, enquire about the store's policy regarding refunds.
- Don't be afraid to ask about anything that may be causing you confusion. You will not look foolish – the only foolish thing is to pay for equipment that later proves useless.

SLR such as Kodak DCS 300, 500, 600 series with a 70–200 mm zoom. May need a rain- or waterproof cover in addition.

Still-life and studio Synchronization with studio flash essential: ensure the camera accepts an adaptor to allow direct connection between digital camera and flash unit. Ideal if the camera controls can be set from the computer.

Travel Good-quality SLR-type digital, such as Olympus E-10 or Fuji 4900, plus attachments to extend zoom range. Power-pack to enable extended working session, extra memory cards or a laptop to download images.

Underwater Housings available for some Canon Ixus, Olympus, and Nikon models. Underwater flash must be synchronized with camera model.

Disabilities

Compared with traditional photography – film-based and with its chemical processes – many of the features found on modern digital equipment make photography more accessible to people with some forms of disability. The reduced need for darkroom or workroom processes, for example, as well as the greater level of automation of equipment, mean that it is altogether easier to produce good-quality, satisfying results. On the whole, however, any advantages disabled photographers may enjoy from using digital equipment have been incidental rather than as a result of the industry taking their needs into account at the design stage.

Accessibility is all about accommodating the characteristics a person cannot change by providing options. For example, a person who has impaired dexterity could control equipment via voice commands. The whole subject of photography for disabled people is a complicated one, but some points can be summarized here (*see also p. 213 for Web resources*).

Physical dexterity

Digital cameras could, almost without exception, be designed to make life easier for those with impaired dexterity. In reality, however, buttons are usually tiny, at times two have to be pressed simultaneously, sockets need connectors that are small and have to be aligned precisely if they are to marry up, and so on. The Kodak DC 5000 stands out from other digital cameras for its larger-than-normal controls and its sturdy, chunky design, which makes it easy to grip and manipulate. In addition, the larger SLR digital cameras, such as the Nikon D1 or Kodak DCS range, are in general far easier to handle than compact models. However, on the downside, they are considerably bulkier and heavier.

Some digital cameras allow remote release – the camera can be set up on a rig or support while the release is conveniently located some distance away. While the remote controls are usually very small, it should be possible to adapt them by attaching a large hand-grip. Most digital cameras are small and light enough to be easily mounted on a helmet or metal bracket attached to a wheelchair. If so, the mounting should have some type of self-levelling mechanism to keep the camera horizontal even if the chair is tilted out of true by an uneven surface.

On the computer side, some software features voice-activated commands, which help to reduce reliance on the the keyboard. With sufficient programming, this software can be used to perform basic image manipulation as well as produce text for captioning or record-keeping notes. There is a wide range of Windows-based software that offers improved access to computing.

Visual ability

The relatively large LCD screens found on digital cameras may help the visually impaired: the Ricoh RDC-i700 is notable for its unusually large LCD screen with touch-screen controls allowing you to select menu items using a pointer.

Back at home, viewing images on a large-sized monitor offers considerable advantages over the traditional prints from most film processors. Selecting a low resolution – say, 640 x 480 dpi, on a 43 cm (17 in) screen renders palettes and labels very large and, therefore, far easier to read. Many software applications employ symbols rather than words to indicate options, which can also be an advantage. Software utilities, such as KeyStrokes, are available, which place an easy-to-read keyboard on the monitor screen: mouse clicks on the screen have the effect of typing letters. Keyboards with extra large keys are also available.

Hearing ability

Most digital cameras give feedback on actions and functions with visual confirmation, so people with hearing difficulties will not be affected. However, with digital cameras there is no physical sensation of a traditional shutter release being triggered. It may be important to find a camera that indicates shutter release with some form of visual signal: many do so indirectly, using a light to indicate that an image is being written to disk.

Survival guide

Do not lose sight of the fact that photography is really about taking pictures. The more familiar you are with your equipment, and the more care you take to ensure nothing is likely to go wrong and therefore distract you, then the more you can put purely technical considerations to one side and concentrate instead on bringing back that winning shot.

Tips for trouble-free photography

Here are some points you might want to consider to help you get the most pleasure from your digital photography:

- Before going away on a trip or out on assignment, test all your equipment before leaving home or the studio. This means checking the entire process – from capture right through to print-out. Take some test pictures, download them onto your computer, and check the image at high magnification for any obvious defects. Then resize the images and print them out.
- Include a battery charger with a suitable travel plug adaptor as part of your basic photographic kit. If you know there will be no mains electricity where you are going, then make sure you take along more than enough spare batteries. For expeditions likely to last more than a month to really remote regions, consider buying a solar-powered battery charger.
- Take as many spare memory cards as you can reasonably afford to buy. Always try to keep at least one memory card safe and empty (but ready and preformatted). However, check it with your camera first – sometimes a camera will take against an individual card for no apparent reason.
- Prepare your equipment carefully against the worst the elements can throw against it. Wrap up everything in double plastic bags if conditions are dusty. Never take your camera from one type of temperature immediately into a radically different one without first sealing it in a case or an airtight bag. If you carry camera equipment from a cool environment, such as an air-conditioned hotel room, into the heat of a tropical afternoon, condensation is almost certain to form on the outer

casings as well as on the glass surfaces of lenses and other optical systems. And if you move your equipment the other way – from tropical afternoon temperatures into a cold, air-conditioned room – without giving it a chance to adapt, you could damage it. In hotel rooms, the bathroom is often not air-conditioned. If so, store your camera bag in there. Otherwise, before leaving your room, turn the air-conditioning down to its minimal (warmest) setting.

- Don't let your camera get too hot – never leave it in a car's glove compartment, for example.
- Keep all optical surfaces clean. Blow dust and sand off the lens and eyepiece optics before wiping any marks off. Use the inside surface of a clean double-thickness tissue to clean your lenses and eyepiece: you can breathe carefully on it and wipe off the pure water condensation. Do not scrub at the lens surface as if it were a car window.
- Batteries are more often the cause of camera malfunctions than anything else. If your camera will not work, first check that you have installed the batteries the right way around. Clean and check the contacts to make sure the batteries are making good contact (contacts can become distorted if roughly handled). Finally, check that all the batteries are fresh – one old battery in a set of three good ones may give sufficient reason for the camera to complain. If you use rechargeable batteries only, take at least one spare as a precaution. In addition, take a set of alkaline-manganese (non-rechargeable) batteries as a back-up.
- Take a small toolkit. Most useful is a jeweller's screwdriver. Many cameras have up to ten little exposed screws, which may work loose. Check regularly and screw them tight if they have worked loose. A pair of pliers may help you bend metal parts back into shape if you have an accident. Repairs like this will invalidate any warranties, however, so regard this as a last-resort measure.
- Obtain insurance to cover you against theft, loss in transit, and damage to equipment.
- Take a film-based camera (one not totally reliant on batteries preferably) with some film in case all else fails.

Glossary

24x speed The device in question reads data from a CD-ROM at 24x the basic rate of 150 KB per second. As a guide, modern CD players may reach speeds of 48x, or greater.

24-bit A measure of the size or resolution of data that a computer, program, or component works with. A colour depth of 24 bits produces millions of different colours.

2D Two-dimensional, as in 2D graphics. Defining a plane or lying on one.

3D Three-dimensional, as in 3D graphics. Defining a solid or volume, or having the appearance of a solid or volume.

35efl 35 mm equivalent focal length. A digital camera's lens focal length expressed as the equivalent focal length for the 35 mm film format.

36-bit A measure of the size or resolution of data that a computer, program, or component works with. In imaging, it equates to allocating 12 bits to each of the R, G, B (red, green, blue) channels. A colour depth of 36 bits produces billions of colours.

5,000 The white balance standard for pre-press work. Corresponds to warm, white light.

6,500 The white balance standard corresponding to normal daylight. It appears to be a warm white compared with 9,300.

9,300 The white balance standard close to normal daylight. It is used mainly for visual displays, since its higher blue content (compared with 6,500) gives better colour rendering in the lighting conditions normally found indoors.

A

aberration In optics, a defect in the image caused by a failure of a lens system to form a perfect image.

aberration, chromatic An image defect that shows up as coloured fringes when a subject is illuminated by white light, caused by the dispersion of white light as it passes through the glass lens elements.

absolute temperature A measure of thermodynamic state, used to correlate to the colour of light. Measured in degrees Kelvin.

absorption Partial loss of light during reflection or transmission. Selective absorption of light causes the phenomenon of colour.

accelerator A device that speeds up a computer by,

for example, providing specialist processors optimized for certain software operations.

accommodation An adjustment in vision to keep objects at different distances sharply in focus.

achromatic colour Colour that is distinguished by differences in lightness but is devoid of hue, such as black, white, or greys.

ADC Analogue-to-Digital Conversion. A process of converting or representing a continuously varying signal into a set of digital values or code.

additive A substance added to another, usually to improve its reactivity or its keeping qualities.

additive colour synthesis Combining or blending two or more coloured lights in order to simulate or give the sensation of another colour.

address Reference or data that locates or identifies the physical or virtual position of a physical or virtual item: for example, memory in RAM; the sector of hard-disk on which data is stored; a dot from an ink-jet printer.

addressable The property of a point in space that allows it to be identified and referenced by some device, such as an ink-jet printer.

algorithm A set of rules that defines the repeated application of logical or mathematical operations on an object: for example, compressing a file or applying image filters.

alias *1* A representation, or "stand-in", for the continuous original signal: it is the product of sampling and measuring the signal to convert it into a digital form. *2* In Mac OS, a file icon that stands for the original.

alpha channel A normally unused portion of a file format. It is designed so that changing the value of the alpha channel changes the properties – transparency/opacity, for example – of the rest of the file.

analogue An effect, representation, or record that is proportionate to some other physical property or change.

anti-aliasing Smoothing away the stair-stepping, or jagged edge, in an image or in computer type-setting.

apps A commonly used abbreviation for application software.

array An arrangement of image sensors. There are two types. *1* A two-dimensional grid, or wide array, in which rows of sensors are laid side-by-side to cover an area. *2* A one-dimensional or

Glossary continued

linear array, in which a single row of sensors, or set of three rows, is set up, usually to sweep over or scan a flat surface – as in a flat-bed scanner. The number of sensors defines the total number of pixels available.

aspect ratio The ratio between width and height (or depth).

attachment A large file that is sent along with an email.

B

back-up To make and store second or further copies of computer files to protect against loss, corruption, or damage of the originals.

bandwidth *1* A range of frequencies transmitted, used, or passed by a device, such as a radio, TV channel, satellite, or loudspeaker. *2* The measure of the range of wavelengths transmitted by a filter.

beam splitter An optical component used to divide up rays of light.

bicubic interpolation A type of interpolation in which the value of a new pixel is calculated from the values of its eight near neighbours. It gives superior results to bilinear or nearest-neighbour interpolation, with more contrast to offset the blurring induced by interpolation.

bilinear interpolation A type of interpolation in which the value of a new pixel is calculated from the values of four of its near neighbours: left, right, top, and bottom. It gives results that are less satisfactory than bicubic interpolation, but requires less processing.

bit The fundamental unit of computer information. It has only two possible values – 1 or 0 – representing, for example, on or off, up or down.

bit depth Measure of the amount of information that can be registered by a computer component: hence, it is used as a measure of resolution of such variables as colour and density. 1-bit registers two states (1 or 0), representing, for example, white or black; 8-bit can register 256 states.

bit-mapped *1* An image defined by the values given to individual picture elements of an array whose extent is equal to that of the image; the image is the map of the bit-values of the individual elements. *2* An image comprising picture elements whose values are only either 1 or 0: the bit-depth of the image is 1.

black *1* Describing a colour whose appearance is due to the absorption of most or all of the light. *2* Denoting the maximum density of a photograph.

bleed *1* A photograph or line that runs off the page when printed. *2* The spread of ink into the fibres of the support material. This effect causes dot gain.

BMP Bit MaP. A file format that is native to the Windows platform.

bokeh The subjective quality of an out-of-focus image projected by an optical system – usually a photographic lens.

brightness *1* A quality of visual perception that varies with the amount, or intensity, of light that a given element appears to send out, or transmit. *2* The brilliance of a colour, related to hue or colour saturation – for example, bright pink as opposed to pale pink.

brightness range The difference between the lightness of the brightest part of a subject and the lightness of the darkest part.

browse To look through a collection of, for example, images or Web pages in no particular order or with no strictly defined search routine.

Brush An image-editing tool used to apply effects, such as colour, blurring, burn, or dodge, that are limited to the areas the brush is applied to, in imitation of a real brush.

buffer A memory component in an output device, such as printer, CD writer, or digital camera, that stores data temporarily, which it then feeds to the device at a rate the data can be turned into, for example, a printed page.

burning-in *1* A digital image-manipulation technique that mimics the darkroom technique of the same name. *2* A darkroom technique for altering the local contrast and density of a print by giving specific parts extra exposure, while masking off the rest of the print to prevent unwanted exposure in those areas.

byte Unit of digital information: 1 byte = 8 bits. A 32-bit microprocessor, for example, handles four bytes of data at a time.

C

C An abbreviation for cyan. A secondary colour made by combining the two primary colours red and blue.

cache The RAM dedicated to keeping data recently

read off a storage device to help speed up the working of a computer.

calibration The process of matching characteristics or behaviour of a device to a standard.

camera exposure The total amount of the light reaching (in a conventional camera) the light-sensitive film or (in a digital camera) the sensors. It is determined by the effective aperture of the lens and the duration of the exposure to light.

capacity The quantity of data that can be stored in a device, measured in MB or GB.

cartridge A storage or protective device consisting of a shell (a plastic or metal casing, for example) enclosing the delicate parts (film, ink, or magnetic disk, for example).

catch light A small, localized highlight.

CCD Charge Coupled Device. A semiconductor device used as an image detector.

CD-ROM Compact Disk–Read Only Memory. A storage device for digital files invented originally for music and now one of the most ubiquitous computer storage systems.

characteristic curve A graph showing how the density of a given film and its development relate to exposure.

chroma The colour value of a given light source or patch. It is approximately equivalent to the perceived hue of a colour.

CIE LAB Commission Internationale de l'Éclairage LAB. A colour model in which the colour space is spherical. The vertical axis is L for lightness (for achromatic colours) with black at the bottom and white at the top. The a axis runs horizontally, from red (positive values) to green (negative values). At right-angles to this, the b axis runs from yellow (positive values) to blue (negative values).

clipboard An area of memory reserved for holding items temporarily during the editing process.

CLUT Colour Look-Up Table. The collection of colours used to define colours in indexed colour files. Usually a maximum of 256 colours can be contained.

CMYK Cyan Magenta Yellow Key. The first three are the primary colours of subtractive mixing, which is the principle on which inks rely in order to create a sense of colour. A mix of all three as solid primaries produces a dark colour close to black, but for good-quality blacks, it is necessary to use a separate black, or key, ink.

codec co(mpression) dec(ompression). A routine or algorithm for compressing and decompressing files, for example, JPEG or MPEG. Image file codecs are usually specific to the format, but video codecs are not tied to a particular video format.

cold colours A subjective term referring to blues and cyans.

colour picker The part of an operating system (OS) or application that enables the user to select a colour for use – as in painting, for example.

colour synthesis Re-creating the original colour sensation by combining two or more other colours.

colour temperature The measure of colour quality of a source of light, expressed in degrees Kelvin.

colorize To add colour to a greyscale image without changing the original lightness values.

ColorSync A proprietary colour-management software system to help ensure, for example, that the colours seen on the screen match those to be reproduced by a printer.

colour *1* Denoting the quality of the visual perception of things seen, characterized by hue, saturation, and lightness. *2* To add colour to an image by hand – using dyes, for example – or in an image-manipulation program.

colour cast A tint or hint of a colour that evenly covers an image.

colour gamut The range of colours that can be reproduced by a device or reproduction system. Reliable colour reproduction is hampered by differing colour gamuts of devices: colour film has the largest gamut, computer monitors have less than colour film but more than ink-jet printers; the best ink-jet printers have a greater colour gamut than four-colour CMYK printing.

colour management The process of controlling the output of all the devices in a production chain to ensure that the final results are reliable and repeatable.

colour sensitivity A measure of the variation in the way in which film responds to light of different wavelengths, particularly in reference to black and white films.

complementary colours Pairs of colours that produce white when added together as lights. For example, the secondary colours – cyan, magenta, and yellow – are complementary to the primary colours – respectively, red, green, and blue.

Glossary continued

compliant A device or software that complies with the specifications or standards set by a corresponding device or software to enable them to work together.

compositing A picture-processing technique that combines one or more images with a basic image. Also known as montaging.

compression A process by which digital files are reduced in size by changing the way the data is coded.

continuous-tone image A record in dyes, pigment, silver, or other metals in which relatively smooth transitions from low to high densities are represented by varying amounts of the substance used to make up the image.

contrast *1* Of ambient light: the brightness range found in a scene. In other words, the difference between the highest and lowest luminance values. High contrast indicates a large range of subject brightnesses. *2* Of film: the rate at which density builds up with increasing exposure over the mid-portion of the characteristic curve of the film/development combination. *3* Of a light source or quality of light: the difference in brightness between the deepest shadows and the brightest highlights. Directional light gives high-contrast lighting, with hard shadows, while diffuse light gives low-contrast lighting, with soft shadows. *4* Of printing paper: the grade of paper used – for example, high-contrast paper is grade 4 or 5, while grade 1 is low contrast. *5* Of colour: colours positioned opposite each other on the colour wheel are regarded as contrasting – for example, blue and yellow, green and red.

copyright Rights that subsist in original literary, dramatic, musical, or artistic works to alter, reproduce, publish, or broadcast. Artistic works include photographs – recordings of light or other radiation on any medium on which an image is produced or from which an image may be produced by any means whatever.

CPU Central Processor Unit. The part of the computer that receives instructions, evaluates them according to the software applications, and then issues appropriate instructions to other parts of the computer system. It is often referred to as the "chip" – for example, G4 or Pentium III.

crash The sudden and unexpected non-functioning of a computer.

crop *1* To use part of an image for the purpose of, for example, improving composition or fitting an image to the available space or format. *2* To restrict a scan to the required part of an image.

cross-platform Application software, file, or file format that can be used on more than one computer operating system.

curve A graph relating input values to output values for a manipulated image.

cut and paste To remove a selected part of a graphic, image, or section of text from a file and store it temporarily in a clipboard ("cutting") and then to insert it elsewhere ("pasting").

cyan The colour blue-green. It is a primary colour of subtractive mixing or a secondary colour of additive mixing. Also, the complementary to red.

D

D65 The white balance standard used to calibrate monitor screens. It is used primarily for domestic television sets. White is correlated to a colour temperature of 6,500 K.

daylight *1* The light that comes directly or indirectly from the sun. *2* As a notional standard, the average mixture of sunlight and skylight with some clouds, typical of temperate latitudes at around midday, and with a colour temperature of between 5,400 and 5,900 K. *3* Film whose colour balance is correct for light sources with a colour temperature between 5,400 and 5,600 K. *4* Artificial light sources, such as light bulbs, whose colour-rendering index approximates to that of daylight.

definition The subjective assessment of clarity and the quality of detail that is visible in an image or photograph.

delete *1* To render an electronic file invisible and capable of being overwritten. *2* To remove an item, such as a letter, selected block of words or cells, or a selected part of a graphic or an image.

density *1* The measure of darkness, blackening, or "strength" of an image in terms of its ability to stop light – in other words, its opacity. *2* The number of dots per unit area produced by a printing process.

depth *1* The sharpness of an image – loosely synonymous with depth of field. *2* A subjective assessment of the richness of the black areas of a print or transparency.

depth of field The measure of the zone or distance over which any object in front of a lens will appear acceptably sharp. It lies both in front of and behind the plane of best focus, and is affected by three factors: lens aperture; lens focal length; and image magnification.

depth perception The perception of the absolute or relative distance of an object from a viewer.

digital image The image on a computer screen or any other visible medium, such as a print, that has been produced by transforming an image of a subject into a digital record, followed by the reconstruction of that image.

digitization The process of translating values for the brightness or colour into electrical pulses representing an alphabetic or a numerical code.

direct-vision finder (or **viewfinder**) A type of viewfinder in which the subject is observed directly – for example, through a hole or another type of optical device.

display A device – such as a monitor screen, LCD projector, or an information panel on a camera – that provides a temporary visual representation of data.

distortion, tonal A property of an image in which the contrast, range of brightness, or colours appear to be markedly different from that of subject.

dithering Simulating many colours or shades by using a smaller number of colours or shades.

d-max *1* The measure of the greatest, or maximum, density of silver or dye image attained by a film or print in a given sample. *2* The point at the top of a characteristic curve of negative film, or the bottom of the curve of positive film.

dodging A darkroom technique for controlling local contrast when printing a photograph by selectively reducing the amount of light reaching the parts of a print that would otherwise print as being too dark. The term also applies to its digital equivalent.

down-sampling The reduction in file-size achieved when a bit-mapped image is reduced in size.

dpi Dots per inch. The measure of resolution of an output device as the number of dots or points that can be addressed or printed by that device.

driver The software used by a computer to control, or drive, a peripheral device, such as a scanner, printer, or removable media drive.

drop shadow A graphic effect in which an object appears to float above a surface, leaving a fuzzy shadow below it and offset to one side.

drop-on-demand A type of ink-jet printer in which the ink leaves the reservoir only when required. Most ink-jet printers in use today are of this type.

drum scanner A type of scanner employing a tightly focused spot of light that shines on a subject that has been stretched over a rotating drum. As the drum rotates, the spot of light traverses the length of the subject, so scanning its entire area.

duotone *1* A photomechanical printing process in which two inks are used to increase the tonal range. *2* A mode of working in image-manipulation software that simulates the printing of an image with two inks.

DVD-RAM A Digital Versatile Disk variant that carries up to 4.7 GB per side that can be written to and read from many times.

dye sublimation Printer technology based on the rapid heating of dry colorants that are held in close contact with a receiving layer. This turns the colorants to gas, which then solidifies on the receiving layer.

dynamic range The measure of spread of the highest to the lowest energy levels that can be captured or reproduced by a device, such as a scanner or film-writer.

E

email Electronic mail. Simple files that can be sent from one computer connected to the Internet to another or group of computers on the Internet.

edge effects Local distortions of the image density in a film due to the movement of the developer and developer products between regions of different exposure. Similar effects can be seen with some image-processing techniques.

effects filters *1* Lens attachments designed to distort, colour, or modify images to produce exaggerated, unusual, or special effects. *2* Digital filters that have effects similar to their lens-attachment counterparts, but also giving effects impossible to achieve with these analogue filters.

engine *1* The internal mechanisms that drive devices such as printers and scanners. *2* The core parts of a software application.

enhancement *1* Change in one or more qualities

Glossary continued

of an image, such as colour saturation or sharpness, in order to improve its appearance or alter some other visual property. 2 The effect produced by a device or software designed to increase the apparent resolution of a TV monitor screen.

EPS Encapsulated PostScript. A file format that stores an image (graphics, photograph, or page lay-out) in PostScript page-description language.

erase To remove, or wipe, a recording from a disk, tape, or other recording media (usually magnetic) so that it is impossible to reconstruct the original record.

EV Exposure Value. A measure of camera exposure. For any given EV, there is a combination of shutter and apertures settings that gives the same camera exposure.

exposure *1* A process whereby light reaches light-sensitive material or sensor to create a latent image. *2* The amount of light energy that reaches a light-sensitive material.

exposure factor The number indicating the degree by which measured exposure should be corrected or changed in order to give an accurate exposure.

F

f/numbers Settings of the diaphragm that determine the amount of light transmitted by a lens. Each f/number is equal to the focal length of the lens divided by diameter of the entrance pupil.

fade The gradual loss of density in silver, pigment, or dye images over time.

fall-off *1* The loss of light in the corners of an image as projected by a lens system in, for example, a camera or a projector. *2* The loss of light toward the edges of a scene that is illuminated by a light source whose angle of illumination is too small to cover the required view. *3* The loss of image sharpness and density away from the middle of a flat-bed scanner whose array of sensors is narrower than the width of the scanned area.

false colour A term usually applied to images with an arbitrary allocation of colour to wavebands – for example, with infrared-sensitive film.

feathering The blurring of a border or boundary by reducing the sharpness or suddenness of the change in value of, for example, colour.

file format A method or structure of computer data. It is determined by codes – for example, by indicating the start and end of a portion of data

together with any special techniques used, such as compression. File formats may be generic – shared by different software – or native to a specific software application.

fill-in *1* To illuminate shadows cast by the main light by using another light source or reflector to bounce light from the main source into the shadows. *2* A light used to brighten or illuminate shadows cast by the main light. *3* To cover an area with colour – as achieved by using a Bucket tool.

film gate The physical aperture in a camera that lies close to the film and masks the image projected by the lens. Its size defines the shape and size of the image that is recorded on the film.

filter *1* An optical accessory used to remove a certain waveband of light and transmit others. *2* Part of image-manipulation software written to produce special effects. *3* Part of application software that is used to convert one file format to another. *4* A program or part of an application used to remove or to screen data – for example, to refuse email messages from specified sources.

fingerprint Marking in a digital image file that is invisible and that survives all normal image manipulations, but one that can still be retrieved by using suitable software.

FireWire The standard providing for rapid communication between computers and devices, such as digital cameras and CD writers.

fixed focus A type of lens mounting that fixes a lens at a set distance from the film. This distance is usually the hyperfocal distance. For normal to slightly wide-angle lenses, this is at between 2 and 4 m (6½ and 13 ft) from the camera.

flare Non-image-forming light in an optical system.

flash *1* To provide illumination using a very brief burst of light. *2* To reduce contrast in a light-sensitive material by exposing it to a brief, overall burst of light. *3* The equipment used to provide a brief burst, or flash, of light. *4* The type of electronic memory that is used in, for example, digital cameras.

flat *1* Denoting a low-contrast negative or print in which grey tones only are seen. *2* The lighting or other conditions that tend to produce evenly lit or low-contrast image results.

flat-bed scanner A type of scanner employing a set of sensors arranged in a line that are focused, via mirrors and lenses, on a subject placed face

down on a flat, glass bed facing a light source. As the sensors traverse the subject, they register the varying light levels reflected off the subject.

flatten To combine multiple layers and other elements of a digitally manipulated or composited image into one. This is usually the final step of working with Layers prior to saving an image in a standard image format; otherwise, the image must be saved in native format.

focal length For a simple lens, the distance between the centre of the lens and the sharp image of an object at infinity projected by it.

focus *1* Making an image look sharp by bringing the film or projection plane into coincidence with the focal plane of an optical system. *2* The rear principal focal point. *3* The point or area on which, for example, a viewer's attention is fixed or compositional elements visually converge.

fog Non-image-forming density in a film or other light-sensitive material.

font A computer file describing a set of letter forms for display on a screen or used for printing.

foreground *1* The part of scene or space around an object that appears closest to the camera. *2* The features in a photographic composition that are depicted as being nearest the viewer.

format *1* The shape and dimensions of an image on a film as defined by the shape and dimensions of the film gate of the camera in use. *2* The dimensions of paper on which an image is printed. *3* The orientation of an image: for example, in a landscape format the image is orientated with its long axis running horizontally, while in a portrait format the image is orientated with its long axis running vertically.

fractal A curve or other object whose smaller parts are similar to the larger parts. In practice, a fractal displays increasing complexity as it is viewed more closely and where the details bear a similarity to the whole.

frame *1* A screen's worth of information. *2* An image in a sequence replicating movement.

G

gamma 1 In photography, a measure of the response of a given film, developer, and development regime to light – for example, a high contrast results in a higher gamma. 2 In monitors, a measure of the correction to the colour signal prior to its projection on the screen. A high gamma gives a darker overall screen image.

GIF Graphic Interchange Format. This is a compressed file format designed for use over the Internet. It uses 216 colours.

grain *1* In film, it is the individual silver (or other metal) particles that make up the image of a fully developed film. In the case of colour film, grain comprises the individual dye-clouds of the image. *2* In a photographic print, it is the appearance of the individual specks comprising the image. *3* In paper, it is the texture of its surface.

graphics tablet An input device allowing fine or variable control of the image appearance in an image-manipulation program. The tablet is an electrostatically charged board connected to the computer. It is operated using a pen, which interacts with the board to provide location information and instructions are issued by providing pressure at the pen-tip.

greeking The representation of text or images as grey blocks or other approximations.

greyscale The measure of the number of distinct steps between black and white that can be recorded or reproduced by a system. A greyscale of two steps permits the recording or reproduction of just black or white. The Zone System uses a greyscale of ten divisions. For normal reproduction, a greyscale of at least 256 steps, including black and white, is required.

H

half-tone cell The unit used by a half-tone printing or reproduction system to simulate a greyscale or continuous-tone reproduction. In mass-production printing, such as off-set lithography, the half-tone cell is defined by the screen frequency, measured as lpi (lines per inch): continuous tone is simulated by using dots of different sizes within the half-tone cell. With desk-top printers, such as laser and ink-jet printers, the half-tone cell consists of groups of individual laser or ink-jet dots.

hard copy A visible form of a computer file printed more or less permanently onto a support, such as paper or film.

hints Artificial intelligence built into outline fonts, which turn elements of a font on or off according to the size of the font. Intended to improve legibility and design.

Glossary continued

histogram A statistical, graphical representation showing the relative numbers of variables over a range of values.

HLS Hue, Lightness, Saturation. A colour model that is good for representing a visual response to colours, one that is not satisfactory for other colour reproduction systems. It has been largely superseded by the LAB model.

hot-pluggable A connector or interface, such as USB or FireWire, that can be disconnected or connected while the computer and machine are powered up.

hue The name given to the visual perception of a colour.

I

IEEE 1394 A standard providing for the rapid communication between computers and devices, and between devices without the need for a computer, such as between digital cameras and CD writers. It is also known as FireWire and iLink.

image aspect ratio The comparison of the depth of an image to its width. For example, the nominal 35 mm format in landscape orientation is 24 mm deep by 36 mm wide, so the image aspect ratio is 1:1.5.

indexed colour A method of creating colour files or defining a colour space based on a table of colours chosen from 16.8 million different colours. A given pixel's colour is then defined by its position, or index, in the table (also known as the "colour look-up table").

ink-jet Printing technology based on the controlled squirting of extremely tiny drops of ink onto a receiving layer.

intensity *1* A measure of energy, usually of light, radiated by a source. *2* A term loosely used to refer to the apparent strength of colour, as in inks or the colours of a photograph.

interpolation The insertion of pixels into a digital image based on existing data. It is used to resize an image file, for example, to give an apparent increase in resolution, to rotate an image, or to animate an image.

J

jaggies The appearance of stair-stepping artefacts.

JPEG Joint Photographic Expert Group. A data-compression technique that reduces file sizes with loss of information.

K

k *1* An abbreviation for kilo, a prefix denoting 1,000. *2* A binary 1,000: in other words 1024, as used, for example, when 1024 bytes is abbreviated to KB. *3* Key ink or blacK – the fourth colour separation in the CMYK four-colour print reproduction process.

Kelvin A unit of temperature that is relative to absolute zero, and is used to express colour temperature.

kernel A group of pixels, usually a square from 3 pixels up to 60, that is sampled and mathematically operated on for certain image-processing techniques, such as noise reduction or image sharpening.

key tone *1* The black in a CMYK image. *2* The principal or most important tone in an image, usually the mid-tone between white and black.

keyboard shortcut Keystrokes that execute a command.

L

layer mode A picture-processing or image-manipulation technique that determines the way that a layer, in a multilayer image, combines or interacts with the layer below.

light *1* That part of the electromagnetic spectrum, from about 380–760 nm, that stimulates the receptors of the retina of the human eye, giving rise to normal vision. Light of different wavelengths is perceived as light of different colours. *2* To manipulate light sources to alter the illumination of a subject.

light box A viewing device for transparencies and films consisting of a translucent, light-diffusing top illuminated from beneath by colour-corrected fluorescent tubes in order to provide daylight-equivalent lighting.

lightness The amount of white in a colour. This affects the perceived saturation of a colour: the lighter the colour, the less saturated it appears to be.

line art Artwork that consists of black lines and black and white areas only, with no intermediate grey tones present.

load To copy enough of the application software

into a computer's RAM for it to be able to open and run the application.

lossless compression A computing routine, such as LZW, that reduces the size of a digital file without reducing the information in the file.

lossy compression A computing routine, such as JPEG, that reduces the size of a digital file but also loses information or data.

lpi Lines per inch. A measure of resolution or fineness of photomechanical reproduction.

LZW Lempel-Ziv Welch compression. A widely used computer routine for lossless file compression of, for example, TIFF files.

M

Mac Commonly used term for Apple Macintosh computers and its operating system (OS).

macro *1* The close-up range giving reproduction ratios within the range of about 1:10 to 1:1 (life-size). *2* A small routine or program within a larger software program that performs a series of operations. It may also be called "script" or "action".

marquee A selection tool used in image-manipulation and graphics software.

mask A technique used to obscure selectively or hold back parts of an image while allowing other parts to show.

master *1* The original or first, and usually unique, incarnation of a photograph, file, or recording: the one from which copies will be made. *2* To make the first copy of a photograph, file, or recording.

matrix The flat, two-dimensional array of CCD sensors.

matte *1* The surface finish on paper that reflects light in a diffused way. *2* A box-shaped device placed in front of camera lens to hold accessories. *3* A board whose centre is cut out to create a window to display prints. *4* A mask that blanks out an area of an image to allow another image to be superimposed.

megapixel A million pixels. A term that is used to describe a digital camera in terms of its sensor resolutions.

moiré A pattern of alternating light and dark bands or colours caused by interference between two or more superimposed arrays or patterns, which differ in phase, orientation, or frequency.

monochrome A photograph or image made up of black, white, and greys, which may or may not be tinted.

N

native *1* The file format belonging to an application program. *2* An application program written specifically for a certain type of processor.

nearest neighbour The type of interpolation in which the value of the new pixel is copied from the nearest pixel.

node *1* A computer linked to others in a network or on the Internet. *2* A word or short phrase that is linked to other text elsewhere in a hypertext document.

noise Unwanted signals or disturbances in a system that tend to reduce the amount of information being recorded or transmitted.

Nyquist rate The sampling rate needed to turn an analogue signal into an accurate digital representation. This rate is twice the highest frequency found in the analogue signal. It is applied to determine the quality factor relating image resolution to output resolution: pixel density should be at least 1.5 times, but not more than 2 times, the screen ruling. For example, for a 133 lpi screen, resolution should be between 200 and 266.

O

off-line A mode of working with data or files in which all required files are downloaded or copied from a source to be accessed directly by the user.

on-line A mode of working or operating with data or files in which the operator maintains continuous connection with a remote source.

operating system The software program, often abbreviated to OS, that underlies the functioning of the computer, allowing applications software to use the computer.

optical viewfinder A type of viewfinder that shows the subject through an optical system, rather than via a monitor screen.

out-of-gamut The colour or colours that cannot be reproduced in one colour space but are visible or reproducible in another.

output *1* The result of any computer calculation – any process or manipulation of data. Depending on the context, output may be in the form of new

Glossary continued

data, a set of numbers, or be used to control an output device. *2* A hard-copy print-out of a digital file, such as an ink-jet print or separation films.

P

paint To apply colour, texture, or an effect with a digital Brush or the colour itself.

palette *1* A set of tools, colours, or shapes that is presented in a small window of a software application. *2* The range or selection of colours available to a colour-reproduction system.

peripheral A device, such as a printer, monitor, scanner, or modem, connected to a computer.

Photo CD A proprietary system of digital-image management based on the storage of image files on CDs, which can be played back on most types of CD player.

photodiode A semiconductor device that responds very quickly and proportionally to the intensity of light falling on it.

photograph A record of physical objects, scenes, or phenomena made with a camera or other device, through the agency of radiant energy, on sensitive material from which a visible image may be obtained.

photomontage A photographic image made from the combination of several other photographic images.

PICT A graphic file format used in the Mac OS.

pixel The smallest unit of digital imaging used or produced by a given device.

pixelated The appearance of a digital image whose individual pixels are clearly discernible.

platform The type of computer system, defined by the operating system used – for example, the Apple Macintosh platform uses the Mac OS.

plug-in Application software that works in conjunction with a host program into which it is "plugged", so that it operates as if part of the program itself.

posterization The representation of an image using a relatively small number of different tones or colours, which results in a banded appearance in flat areas of colour.

PostScript A programming language that specifies the way in which elements are output: it uses the full resolution of the output device.

ppi Points per inch. The number of points that

are seen or resolved by a scanning device per linear inch.

prescan In image acquisition, it is a quick view of the object to be scanned, taken at a low resolution for the purposes of, for example, cropping.

primary colour One of the colours – red, green, or blue – to which the human eye has a peak sensitivity.

process colours Colours that can be reproduced with the standard web offset press (SWOP) inks of cyan, magenta, yellow, and black.

proofing The process of checking or confirming the quality of a digital image before final output.

Q

quality factor The multiplication factor – usually between 1.5 and 2 times the screen frequency – used to ensure a file size that is sufficient for good-quality reproduction.

QuickDraw An object-oriented graphics language native to the Mac OS.

R

RAM Random Access Memory. The component of a computer in which information can be temporarily stored and rapidly accessed.

raster The regular arrangement of addressable points of any device, such as scanner, digital camera, monitor, printer, or film writer.

read To access or take off information from a storage device, such as a hard-disk, Zip disk, or CD-ROM.

resizing Changing the resolution or file size of an image.

refresh rate The rate at which one frame of a computer screen succeeds the next. The more rapid the rate, the more stable the monitor image appears.

res The measure of the resolution of a digital image expressed as the number of pixels per side of a square measuring 1 x 1 mm.

RGB Red Green Blue. A colour model that defines colours in terms of the relative amounts of red, green, and blue components they contain.

RIP Raster Image Processor. Software or hardware dedicated to the conversion of outline fonts and vector graphics into rasterized information – in other words, it turns outline instructions such as "fill" or "linejoin" into an array of dots.

S

scanner An optical-mechanical instrument that is used for the analogue-to-digital conversion, or digitization, of film-based and printed material and artwork.

scanning The process of using a scanner to turn an original into a digital facsimile – in other words, a digital file of specified size.

scrolling The process of moving to a different portion of a file that is too large for it all to fit onto a monitor screen.

SCSI Small Computers Systems Interface. A standard for connecting devices, such as scanners and hard-disks, to computers.

soft proofing The use of a monitor screen to proof or confirm the quality of an image.

stair-stepping A jagged or step-like reproduction of a line or boundary that is, in fact, smooth.

subtractive colour synthesis Combining of dyes or pigments to create new colours.

SWOP Standard Web Offset Press. A set of inks used to define the colour gamut of CMYK inks used in the print industry.

system requirement The specification defining the minimum configuration of equipment and the version of the operating system needed to open and run application software or a device. It usually describes a type of processor, amount of RAM, amount of free hard-disk space, or version of the operating system, and, according to the software, the number of colours that can be displayed on a monitor as well as needed for a specific device.

T

thumbnail The representation of an image in a small, low-resolution version.

TIFF Tag Image File Format. A widely used image file format that supports up to 24-bit colour per pixel. Tags are used to store such image information as dimensions.

tile *1* A subsection or part of a larger bit-mapped image. It is often used for file-storage purposes and for image processing. *2* To print in small sections a page that is larger than the printing device is able to output.

tint *1* Colour that is reproducible with process colours; a process colour. *2* An overall, usually light, colouring that tends to affect areas with density but not clear areas.

transparency *1* Film in which the image is seen by illuminating it from behind – colour transparency film, for example. Also known as a slide. *2* The degree to which background colour can be seen through the foreground layer.

transparency adaptor An accessory light source that enables a scanner to scan transparencies.

TWAIN A standardized software "bridge" used by computers to control scanners via scanner drivers.

U

undo To reverse an editing or similar action within application software.

upload The transfer of data between computers or from a network to a computer.

USB Universal Serial Bus. A standard for connecting peripheral devices, such as a digital camera, telecommunications equipment, or a printer, to a computer.

USM UnSharp Mask. An image-processing technique that has the effect of improving the apparent sharpness of an image.

V

variable contrast A coating formula that mixes emulsions of different speeds and sensitivities to light, with the effect that the mid-tone contrast can be varied by changing the spectral qualities of the illumination.

vignetting *1* A defect of an optical system in which light at the edges of an image is cut off or reduced by an obstruction in the system's construction – for example, a lens tube that is too narrow. *2* A visual effect in which the corners are darkened – used to help frame an image or soften the frame outline.

VRAM Video Random Access Memory. Rapid-access memory that is dedicated for use by a computer or graphics accelerator to control the image on a monitor.

W

warm colours A subjective term referring to reds, oranges, and yellows.

watermark *1* A mark left on paper to identify the maker or paper type. *2* An element in a digital image file used to identify the copyright holder.

write To commit or record data onto a storage medium, such as a CD-R or hard-disk.

www.resources

NEWS, INFORMATION, REVIEWS

www.what-digital-camera.com
News, information, reviews, sample images, and more on useful Web sites for digital photography.

www.dpreview.com
Digital Photography Review: up-to-date, highly detailed and informative reviews of digital cameras, as well as news and information.

www.shutterbug.net
Wide-ranging photography resource run by the great eponymous US magazine with a section on digital photography.

www.imaging-resource.com
Up-to-date reviews of digital cameras.

www.internetbrothers.com/phototips.htm
Basic information and advice on digital photography.

www.zonezero.com
Mixture of photography and digital photography with text in English and Spanish.

www.shortcourses.com
On-line books on digital photography and instruction books for digital cameras, with links to other resources.

www.rit.edu
On the site for this great educational institution you can find long lists of discussion groups covering every angle of photography.

COPYRIGHT SITES

www.intelproplaw.com
The Intellectual Property Law server contains useful material on copyright, among coverage of patents, designs, and so on.

www.tilj.com
The Internet Law Journal site is an excellent source of up-to-date changes in law and cases relating to Internet Law in general, much of which is directly pertinent to copyright matters.

www.benedict.com
Wide coverage of copyright issues with relevant case law: it is heavily US-biased as much new law is being created there.

PORTFOLIO SITES

www.fotango.com
Photo processing services and a site that hosts portfolios of images free of charge.

www.printroom.com
Free membership makes on-line albums available for private – in other words, password-protected – or public viewing. Prints can be ordered from the site.

www.focus-online.com
Free gallery for digital images that are accepted on merit. Also news and reviews.

TECHNICAL INFORMATION

While technical information is easy to obtain on the Internet, the quality can be variable. Visit the manufacturer of your equipment or software before deciding to visit any others – some are very informative.

Digital photography

www.dcresource.com
Reviews, sample images and buyers' guides to digital cameras.

www.dpcorner.com
General information on digital photography and cameras, glossary and features on digital photographers.

www.dpreview.com
News, discussion groups and comprehensive reviews of cameras and accessories make up an excellent site. There is also a section for learning about digital photography and a glossary.

www.photocourse.com
An on-line digital photography textbook, together with a Teacher's Forum – designed as an educational resource.

www.what-digital-camera.com
News, chat room, downloadable reviews and sample images for tutorials are available from this constantly up-dated, useful, and informative Web site.

Ink-jet

www.wilhelm-research.com
Reports of tests on inks and papers to help judge quality, longevity, and other attributes.

www.inkjetmall.com
Resources, techniques, and services relating to ink-jet products.

www.epson.com
Helpful technical guides on troubleshooting your printer and how to obtain the best results.

www.inkjetmall.com
Commercial site for selling black and white
ink-jet inks, and also containing much useful
information.

Underwater photography
www.wetpixel.com
Information for underwater digital photography,
including specialist equipment, diving up-dates,
and portfolios of images.
www.aquapac.co.uk
Suppliers of underwater housings for cameras.

Photojournalism
www.digitaljournalist.org
A first-rate site with excellent features by leading
photographers, a superb gallery of modern
photojournalism. Must be visited.
www.robgalbraith.com
An invaluable site by the guru of digital photo-
journalism, offering technical information and
plenty of links to latest information and to
software upgrades.

Web authoring
www.wpdfd.com/wpdhome.htm
Web Page Design for Designers is devoted to design
issues with excellent links.
www.webreference.com/graphics
Covers a range of relevant issues from scanning,
formats to animation.

SOFTWARE ON THE INTERNET
See also pages 396–7 to reach Web sites for
commercial software.
www.creativepro.com
Provides free on-line version of Extensis
Intellihance Pro working through and Internet
browser to manipulate images to improve overall
quality. See also On-line image editing (*below*).
www.graphicconverter.net/
Excellent yet inexpensive software for image
conversion and basic manipulations; some features
are industry-leading.
www.moochers.com
General collection of freeware utilities, including
those suitable for viewing images, basic
manipulation, format conversion, and so on.

www.bitwareoz.com
Software for calculating depth of field using
different settings for focal length, apertures, circle
of confusion: called Focus +, it is available as very
inexpensive shareware for Palm OS organizers.

ON-LINE IMAGE EDITING
http://playground.kodak.com
www.myimager.com
www.gifworks.com
These three sites allow you to edit images for the
Web without owning your own image-manipulation
software – obviously it is not as fast as working
with the application on your own computer, so files
should be kept small to start with.

RESOURCES FOR THE DISABLED
http://joeclark.org/access/
**http://directory.google.com/Top/Shopping/Health
_and_Beauty/Disabilities/**
www.madentec.com/
http://store.prentrom.com/
The first two sites offer information for the disabled.
The others detail and offer for sale adaptive
technologies, such as those designed to improve
accessibility of computing to those with disabilities.
These include voice-activated commands, being
able to hear Braille and text documents, adapting
keystrokes, and so on.

Picture sources

Thanks to two parallel developments – the World Wide Web and the universal adoption of the CD-ROM on computers – it is easier than ever before to access reproduction-quality images. The total number of pictures available runs into the millions, if only because some of the largest of the agencies now have their collections in electronic form. Listed below is a selection for different categories of usage and rights-management.

FREE IMAGES

Many sites offer free images to be used for personal purposes, such as screen savers, or to practise image manipulation techniques. The AltaVista AV Photo Finder is a search engine designed to find images according to key-words. Beware that if you find an image this way, copyright notices may not be obvious, nor can you assume the Web-site owner has permission to use the image: if you were to download it, you could be infringing copyright.

Obviously, you should visit the Web sites of major photographic enterprises, such as Kodak at **www.kodak.com** – it is generous with information and pictures. In addition, try visiting Web sites for universities, research centres, and museums for a wealth of interesting images – from archaeological treasures to pictures of deep space, from satellite images from remote sensing to electronmicrographs of viruses. Other sources are agencies promoting an industry or country: images of steelmaking, aeroplanes or shipbuilding, for example, or images of tourist spots and national costume are all often available for free use, even in a professional context, provided credit is given.

ROYALTY-FREE IMAGES

Once you pay for the CD or downloaded image, you have no further fees to pay for unlimited use. However, some contracts require you to pay an extra amount of money if the image is used for marketing purposes, such as a book cover or other form of packaging.

Corel Large range of images available with low-resolution ones at very low cost on CD but more costly on-line. **www.corel.com**
DigitalVision Wide range of subject with images in a range of sizes, some up to 75 MB, available on CD, also on-line. **www.digitalvision.ltd.uk**
PhotoDisc Huge collection on CDs, with large printed catalogues, and tens of thousands of images available on-line. **www.photodisc.com**
Stockbyte Specializing in still-life images of objects and people in a variety of poses available on-line as well as on CD. **www.stockbyte.com**

OTHER IMAGE SOURCES
http://images.jsc.nasa.gov/iams/
NASA Thousands of images of the planet and near sky taken by NASA space flights can be viewed and some downloaded.

ON-LINE PRINTING
The following offer printing services to customers who either download image files or send in their film or images stored on removable media. But this is only the core of the service: several sites allow registered customers to manage their own album, which is used to store image files but which may be accessed by others for viewing and sharing. It is advisable to check on postal costs if the printing service is based in a different country from the one you reside in.
www.cartogra.com
Prints made on Kodak Professional paper on a site run by Hewlett-Packard. You can upload images directly from an HP scanner to this site.
www.easymemories.com
Print service as well as access to online photogallery.
www.fotango.com
Users with their own Web sites can use script supplied by Fotango to make it easy for visitors to order hard-copy prints (mouse mat, mug, and so on) – with printing handled by Fotango.

WEB PRESENCE PROVIDERS (WPPs)
Some WPPs offer limited free Web space for non-commercial use. Beware that by using the service you may lose copyright; there may also be limits on the level of traffic allowed. Check before uploading any files. Examples of free WPPs include:
geocities.yahoo.com
www.tripod.lycos.com
xoom.com

Manufacturers

Many of the multinational manufacturers provide different Web sites for each of their sales regions. It may be worth visiting those outside your region, as the quality and information can vary greatly between sites: some, for example, may simply offer pages of their product catalogues, while others are a rich resource of practical tips and technical resources as well as giving product information. The following is a selected list of photographic manufacturers you may find helpful.

EQUIPMENT MANUFACTURERS

Agfa Digital cameras, scanners, film
> **www.agfa.com**

Apple Computers, displays
> **www.apple.com**

Canon Cameras and lenses and accessory system, digital cameras, printers, scanners
> **www.canon.com**

Epson Printers, digital cameras, scanners
> **www.epson.com**

Fuji Digital cameras, film cameras, medium-format cameras
> **www.fujifilm.com**

HandSpring Personal Data Assistants (organizers) and accessories
> **www.handspring.com**

Hasselblad Medium-format cameras with lenses and accessory system
> **www.hasselblad.com**

Heidelberg Scanners, fonts, colour software – formerly known as Linotype-Hell
> **www.heidelberg.com**

Hewlett-Packard Printers, ink-jet papers, scanners, digital cameras, computers
> **www.hp.com**

Jobo Digital scanning camera backs, darkroom and other accessories
> **www.jobo.com**

Kodak Digital cameras, film cameras, film, printers
> **www.kodak.com**

Konica Digital cameras, film cameras, film
> **www.konica.com**

LaCie Storage drives and media, displays
> **www.lacie.com**

Leica Cameras and lenses and accessory system, digital cameras
> **www.leica.com**

Lexar Memory cards and readers for digital cameras
> **www.digitalfilm.com**

Lexmark Printers
> **www.lexmark.com**

Microtek Scanners
> **www.microtek.com**

Minolta Cameras and lenses and accessory system, digital cameras, film scanners
> **www.minolta.com**

Nikon Cameras and lenses and accessory system, digital cameras, film scanners
> **www.nikon.com**

Nixvue Digital album for computerless storage of files from memory cards
> **www.jobodigital.com**

Olympus Cameras and lenses, digital cameras, printers, removable storage
> **www.olympus.com**

Pentax Cameras and lenses, digital cameras, medium-format cameras and lenses
> **www.pentax.com**

Ricoh Digital and conventional cameras
> **www.ricoh.com**

Umax Scanners
> **www.umax.com**

Software sources

IMAGE-MANIPULATION SOFTWARE
Despite the dominance of Photoshop, there are many software applications capable of producing excellent results. The simpler programs are better suited to the beginner or if you don't wish to commit a large amount of time to learning how to use the software.

Photoshop
Industry-standard application thanks to professional features such as colour control and a vast range of features but difficult to master and still burdened by weak features, costly to purchase, and at its best when used on powerful computers with enormous RAM allocations. For Mac OS and Windows.
 www.adobe.com
Photoshop Elements
An extremely capable image-manipulation application that is easy to use yet has functions missing from Photoshop. For Mac OS and Windows.
 www.adobe.com
PaintShop Pro
Affordable, powerful software with good Layers features, able to meet most requirements, including work intended for the Web. Windows-only.
 www.jasc.com
Painter
Enormous range of Brush tools with highly controllable painting effects available, as well as powerful cloning tools. Provides an excellent supplement to Photoshop.
 www.corel.com
PhotoImpact
Very good range of tools that are strong on features for Web imagery, in an affordable package that is easy to use. Layers-based work is cumbersome.
 www.ulead.com
PhotoPaint
Powerful and comprehensive features with good Layers and cloning features. Usually part of CorelDraw suite of graphics applications but is also available as an affordable, stand-alone program.
 www.corel.com
PhotoSuite
Inexpensive, tutorial-based software with a good range of tools and Layers handling, together with good functions for Web work.
 www.mgisoft.com

Picture Publisher
Tutorial-based application with very good Layers implementation and extensive resources, including cataloguing features. Windows-only.
 www.micrografx.com
Satori FilmFX
Vector-based painting program of great power and flexibility but tricky to learn and expensive to buy. Windows-only.
 www.satoripaint.com

PHOTOSHOP PLUG-INS
Plug-in software adds functions to the prime software, appearing in its own dialogue box for settings to be made. Many of these will work with applications – such as Painter, which accepts Photoshop-compatible plug-ins. Check with the supplier prior to purchase.
Andromeda 3D
Powerful ability to wrap images around basic 3D objects, but tricky to learn.
 www.andromeda.com
Eye Candy
More than 20 different filters to create a wide range of effects – an excellent introduction for filter enthusiasts – and easy to use.
 www.alienskin.com
Intellihance
Automatic enhancement of images through colour balance, saturation, sharpness, and contrast.
 www.extensis.com
KPT
The Kai's Power Tools application has powerful sharpening, distorting, texturizing, lens flare, and perspective-distortion facilities, as well as having the ability to create skies, complicated lighting, and so on. It can be tricky to learn to use, but it is well worth the effort.
 www. corel.com
Knoll Lens Flare Professional
Extends Photoshop's lens flare filter for impressive effects, but it is limited to this one trick.
 www.puffindesigns.com
Paint Alchemy
Wide range of paint textures can be produced easily and controllably – far superior to Photoshop's range and worth investigating.
 www.xaostools.com

Photoframe
Quick and versatile method of creating custom frames to images, with a large collection of designs.
www.extensis.com

Pen & Ink
Turns images into sketches with different hatching and drawing styles; free download from Web site.
www.inklination.com

PhotoAnimator
Part of the PhotoTools set of applications, and it is excellent for creating GIF animations for Internet use.
www.extensis.com

Terrazzo
Creates tessalated patterns, sometimes of great beauty, from any image – well worth investigating.
www.xaostools.com

Xenofex
Wide range of effects, such as adding elements or distorting the image, which can be controlled to a great extent.
www.alienskin.com

DESIGN AND OTHER SOFTWARE

BBEdit
HTML editor beloved of experts working on Mac OS and containing many useful features. The Lite version is available as freeware.
www.bbedit.com

Dreamweaver
Professional, full-featured software for designing Web pages and managing Web sites. For Mac OS and Windows.
www.macromedia.com

Flash
Powerful software for drawing, animation, and multimedia creation. Flash animation is widely readable on the Internet. For Mac OS and Windows.
www.macromedia.com

FotoStation
Simple and effective for creating sets of pictures and management, with multiple printing and Web-page-output options. For Mac OS and Windows.
www.fotostation.com

FrontPage
Fairly easy to use software for the creation of Web pages, but lacks the power features for top-quality designs. Windows-only.

GoLive
Industrial-strength design tool for Web-page and Web-site management with a full range of features, but is difficult to learn. For Mac OS and Windows.
www.adobe.com

HomeSite
HTML editor for Windows users, with features making it suitable for writing in other Web languages.
www.allaire.com

InDesign
Very powerful page-design software with excellent feature set, but difficult to learn and demanding on computer resources. For Mac OS and Windows.
www.adobe.com

Portfolio
Powerful tool for the management of picture libraries with the ability to publish on the Internet, and has search facilities. Suitable for use over networks but can be slow. For Mac OS and Windows.
www.extensis.com

Retrospect
Widely adopted back-up software – not the most straightforward to use, but appears reliable.
www.dantz.com

XPress
Industry-standard software for page design. It can be made very powerful with extension software and is relatively easy to learn. However, it is expensive to buy and can be unreliable. For Mac OS and Windows.
www.quark.com

Index

Index continued

Index continued

Acknowledgments

Author's acknowledgments

My first thanks go to Judith More, for commissioning the book and to the team at Dorling Kindersley who saw it through to completion, namely Sharon Lucas, Neil Lockley, Kevin Ryan, Simon Webb, Lee Riches, and Samantha Nunn.

Thanks to Adobe and Corel for keeping me up-to-date; to my editors on *MacUser* magazine whose commissioning has given me the opportunities to keep up with the industry and to *What Digital Camera* magazine for keeping me informed.

The greatest and deepest are my thanks to Wendy for all she has done for me. The word "all" encapsulates a universe of support, help and inspiration which has made possible the enormous project that has been this book.

Tom Ang
London 2003

Dorling Kindersley would like to thank the following for their contributions:
Editorial: Georgina Garner; **Design:** Derek Coombes, Simon Webb, Lee Riches, Simon Wilder, Marianne Markham, Paul Drislane, Jenisa Patel, and Janis Utton; **Jacket Editorial:** Beth Apple; **Jacket Design:** Natalie Godwin; **Index:** Ann Parry; **Picture Research:** Samantha Nunn, Carlo Ortu; **Illustrator:** Patrick Mulrey.

Picture credits
The publisher would like to thank the following for their kind assistance and for permission to reproduce their photographs:

ACDSee, Adobe, Agfa UK, Louse Ang, Apple, Aquapac International Ltd, Belkin Components Ltd, Better Light Inc, M. Billingham & Co Ltd, Bite Communications Ltd, Blitz PR, Broncolor, Calumet International, Canon UK, Casio UK, Casio Electronics Co Ltd, Centon, Companycare Communications, Compaq UK, Contax, Corel, Andy Crawford, John Curno, Dorling Kindersley Picture Library, Epson UK, Extensis, Firefly Communications, Fuji, Fujifilm UK, FutureWorks, Inc, Gateway, Goodmans Industries Ltd, Gossen, Hasselblad, Heidelberg USA, Hewlett-Packard, IBM, Ilford Imaging UK Ltd, Iomega, JASC, Johnsons Photopia Ltd, Kodak, Konica UK Ltd, Kyocera Yashica (UK) Ltd, LaCie, Leica, Lexar, Lexmark, Linho, Linhof, Logitech Europe SA, Lowepro UK Ltd, Macromedia Europe, Mamiya, Manfrotto, Megavision, Mesh, Metz, Microsoft, Microtek, Minolta, Mitsubishi, Nikon UK Ltd, Nikkor, Nixvue Systems, Olympus-Europa, Packard Bell, Panasonic Industrial Europe Ltd, Peli Cases, Pentax, Phillips, Ricoh, Rollei, Roxio, Sigma Corporation, Smartdisk Europe, Sony, Tamrom UK, Tenba Quality Cases, Tokina, Ulead, Umax, Wacom.

Jacket Picture Credits
Back flap centre © Carolyn Watts (c); Front © Chloë Alexander